RUGGLES STREET
THE LIFE OF AN AMERICAN ARTIST

Robert O. Caulfield

By Robert O. Caulfield
and Craig Caulfield

Edited by Melissa J. Hayes

★

RS PUBLICATIONS
Woodstock, Vermont

RS PUBLICATIONS
Woodstock, Vermont

Design by Lauren Hawkins
www.paperdolldesign.com

Illustration on page 58 reprinted with
permission of the *Boston Herald.*

First Edition
SAN 256-0119

Library of Congress Cataloging-in-Publication Data
Caulfield, Robert O., 1930–
 "Ruggles Street" : the life of an American artist /
by Robert O. Caulfield & Craig Caulfield
 p. cm.
 LCCN 2004093203
 ISBN 0-9701846-1-1

 1. Caulfield, Robert O., 1930– 2. Painters--United
States--Biography. I. Caulfield, Craig. II. Title.

ND237.C375A2 2004 759.13
 QBI04-200179

13 12 11 10 09 08 07 06 05 04 5 4 3 2 1

For my family

Marine Corps.
1951.

Contents

List of Plates

List of Plates

List of Plates

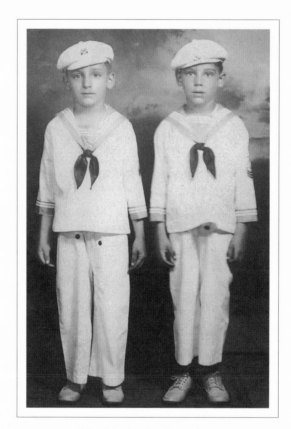

My older brother Joe and me
posing in borrowed clothes.
Roxbury, 1935.

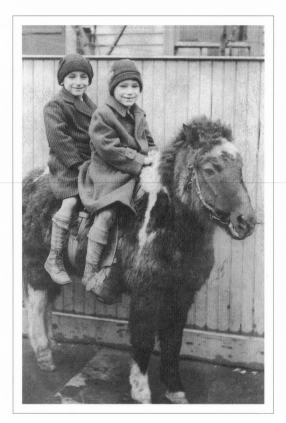

Me up front and Joe riding shotgun.
Roxbury, 1938.

A Death at Champney

It was cold and after dark, and I must have been so involved, crouched on my hands and knees over my chalk drawing in the gutter, that I didn't see the car coming. Ear-splitting, screeching brakes startled me as the old Model T swerved my way, flickering shadows of its wooden spoked wheels over my face. The driver honked his horn and barked, "Get the hell out of the street, you goddamned stupid kid!" His car squealed to a stop inches away from my nose. Grabbing my chalk, I hopped back onto the curb and watched the old car chug off, balls of black smoke coughing from the exhaust pipe, *puff puff puff.* Above me twinkled the endless rows of blinking lights that made up my sorry firmament, the Roxy Theatre marquee. The Roxys were a chain of elaborate movie palaces, and how one ended up in my miserable neighborhood in Roxbury, Massachusetts, I'll never know. I was living for the moment with my parents just next door, one flight up a dark stairwell in a cramped and shabby apartment, with little in the way of furniture, food, or hope.

My memory begins with violence. A bitter cold wind whipping through a February night. Sleet stinging my face. Snow swirling, its fluid patterns whirling through harsh shafts of light thrown off by municipal streetlights back into the night. My older brother Joe was standing beside me in an alley off Dudley Street. An alley we played in every day. A mixture of terror and awe gripped our features as we watched two gigantic men beat the living hell out of each other in a ferocious fistfight. We were the only children in the pushing, shoving crush of adults crowding closer to watch the men throw punches. Blood glistened on the shiny bald head of one of the men, the one who was taking furious smacks to the face and chest. Excitement rippled through the crowd as the men and women screamed insults or encouragement. My hands were numb, and my body trembled with equal parts fear and cold.

With an awful gasp, the bald man went down hard, a locomotive blowing steam as his breath turned to fog in the frigid, late-night air. He hit the icy ground face-first, wheezing and making a horrible gurgling sound. A flashy prostitute in a yellow hat screamed, "He's dead! Lord have mercy!" The brute who had beaten the bald man kicked the fallen warrior in the head and stalked off into the alley's murky shadows. Who knows why Joe and I stayed on and watched while most of the adults walked away. The bald man on the ground groaned for a moment, then shook, convulsed, and wheezed his last breath. A couple of cops came by ten minutes later. They didn't do much except ask a few questions of the straggling adults who had stayed on to gasp and wallow in the horror of watching the dead man's blood turn the white snow red.

A horse-drawn wagon pulled up and some men heaved the bald man's body onto it. Dangling over the edge of the tailgate, his lifeless head bobbed up and down like a ball on a string as the wagon pulled off. Blood pouring from one of his ears left a trail marking his sorry exit from this life, drop by drop in the snow. My heart broke for that poor man and I sobbed a bit. This event has remained crystal clear in my memory throughout my life. It was the winter of 1937. I was six years old.

Roxbury was a dangerous, poverty-stricken neighborhood, dead center in the city of Boston; it was known at the time as a "colored district," its population almost entirely African-American. Aside from my usual bad-boy activities on the city's mean streets, I was completely consumed with drawing. It was as if a force within me compelled me to draw, any chance that I could grab. Ironically, Boston's Museum of Fine Arts was only five or six blocks from the neighborhood I grew up in, but it may as well have been across the chilly Atlantic.

Art was not an aspect of my family's life in any shape or form. My mother forbade me to draw inside our apartment anymore because I had covered one of my bedroom walls with all kinds of crayon drawings. I have no idea where the crayons came from. I probably stole them. We lived in abject poverty and literally did not have a cent. Probably fearing the landlord's wrath, my father decided to paint over my crayon drawings one day, and left a coffee mug full of white paint on a table. Joe took a huge gulp thinking it was milk, and there was a frantic scramble to rush him to the hospital and have his stomach pumped.

Heading upstairs to the second-floor apartment I temporarily called home, I'd pause and place my ear to the door. My father worked nights as a steward in a Boston hotel. When he was home during the day, if his nose wasn't buried in a newspaper or magazine, he and my mother were

arguing. That is, if she was home and hadn't quit or been fired from the latest in an endless string of waitressing jobs. If I heard the shrill voices I so dreaded, I'd run downstairs and hurry next door to the Roxy. There I could watch the crowds coming to see a movie, or admire all the colorful "coming attraction" posters while I waited out yet another screaming match.

When my father was at work, my mother spent a lot of time alone, crying and listening to the radio. She paid little attention to me or to my brother Joe, except to explode into a tirade over nothing every so often. Her face would flush and her blue eyes would be seized with a manic electricity that almost seemed to throw off sparks. The fury that could erupt from her tiny frame over a spilled bit of jam on your shirt was out of control and terrifying. My mother Marie was a porcelain-pretty brunette with striking blue eyes. A slight woman, weighing barely a hundred pounds, she was in frail health, often anxious, and always wringing her delicate, flawless hands. She kept a fanatically clean house and was forever shining this or dusting that, despite the fact there was barely anything in the apartment to keep clean. Her clothes were always fresh and crisply pressed due to her obsessive diligence at the ironing board, and she presented an immaculate appearance at all times.

I never could have known it, being so young, but my parents' was a marriage that should never have been. They had no love for one another, and though currently living as man and wife together under the same roof, we were not a family in any conceivable sense of the word.

My mother was born in November of 1910, in the Boston Lying-In Hospital. Now known as Brigham and Women's Hospital, at the time of her birth the hospital served those in indigent circumstances. Her father, a man with the fantastic name of Nehemiah Hemeon, died shortly after her birth. Her mother, also named Marie, and known to us as Grandma Stoner, was a frequent visitor to our apartment as she lived only three or four blocks away on Ruggles Street. Joe and I had lived with her almost since the day each of us had been born. The only details I know about my mother's childhood were garnered from my parents' divorce records.

The Family Welfare Society of Boston filed a report on Grandma Stoner in 1916, when my mother was six years old, saying they "did not believe she was a proper person to have her daughter." The Society for the Prevention of Cruelty to Children record reports that an anonymous letter was received, stating that my mother's mother was sending young Marie out on the street to beg for money with a tin cup (a common practice among the poor at that time), but there was not sufficient evidence to

make a neglect complaint. From that wisp of information I can guess that my mother's childhood was most assuredly bleak.

My mother would often leave my father for periods of time that could stretch to three or four months. I'm not sure where she went on these "trips," but sometimes she would take Joe and me and move in with Grandma Stoner, in the cramped little row house we all shared on Ruggles Street, for the duration of her latest estrangement from my father.

Grandma Stoner had married again after Nehemiah's death, to a man named Robert Stoner, whom I know nothing about. Widowhood had visited her a few years into that childless marriage. My mother was the only child she'd brought into this world.

My mother met my father while working in a summer hotel in New Hampshire in 1928. My father was a good-looking man with hazel eyes and dark olive skin. He was four years older than she was. Whatever golden romance flared between them in the White Mountains during those days must have tarnished early on. The fact that my mother was seven months pregnant when she married my father in July of 1929 indicated there must have been tremendous dissension between them in order to have postponed marriage that long in a moral climate where an unmarried mother was considered ruined—not to mention the fact that my mother was Roman Catholic. My father came from a staunchly Catholic family as well. I have no idea why my parents postponed marriage for so long. Was my mother resistant to the idea of matrimony, or was it the more obvious choice, my father? Had a summer fling exploded into circumstances neither one of them could accept or cope with? Had love ever pulled their hearts together?

My brother Joe was born that September. When he was a few months old, my father forced my mother to return to restaurant work. By December of that year she was once again back living with her mother. Reconciling shortly thereafter, my parents took a train to Florida, hoping to find better economic prospects in the South. They left Joe in Grandma Stoner's care.

Returning to Roxbury alone and pregnant with me in the autumn of 1930, my mother once again moved in with Grandma Stoner to await my birth, which came on December 14 of that year. Finding no relief from the Depression in Florida, my father returned to Roxbury soon after I was born. The first few years of my life were defined by the ceaseless merry-go-round of battles, split-ups, abandonment, and reconciliations that riddled my mother and father's unfortunate union. The Boston Public Welfare Society provided aid to them for a number of months in

1931 and 1932, some of the most dismal days of the Great Depression. The woeful financial straits my parents found themselves trapped in could only have encouraged the demons that bedeviled their domestic relationship.

For all intents and purposes, Grandma Stoner was my mother for the first decade of my life. Even during the erratic reconciliations my parents attempted when I lived with both of them—usually for a month or two—I more or less saw Grandma Stoner on a daily basis because she lived just around the corner on Ruggles Street. Both of my parents contributed to the cost of caring for Joe and me, but Grandma was always complaining that my father never paid up on time. She bad-mouthed him to anybody who'd listen, any chance she got.

Jittery and high-strung, Grandma Stoner was always yelling and screaming at us. It's my guess that the primary reason she was our caretaker was because of the money my parents paid her for our keep. I have no memory whatsoever of a kind word, a hug, or a kiss from my mother, ever. She was so distant she may as well have been an apparition. The only time she paid attention to her children was when we were acting up and she had to discipline us with a red-faced tantrum or a spanking.

I loved her, though. I dreamed that maybe someday everything would change and she'd show me that she loved me too. My feelings for my mother were projected onto a stranger, which she was to me. My love was never reciprocated. How can a child comprehend the lingering sting of rejection and indifference from his own mother? My father was equally distant and cold to us, but I couldn't help noticing how other people seemed to like his company. With his handsome charm, I could never understand why he wasn't as full of personality and laughs with us at home, as he was with his friends and acquaintances. He and my mother were trapped in a loveless marriage. The arctic indifference he bestowed upon his children was perhaps an honest expression of his feeling trapped by the circumstances of his life.

Of Irish and French-Canadian descent, Grandma Stoner was a short, formidable woman of well over two hundred pounds. I can't recall ever seeing her without a cigarette jammed between her pursed lips. Joe and I thought she was an ancient old hag. It is striking to look back and realize that having been born in 1893, she was only in her late thirties and early to mid-forties during the years she was our guardian. She, too, had striking blue eyes, but they were much smaller than my mother's,

kind of beady. They made her look mean, which there was no doubt she was. She kept her graying hair wrapped up in a bun, and I never saw her without a clean white apron on. A few scraggly gray whiskers jutted from her chin. Joe and I spent countless moments being horrified by their presence, and spent even more time hatching plots to snip them off when she was asleep or passed out on the couch after another round with the whiskey bottle. "But more will just grow back!" I'd always tell Joe.

Grandma Stoner's temper had the force of an earthquake. The walls on Ruggles Street seemed to rattle when she'd get rolling. It's astonishing I didn't end up with cauliflower ears, since yanking me around by them was her favorite form of discipline. My brother and I were inseparable during those years on the streets of Roxbury. It wasn't just brotherly love that kept us close, but also a necessity in terms of basic survival. Although I had a few black playmates before I began my school years, for the most part the color lines were impenetrable in Roxbury. The litter-clogged streets we played on had one simple rule, and that was blacks stayed with blacks, and whites stayed with whites.

Joe and I and our little neighborhood gang got into countless scrapes and fistfights; you always had to watch your back. Once in a while Grandma Stoner would send us down to stand in a breadline, or to get oranges or blankets handed out to the poor that day by a government agency or the local mission. Even at that young age I hated every humiliating second of standing in those lines of the down and out. I knew those people in their shabby clothes were the dregs, the poorest of the poor, and that *I* was one of *them*. Making my way home I had to take extra caution not to have even those meager handouts stolen from me by other kids or men with scary stares.

Having the O'Neills as neighbors was a boon to Joe's and my defenses. They lived on Ruggles Street too, a few doors down from us—all eighteen kids, their parents, and maybe a couple of aunts thrown in there. It seemed as if the O'Neills' front door never stopped opening and closing, no matter what time of the day or night.

Ruggles Street seemed vast to my childhood eyes, with its series of drab row houses all joined together, each one with a tiny little fenced-in yard in front, maybe ten feet by ten, with patches of crabgrass and weeds fighting for sun among the dirt and debris. One of the O'Neill daughters, May, was a friend of ours. Her specialty was hanging her backside over the porch railing one story up and taking a crap for the entertainment of her siblings and pals, who would collapse in screaming fits of laughter as yet another poop plunged into the stained bushes below.

There were a bunch of abandoned cars behind Grandma Stoner's house, which looked out on Champney Place. I remember sitting on the ripped-up seat of an old junker with Joe, spinning the steering wheel, when I heard May call out, "Hey, Bobby and Joe!" We climbed out of the car. Shielding my eyes from the sun, I looked up as May eased her snow-white bum onto the railing and shouted, "Bombs away!" Joe elbowed me in the ribs and said, "Bobby, she's got no pee-pee." We laughed like hell, but it was the first time I had been exposed to that part of a girl's anatomy, and it was a real shock that haunted me for weeks. This was a tender subject for me because my circumcision had been put off until I was six years old. During that visit to the doctor's, I was terrified that the man in the white coat with the bad breath was intent on cutting off my penis. I thought maybe the doctor had cut off May's for real.

My school years began when I was six years old. Grandma Stoner had decided to keep Joe back one year so that we could begin the first grade together. We were enrolled in Saint Rita's, a parochial school in Roxbury. The nuns who taught us seemed to frighten a lot of my schoolmates with their flowing black habits and stern expressions, but they didn't scare me. They were certainly strict. I'm sure I railed against their discipline at times, but overall, I found the nuns to be gentle. Those fine women were a caring and soothing maternal presence for me and a kind influence in my rough and turbulent life.

I was astonished when I first saw the big schoolyard at Saint Rita's, after spending my life up to that time in the cramped quarters of my neighborhood block around Champney Place. When I heard the bell ring after recess that first day of school, I thought it meant that classes had ended, so I walked the five or six blocks home. Grandma Stoner was not at all happy to see me reappear at her door so early, and hauled me back to the equally disapproving nuns. I never liked school, so I guess from day one my actions were sort of an indication of how things would play out in that arena.

I'm not sure if Grandma Stoner had electricity in her row house in my early years. She would light kerosene lamps as night fell, and she had an icebox, because I can remember stealing ice from the iceman's wagon when he delivered a block every couple of days. She had a music box, a beautiful machine of glass and brass that only she was allowed to crank. I know we had electricity by the time I was ten or eleven, because I must have heard Kate Smith singing "God Bless America" ten million times that year on the junky, secondhand radio Grandma Stoner had somehow acquired.

Grandma Stoner loved cats. A month could hardly pass without her trying to sell a litter of kittens, or trying to give them away when they got too big. The house always reeked of cat pee.

Saturday night was Grandma Stoner's big night out every week. Saturday night dinner was always the same thing: hot dogs and beans. When dinner was finished, she'd fill a huge tin tub in the kitchen and take a bath. One time Joe and I hid under the kitchen table and watched her dab at her chubby arms with a big soapy sponge, all the while puffing on an endless chain of cigarettes, before flicking the butts into the sink. I dreaded Saturday nights because after she got dressed and had a few sips from her whiskey bottle, she'd yell for Joe and me to climb the stairs to the windowless attic. The roof up there was so low that Grandma Stoner would have to stoop as she lit a kerosene lamp in the corner. When the attic door would slam shut, the key turn, and the lock click, my heart would sink. The routine never changed; I knew I wouldn't hear that key in the lock again until late the following morning.

I could tell when morning came by the increase in everyday sounds outside, and by the tiny shaft of light that came in through the keyhole and under the door. The attic was furnished with a ratty old bed and a chamber pot. We had a couple of broken toys to play with and some worn comic books. In retrospect it's sort of miraculous that with all our roughhousing Joe and I didn't knock the kerosene lamp over and burn the place down. Grandma Stoner never left us anything to drink, just two Milky Way bars sliced into little pieces and left on separate plates.

Grandma Stoner was a flat-out lousy cook. She might go five nights in a row serving Joe and me mustard sandwiches. Two slices of white bread and a dollop of French's yellow mustard and nothing else. Sometimes I'd sneak downstairs at night when Grandma was asleep and gulp spoonfuls of sugar to satisfy my sweet tooth, then have to come up with a good story when she began screaming about somebody stealing from her the next morning.

When I was about seven years old, we accompanied Grandma Stoner on a visit with some friends of hers. Joe and I ended up wrestling on the floor beneath a table. I felt a sharp jab in the palm of my right hand. When I held it up, I saw a needle sticking into it. An old man who was there tried to pull the needle out, but it broke in half. I was taken to the hospital where I pleaded with Grandma Stoner not to leave me alone. I underwent an operation in which the doctors couldn't find the other half of the needle in my hand, so they had to operate again the next day. Somehow the needle had traveled, and they found it in my arm.

The operation left a long incision in my palm and a smaller one in my forearm. I was kept in the hospital for almost a week. I've always been left-handed, so the accident didn't affect my drawing ability. The main thing I remember about my hospital stay was that I was scared and lonely. I had a paper doll of cowboy star Gene Autry for company, and I'd hide it under my pillow any time the nurses came around. Grandma Stoner came to visit me a few times and even brought Joe along once, but my parents never set foot in the hospital, for whatever reasons they might have had.

I spent most of my time in school daydreaming and drawing in my notebooks. Most of my time out of school was spent finding trouble. Joe and I were constantly getting into one scrape or another. We were very adept thieves. Snitching candy, apples, and other small items from the local store was a favorite pastime. On rare occasions, we made the journey to Lynn, a seaside industrial community roughly fifteen miles north of Boston. My father grew up in Lynn. His parents and brothers and sisters still lived there. My father's younger sister Dorothy, whom we called Aunt Dot, would drive into Roxbury in her coupe a couple times a year. She'd pack Joe and me into the rumble seat and drive off past Revere Beach, with its amusement park we never got to visit, and on through the salt marshes into Lynn. Riding in Aunt Dot's coupe was always a big deal for Joe and me and made us feel like big shots.

I adored my father's parents, whom we called Gramma and Grampa. Visits with them were a world apart from anything I knew in Roxbury. Gramma and Grampa Caulfield were always kind and gracious. Gramma was a terrific cook, and never stopped encouraging us to have second and third helpings at meals. However, my affection for them didn't prevent me from rifling through their coat pockets or dresser drawers in search of loose change when their backs were turned.

Back on Ruggles Street, Grandma Stoner did her best to keep us in line, but in reality, we had no authority figures whatsoever, apart from the occasional reprimands and constraints imposed by the nuns and administrators at school. Despite her alcoholic indifference toward us most of the time, Grandma Stoner was fiercely protective of Joe and me. People on our block knew enough to keep their distance from Grandma Stoner and her rolling pin, which once or twice a day would threaten to come crashing down on the skull of somebody who had crossed her.

Once a week, every week, we'd accompany Grandma Stoner to a grimy parlor in a house a few blocks away from ours. Easing her bulk into a plush chair beside a rickety table, Grandma Stoner would manage

a rare smile when a scary, pruned-up old woman with lingering body odor and black teeth slithered through faded curtains carrying a teapot. Flickering candlelight shimmered in the golden finish of the teapot, and illuminated stagnant streams of incense. When Grandma Stoner finished sipping her tea, the dregs of her tea leaves would be spread out on a saucer and the old crone would lean in close to read them. I'd look at my distorted reflection in the teapot or close my eyes and daydream. Occasionally I'd give Joe a roll of the eyes and then count the seconds till we could get out of there. I guess Grandma Stoner must have liked what the fortune teller was predicting because this went on for years.

Joe and I loved the Fourth of July. Fireworks like cherry bombs and Roman candles were legal in those days, and they were sold in a store just around the corner from us on Dudley Street. We never had any money to buy them, so the day after the Fourth, we'd rummage through the trash bin behind the store. We'd almost always find enough firecrackers and cherry bombs to cause some trouble and scare the hell out of a few adults who mistakenly thought all the explosions were over for that year.

Firewood and newspapers were stored in the cellar at Ruggles Street to fuel Grandma Stoner's big, black kitchen stove. One day, Joe and I lit some matches and set the newspapers on fire just to watch them burn. It wasn't long before billowing white smoke filled the house. The fire department arrived in a whirl of ringing bells, and big men in fire hats carrying canvas hoses rushed in the back door to douse the flames. After the firemen left we got a five-alarm spanking and were sent to bed without any supper.

Not long after that episode, Joe and I were performing one of our daily chores—splitting wood for Grandma Stoner's stove. As usual, I held a piece of wood on a stump while Joe raised the ax and swung it down hard. Somehow, he misjudged his aim and bashed me in the head. Within seconds, Grandma Stoner's plump legs were pounding down the cellar stairs in response to my screams, she herself screaming at the top of her lungs at the sight of the blood gushing from my head. In the hospital my head was shaved. I can still see all two hundred-plus pounds of Grandma Stoner hitting the tile floor when she walked in and fainted after seeing the doctor pull a hook-shaped needle through my gaping wound. After I was stitched up, my head was wrapped in gauze, mummy-style, with only my eyes and mouth showing.

By this time, I was seven years old. I had once again missed so much school that I was kept back to repeat the first grade. So much for going through school in the same grade as Joe! I have no idea if the doctor's

bills were ever paid. Joe and I also had childhood bouts of measles and chicken pox. In those days the house was quarantined at the first hint of those diseases; so, if Joe was down for the count with something, I couldn't go to school, and vice versa. I'm sure we missed even more time in the classroom for that reason.

I always liked the winter months, if for no other reason than the fact that the snow would make the neighborhood look beautiful for a day or so, until everything was covered in soot and grime again. The cold weather drastically reduced the wild goings-on I saw on the streets everyday in the warmer months, things that reflected the darker side of the human condition—hookers and flashy pimps parading around, drunks and bums who never smiled, petty thieves, bullies, and very minor gangsters in really cheap suits—all playing out the drama in their lives at full speed.

An overhead elevated subway train we called the "el" passed by the end of our block, not eighty feet from our front door; every ten minutes or so we would hear the electric screech of steel wheels on iron rails, accompanied by clanging bells. Even all that racket seemed muffled by winter's snow. One time the snowflakes were so endless that we had to shovel a tunnel through a ten-foot-high snowdrift to get to our back door, where we found one of Grandma Stoner's favorite cats frozen stiff.

By the time I turned eight, I was getting into fights every day at school, or on the way home from school. When I couldn't find anybody to pick a fight with, I'd end up swinging punches with Joe. On a February day after yet another huge snowstorm, my friends and I grabbed a snow shovel and took turns sliding down a steep snowbank adjacent to the street. Joe came strutting over, and when it was his turn he shot down the slope with terrific speed, directly into the path of an oncoming car. It was one of those moments when time stands still, and it did for me that day as Joe got caught up in the spokes of one of the car's wheels, spinning around in a blur of blue terror in the long seconds before the driver skidded to a halt.

My feet were almost tearing through the pavement as I ran along Ruggles Street screaming, "Joe's dead! *Joe's dead!*" In a haze of cigarette smoke and whiskey interrupted, Grandma Stoner dashed out the back door with a butt between her lips and her crisp white apron blowing in the wind. She did her best to cut through my hysteria and find out what had happened, made all the more difficult because of my blubbering friends. To my astonishment, Joe came home in an ambulance that night, his brush with death no more severe than a few scrapes and a broken

ankle. Somebody at the hospital had given Joe fifty cents, which was an absolute fortune in our eyes. He tried to hide it from Grandma Stoner, but the two shiny quarters disappeared into her hands, and probably that Saturday night, into the till of the local bartender.

The amount of time my parents spent trying to unite as a family under one roof, in that glum apartment beside the Roxy Theatre, measured just a few months during those early years. When Joe and I had returned to live with Grandma Stoner, it wasn't jarring; it was like coming home after a vacation down the block. I saw my father rarely after that, usually only when he would show up at school to talk the nuns out of expelling us for whatever trouble we'd caused that week. At one point Joe and I were expelled for being "incorrigible," but my father somehow had us reinstated, no doubt winning the nuns over with his considerable charm.

In May of 1937 my parents returned to work for the summer in the New Hampshire hotel where they'd first met. Early on, my mother fell extremely ill. Doctors performed an emergency appendectomy, followed by a hysterectomy and a long convalescence at Massachusetts General Hospital. In the gloomy months that followed, my mother suffered a nervous breakdown, an incapacitating emotional disorder marked by fatigue, loss of energy and memory, and feelings of inadequacy. Joe and I were protected from hearing any of this.

In the spring of 1938, there was one last attempt at reconciliation between my parents. Joe and I crouched outside Grandma Stoner's living room window and eavesdropped as my parents met there to discuss the possibility of getting back together again. The conversation was barely five minutes in when it exploded into a shouting match, with Grandma Stoner joining in and yelling the loudest.

My mother's voice trembled as she begged my father to make a home for her and her sons. My father railed over her sickly nature and accused her of milking her illness instead of going out and working and contributing to family finances. I looked in the window and saw my father slap my mother in the face. Her tiny body collapsed to the floor in gut-wrenching tears. After slamming the door so hard it shook the house, my father stormed off in an absolute fury.

I was walking home from school the next day when I spotted my mother at the end of the block, handing a suitcase to a cab driver. He placed it into the trunk and opened the cab door for her to get in. Running toward the end of the block as fast as I could, I called out, "Mom!"

She didn't seem to hear me. The cab began moving and I banged on the window, yelling, "Mom!" She reached over and locked the cab door without so much as a glance in my direction. The taxicab pulled away as I shouted, "Mommy, don't go!" She never looked back.

Joe and I were heartbroken. It seemed no one really wanted us or loved us. I stuttered until I was in my early teens. I'm sure this was a manifestation of the tumultuous circumstances of my domestic life, not to mention life on the hard streets of Roxbury; although, in my young mind, I thought—as most kids do, no matter what their social circumstances—that everybody except rich people and cowboys lived like I did.

My father's mother, Gramma Caulfield, was a tiny woman in her late fifties. She was barely five feet tall. Right after my parent's final battle in the living room, she began making more frequent visits to Roxbury. Her parents had emigrated to America from the island of Pico in the Azores, a rocky outcropping of lush islands with sharp, cone-shaped peaks located in the Sargasso Sea of the North Atlantic, about nine hundred miles west of Portugal and seven hundred and fifty miles north of Africa. This earthquake-prone chain of islands was inhabited only by birds and plants until the 1400s, when it became home to a hardy population of settlers of Moorish, Flemish, and Portuguese descent. The Azores were an important way station in the Portuguese trade routes, and also an extremely popular destination for Jews fleeing the punishments meted out by the courts of the Inquisition, a period in which the Catholic Church persecuted the practice of Judaism as a sin punishable by death at a burning stake. The Azoreans are a deeply spiritual people. One of their greatest annual celebrations is held in honor of the Holy Ghost during Pentecost. Over twenty-one major volcanic eruptions have wracked these islands in the last six hundred and fifty years. People in the Azores are accustomed to calamity.

Gramma Caulfield had hazel eyes and olive skin, as did I. She was born in Massachusetts, and had grown up in Provincetown at the tip of Cape Cod. Her family had been prominent members of that city's fishing community. Family legend has it that she met my grandfather, an Irishman from Newry in County Armagh, when he was a member of the English Navy and his ship stopped in port. This was long before the Irish Rebellion of 1916, when Ireland was entirely under British rule. His name was Owen Caulfield, and he had once served in the Queen's Guard at Buckingham Palace during the reign of Queen Victoria. When his ship docked in Provincetown, he met my grandmother during shore leave. Soon after that he decided to stay in America and jumped ship.

Their romance led to marriage in 1904, when he was twenty-six and his bride just twenty. They settled in the north shore city of Lynn, where they were to spend the rest of their long lives.

It was always an exciting occasion when Joe and I would spot Gramma Caulfield walking down Ruggles Street after getting off the overhead "el." Joe and I would run to greet her, and she'd always give us a quarter, then lean down and in a conspiratorial tone tell us not to let Grandma Stoner know we had any money. She'd encourage us to buy whatever we wanted or urge us to go see a movie at the Roxy, which cost ten cents at the time.

After watching Gramma Caulfield shoo cats away every five seconds during her visit with Grandma Stoner, we'd hurry down the block to the Roxy Theatre and buy our tickets at the kiosk fronting the street. From there it was a fifty-foot walk to the lobby entrance, past the colorful posters of coming attractions I loved so much, and a gauntlet of tough punks who'd try to bully us into giving up our tickets. More often than not, we made it inside the lobby doors after a few rounds of flying fists.

Like millions of other kids, I absolutely loved the movies. There were all kinds of short movies and cartoons they'd show before the feature; my favorite of all were those with Gene Autry, the singing cowboy. The appearance of The Three Stooges logo on the Roxy's big screen would bring the house down every time. Serials like *Flash Gordon* starring Buster Crabbe would keep you in suspense for a whole week, as you waited to find out the resolution to each episode's cliffhanger. You got a lot for your money at the Roxy, and a double feature on top of everything else. Those dazzling images on the movie screen were one thing, but the fantasy world projected by the movies was actually taking place within the borders of Roxbury, and there were some pretty wild things going on in the theater itself. A solo trip to the restroom sure beat anything onscreen in terms of potential thrills and chills. You always had to watch your back. You never knew who or what might come at you out of the ornate dark corners.

When I was stepping out of the Roxy into the harsh sunlight after an afternoon matinee one day, a man jumped in front of me and shot another man in the face. Blood gurgled, people screamed, and the victim kept trying to stand up, all the while shrieking in agony. The odd thing was that the shooting seemed less real to me than what you'd expect, after all the gunplay I'd witnessed on the Roxy's silver screen. The bang the gun made sounded more like a pop, though the blood spurting everywhere was all too real.

Grandma Stoner was a big movie fan. She was always dragging Joe and me along to the Roxy with her. She preferred "women's pictures," movies heavy on love, love, love, which bored us stiff. Although one night during a Bette Davis movie, the action in the audience far outpaced the canned dramatics onscreen. Halfway through the movie, two rows in front of us, raised voices between two men reached the boiling point. One of the men leapt to his feet and raised his arm. A sliver of steel caught the flickering light from the projector. The shadow of his hand clutching a blade appeared against the black-and-white image of Bette Davis. He plunged the knife into the other man over and over. Panicked people fled screaming up the aisles. The house lights clicked on and Bette Davis was suddenly playing to a rapidly emptying house. Grandma Stoner grabbed my hand and hauled me out of there.

Shortly after this incident, Gramma Caulfield visited Ruggles Street again, bringing two sets of brand-new clothes, including shoes, for Joe and me to wear when we returned to school in September. We never had a chance to wear those clothes because the very next day, Grandma Stoner pawned them. One way or another, this got back to the relatives on my father's side of the family. I was being raised in the lowest of socioeconomic surroundings, and the occasional appearance of my father's middle-class relatives must have been a boon to Grandma Stoner's pocketbook one way or another.

Recollections

·PLATE 1·

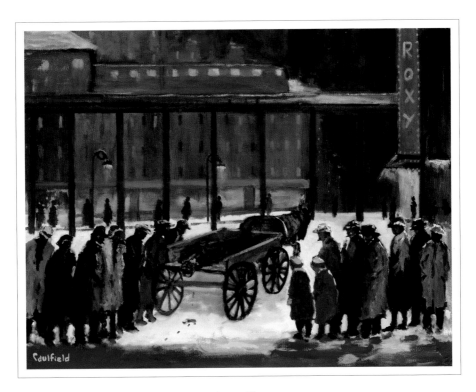

A Death at Champney
·2003·

·PLATE 2·

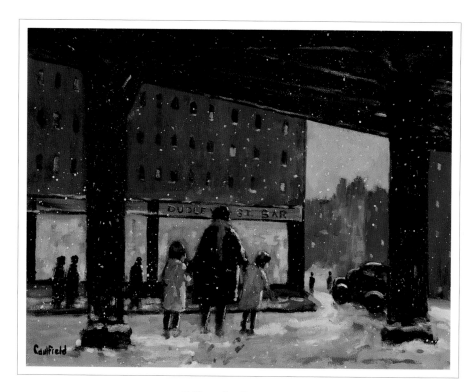

Off to the Barroom
·2004·

·PLATE 3·

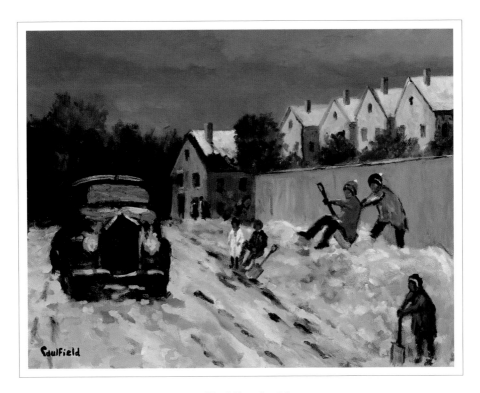

The Sledding Incident
·2004·

·PLATE 4·

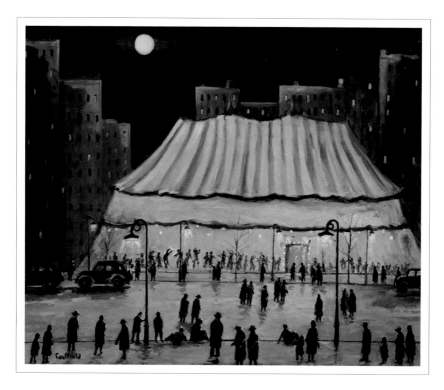

Holy Jumpers
·2004·

02
RUGGLES STREET

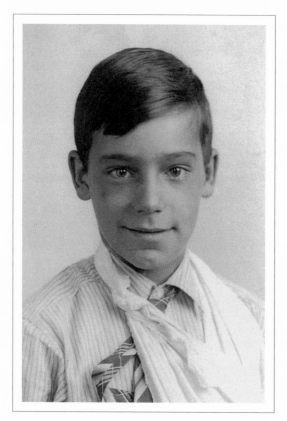

Shortly after I fell off Gramma Caulfield's roof.
1941.

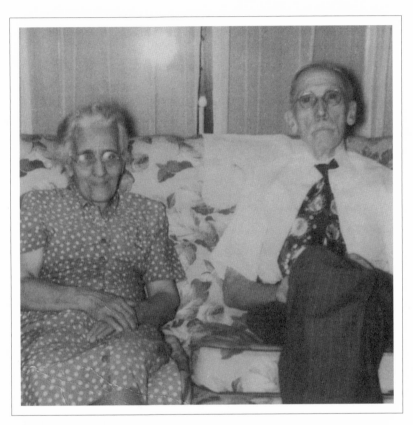

Gramma and Grampa Caulfield.
1940s.

On Our Best Behavior

The Hurricane of 1938 is emblazoned in my memory. The storm that slammed into New England on September 21 was among the most powerful ever; at its height, winds at speeds up to 121 mph were recorded at the Blue Hills Observatory in Milton, Massachusetts. Joe and I were playing with some of the kids in our gang in a sprawling open lot on the outskirts of Champney Place. The tree branches rattled and shook and the wind blew out of nowhere with a ferocity you could lean into, almost touching the ground, and still not fall down. It wasn't long before Grandma Stoner hurried our way through the driving rain, waving her arms, yelling and screaming for Joe and me to come home just as a huge beam flew over her head and missed us by inches. We spent the rest of the day and the entire night in the basement together while the wind screeched outside. It seemed like the house would explode and be ripped to shreds around us at any moment. The storm was a killer, destroying over eight thousand homes and taking more than six hundred lives, mostly by drowning caused by the storm surge in northeastern coastal regions.

The open lot on Champney Place was also the site of evangelical revival meetings every summer. An immense tent would be erected and hundreds of people would congregate within, singing gospel songs, clapping, stomping, and praising the Lord. People called the worshipers, "Holy Jumpers." It was all so mysterious to us and sort of wonderful, watching the swaying shadows of the gyrating figures illuminated from within playing over the canvas. Joe and I would sneak closer and catch a peek through holes in the tent when nobody was looking. As I watched everybody hopping around, I wondered why people didn't cut loose like that on the rare occasion when we went to the Catholic church.

Despite all the rough times we endured in our childhood, we did have some funny moments. Once I was sketching up in my room above Grandma Stoner's kitchen when I heard her telling a neighbor she had

made a cake with sour cream. I heard Joe come in downstairs and ask if he could have a piece. I bolted into the kitchen yelling, "Joe, don't eat the cake! It's poison! Grandma Stoner made it with sour milk!" Everyone got a big laugh out of that one.

One day on the way to school, I got into a fight with some members of a rival gang. One of the kids sucker-punched me and then ran around the corner. I picked up a rock and tore after him, throwing it just as I rounded the corner and hitting a policeman who was standing there. I tried to take off, but he grabbed me. Terrified, I stuttered out some sort of excuse. Looking as mean as anybody I'd ever run into, he told me he was coming to school later on to make sure I really got punished, then told me to get lost. I sat in my classroom all day, glancing at the clock every five seconds as my anxiety reached a fever pitch, but the cop never showed up.

Grandma Stoner wasn't a mean drunk; her behavior was more on the jolly side when she'd been drinking, except when she was yelling at Joe and me. By the time I was eight or nine she stopped locking us in the attic when she went out. If we were outside playing, we always headed for home when it grew dark. Grandma Stoner never let us carry keys. If the lights weren't on in the house by the time we got there, we knew we could find her at a seedy bar right around the corner from our house. Three or four times a week, Grandma Stoner would take us there and sit Joe on one stool beside her, and me on the other. Her drinking bouts could last for two or three shots of whiskey, an endless chain of cigarettes, and some chat with the locals before we'd all go home, but just as often devolved into Grandma Stoner ordering round after round and becoming a drunken mess.

On a snowy winter night in 1939, Joe and I turned the corner and saw the house was dark. As was our routine, we headed to the bar to plead with Grandma Stoner to come home and make us some dinner. We found her slumped in a booth, so bombed she could barely stand up, never mind walk. With her impressive bulk supported by Joe and me, the three of us stumbled down Ruggles Street. The moment we reached the doorstep, she passed out. We searched through her pocketbook, but couldn't find the key to the door. Although we were afraid we'd all freeze to death in the snowstorm, we just sat there shivering and trying to wake her up. An hour later we'd progressed to hysteria when one of Grandma Stoner's friends passed by, a man named Jim Grimm. He somehow found the key and dragged Grandma Stoner inside. After lighting a fire in the kitchen stove to get some heat in the house, he helped Grandma Stoner get settled in her bed.

Word of this incident must have reached my father's relatives. Right after this happened, Gramma Caulfield's visits to Ruggles Street became more and more frequent. Every time she visited she'd give Joe and me a quarter, and sometimes even a dollar each. The cash disbursement was always followed by the admonishment, "Now, don't tell your Grandma Stoner."

I'm not sure what the catalyst was for the next turn of events, but in the early days of 1940 Gramma Caulfield received a call from Grandma Stoner telling her, "If you ever want to see the boys again you'd better come in tomorrow, because the day after that they're going into the Boys Home." My Aunt Dot drove in from Lynn to get us the next day. Off we went in the rumble seat of her coupe, everything we owned packed into two raggedy suitcases jammed in the front seat beside her.

Within a few weeks, Joe and I found ourselves dressed to the nines in some of the new clothes Gramma Caulfield had bought us. Both of us knew something big was up from the way all of the adults in the house had been whispering amongst themselves. Gramma Caulfield put on her finest dress and coat, and we all took the train into Boston to go to the courthouse. I was sitting in the courtroom, being suitably intimidated by the atmosphere, when I caught a glimpse of my mother coming through the door. My heart pounded. Maybe my mother wanted me after all.

Grandma Stoner followed her through the door looking sullen and serious. She was all dressed up too. I think it was the only time in my life I ever saw her without an apron on. I hadn't seen my mother at all since her speedy exit in the cab after the final fight she'd had with my father, and that was a year before. I gave her a big smile, but she never once looked over at Joe and me. We sat there across the aisle, fifteen feet away from my mother, in total confusion as she stood in front of the judge and told him she'd like to request that her children live from now on with their father's parents instead of with her mother.

Grandma Stoner took the stand and said that she had raised Joe and me since birth, except for the short periods when we had gone to live with our parents. She chattered on about how both my parents had contributed to our support, but emphasized that she always had difficulty collecting from my father. She went on to say she believed in her heart that her daughter should have custody of Joe and me, but she would not stand in the way of us moving to Lynn for good if that's what her daughter had decided was best for everyone.

Gramma Caulfield took the stand and described to the judge the sort of home she and her husband would provide for us. My father never

made an appearance in the courtroom. The judge ushered Joe and me into his chambers. He asked us how we'd feel about moving to Lynn to live with Gramma and Grampa Caulfield. There were lots of tears. I couldn't comprehend why my mother wouldn't even look at us, never mind talk to us. I kept saying, "I want to see my mother." Moving to Lynn seemed like a terrifying prospect. No matter how bad Roxbury might appear to outsiders, it was home; it was all we knew, and neither Joe nor I wanted to leave, no matter how nice Gramma and Grampa Caulfield were.

When we came out of the judge's chambers, my mother was gone. Grandma Stoner took Joe and me aside and told us in no uncertain terms that we were moving to Lynn. She walked away and never even said good-bye. What had brought Grandma Stoner and my mother to this point is beyond me. Joe and I were a handful. Our bad behavior had been constant through the years, so it's not as if things were getting any worse. Fistfights were a daily part of our lives; so was causing trouble. Whether Grandma Stoner's giving us up was the cumulative effect of us driving her crazy with our antics, the financial burden of raising us, her advancing age and alcoholism, or some other factor, will remain forever unknown to me.

To ease our transition into our new home in Lynn during the summer of 1940, Gramma Caulfield sent Joe and me to the movies six days in a row. Flush against the cold, green north Atlantic, Lynn was an industrial center of nearly one hundred thousand people at the time; its primary employers were the General Electric Manufacturing Plant and numerous shoe factories. In 1940, Lynn was a vibrant city, its population almost entirely the working and middle class. Lynn's population was far less diverse than Roxbury's, and for a while, I had a hard time comprehending why I rarely saw any black people living there. The violence that was an everyday aspect of life in the streets of Roxbury was nonexistent in Gramma and Grampa Caulfield's neighborhood of tidy three-family apartment houses and neat lawns.

Our Uncle Francis was a happy-go-lucky man who shared a home with his wife, Marge, and their two baby daughters, not all that far from Gramma Caulfield's house. One day Uncle Fran dropped by and told Gramma Caulfield he had gotten some chickens, saying he would be happy to let her have a couple for dinner. Gramma Caulfield sent Joe and me along with our uncle to his house to pick them up. Being a city boy, I thought we'd be picking up some chickens wrapped in paper, like what you'd see at the butcher's.

Uncle Fran led us down to his basement where he had five live chickens in a cage. Before Joe or I knew what was up, he grabbed one of the chickens by its legs, tossed it on a block, and swung a hatchet into its neck. Blood spurted everywhere. To our absolute horror, the chicken's body kept jerking and the legs kept pumping long after it was decapitated. The bloody mess didn't bother Uncle Fran. In two seconds he swung another squawking chicken onto the chopping block. The next victim flapped its wings, screeching and clucking in a tornado of feathers, before it, too, was beheaded. I ran up the stairs three at a time with Joe on my heels. I didn't eat the chicken portion of the dinner Gramma Caulfield prepared that night and avoided that particular choice of meat for a long time afterwards.

We lived with Gramma and Grampa Caulfield in their first-floor apartment in a big building on Boynton Terrace in East Lynn. Joe and I shared a bed in a room that overlooked a small green lawn. Gramma Caulfield's apartment had nice furniture and electric lights in every room. There was a huge Philco radio in the living room, and we'd spend nights laughing together listening to the antics of Bob Hope, Edgar Bergen and Charlie McCarthy, or George Burns and Gracie Allen.

Gramma Caulfield was sixty years old in 1940. Grampa Caulfield was sixty-five. It amazes me to this day that these two seniors would take on the task of raising two scrappy wild boys from the streets of Roxbury. Two finer, more decent people never walked the earth.

Their second child, Aunt Dot with the flashy coupe, also lived with Gramma, Grampa, Joe, and me. Aunt Dot had a very good job in management with the telephone company. From the day we moved in, Gramma Caulfield called the shots in raising and disciplining us. Aunt Dot would become a reluctant disciplinarian on occasion if she caught us stepping out of line, which was all too frequent an occurrence.

Gramma Caulfield was always busy in the kitchen. One of my fondest memories was walking into the house and smelling the aroma of Irish soda bread baking. Gramma Caulfield did all of her cooking on a wood stove. She also had an icebox that looked just like the one we had on Ruggles Street. Electric refrigerators didn't become common in homes until after the war years, even so, Gramma was always dreaming of getting a Frigidaire. We just couldn't afford one.

Dinnertime every night at Gramma Caulfield's table seemed like a delectable dream. We were served everything from meat loaf and mashed potatoes to roast beef or New England boiled dinner. There was all the bread and butter you could eat and endless milk to drink. Gramma

Caulfield always encouraged us to have seconds and then some dessert. It was all a pretty big deal for a couple of kids who had been brought up on mustard sandwiches and neglect.

Warm, kind-hearted, and generous with her time, within a matter of months Gramma Caulfield made me feel loved for the first time in my life. I grew to love her and Grampa Caulfield more than I could ever express. A devout and pious Catholic, Gramma Caulfield attended mass every morning. As part of our newly structured life, Joe and I attended mass with the family every Sunday.

Our first summer in Lynn passed quickly. Joe and I spent endless hours exploring the surrounding area and making new friends. There was a tiny pond near our house called Goldfish Pond. Joe and I spent many days there playing at the water's edge, as we didn't know how to swim yet. Lynn Beach was about a half-mile walk from our apartment. My lifelong love of the ocean was kindled with my first visit there that summer. Sunlight sparkled on the swirling waves for what looked like forever and ever, clean and free.

I began fourth grade that September when Joe and I were enrolled in Saint Joseph's Institute, the parochial school attended by all five of Gramma and Grampa Caulfield's children. Besides our Aunt Dot, their children included my father, the oldest, his brothers Owen and Francis, and Aunt Mary. Aunt Mary and Uncle Francis were twins. Gramma Caulfield had lost two other children in infancy. Except for my father, who lived in Boston, the rest of her children still lived in Lynn and were frequent visitors to our apartment. Why my father was somewhat distant from even his own family is known only to people long gone.

The first major ruckus Joe and I caused came later that summer. My Uncle Owen and his wife Nan invited Joe and me to come along with them and Gramma and Grampa Caulfield for a weekend trip to the White Mountains in New Hampshire. Having never been anywhere but Roxbury and Lynn, the mountains and forests I saw on that trip had a spectacular effect on me. I remember standing in a valley in Franconia Notch gazing up at "The Old Man of the Mountain," a profile rock formation up on Cannon Mountain, since collapsed, and thinking it was the most fantastic thing ever.

We stayed at one of those motor courts made up of a bunch of white cabins. Joe and I slept in the same one as Gramma and Grampa Caulfield. Despite the scenic surroundings, it wasn't long before Joe and I were fighting tooth and nail at every opportunity. Gramma would chastise us, and Uncle Owen took us aside a few times that

weekend and threatened to spank us if we didn't behave. We'd quiet down for a short time and then start arguing again. Remaining above the fray, Grampa never had a stern word for either of us.

When we drove into Lynn two nights later, Joe and I were still fighting. Grampa Caulfield, the quietest man who ever lived, raised his voice and said, "Pull over, Owen." Grabbing a bag full of fireworks he'd bought for us in New Hampshire, he charged out of the car and headed into The Meadow, a sports practice field located a few blocks from our house. We all got out of the car and watched Grampa Caulfield light off every single last one of the bottle rockets, firecrackers, and Roman candles he had bought. After the last bang, he got back into the car and said, "Maybe in the future you boys will try to behave."

Grampa's fireworks display did quiet us down for a while, and things were pretty low-key until February of 1941. Joe and I refer to the next incident as "The Saint Valentine's Day Massacre." Heading home after school, carrying paper bags loaded with valentines, we started throwing punches at one another over a mix-up of whose valentine was whose. Aunt Dot's coupe screeched to a halt on the street beside us and she charged out with her features locked in fury. Grabbing each of us by the ear, she tossed us into the rumble seat, then got behind the wheel and tore up every single one of our valentines.

Aunt Dot was around thirty years old at the time; pretty and stylish, she had a boyfriend but never married. A career woman, Aunt Dot was focused on her position as a manager at the phone company. She was never a big fan of childish antics in the first place, and probably didn't appreciate having to help raise and discipline her irresponsible brother's kids.

Gramma Caulfield was strict but fair, and had no compunctions at all about swatting Joe or me on the behind from time to time, or even snatching us up by an ear, Grandma Stoner-style. Grampa Caulfield was the most easy-going individual I've ever known. He was quiet, always reading a newspaper, magazine, or book, once in a while raising his voice to admonish Gramma, "May, will you leave those kids alone!" Grampa was our co-conspirator. For the most part he let us get away with murder, acknowledging our latest prank with a wink and a nod.

As the months passed I got used to my new surroundings. Lynn had its tough neighborhood, a section of West Lynn known as "The Brickyard," but that was a world away from Boynton Terrace. I was still one hell of a tough kid, and very few other boys challenged me to fight, my reputation established after a few battles when Joe and I first moved to town.

Joe and I were enrolled in the local Boy's Club where we spent many afternoons learning how to swim. We played basketball there in the winter and football out back in the warmer months. One day I was walking along with some friends near Goldfish Pond when a group of high school boys came toward us and asked if anybody knew how to swim. I told them I'd just learned how. They said, "Great," then picked me up and threw me fully clothed into the water. I dragged myself out, dripping wet and ready to take them all on, but they'd run off. My friends all stood around me laughing their heads off.

Later that year, as the summer days shortened to fall, I was playing with a bunch of friends. I jumped off a porch from a height of fourteen feet, aimed for a pile of leaves, and landed hard on my left wrist. Stabbing currents of pain shot up my arm. When I held my hand up, it dangled at a weird angle and I had trouble moving it. Gramma Caulfield almost fainted when she saw my injury. She worked herself into such a panicked state that she called the fire department. A fire truck with a ladder on top soon pulled up in front of our apartment building. The confusion was sorted out and I eventually got to go to the hospital in an ambulance. After missing the first week of school, when I did return to begin the fourth grade with my left hand in a cast, the nuns tried their damnedest to turn me into a "righty." The nuns had coaxed and sometimes forced me into writing with my right hand ever since my first day of school back in Roxbury. Writing with your left hand was scorned and frowned upon, but despite the best efforts of the sisters, I remained left-handed.

School was a real ordeal for me. I've always been an avid reader, and I can't attribute my lack of focus or interest on a learning disability. It was simply because I found it hard to pay attention, unless the subject we were studying interested me. The only subjects I liked were history, and, of course, art class once a week. I spent most of my time in the classroom daydreaming, goofing around behind the teacher's back, or filling my notebook with drawings. I just plain didn't give a damn about all the other boring stuff the teacher went on about.

In April of 1941 my parents' divorce became final. The divorce decree granted to my mother reads, "Said libellee [my father] on Saturday the 23rd day of December, A.D. 1939, did cruelly and abusively treat your libellent, and that the said libellee, being of sufficient ability, grossly and wantonly and cruelly refuses and neglects to provide suitable maintenance for your libellent and that there has been borne to them two children who are living and are minors, whose names and dates of birth are as follows:

Joseph H. Caulfield, Jr.—September 9, 1929, and Robert O. Caulfield—December 14, 1930. No previous libel for divorce, nor petition nor libel for nullity or affirming marriage, nor petition for separate support, for desertion and living apart for justifiable cause of children had been brought by either of the parties against the other."

In other words, neither one of my parents wanted custody of their own children. The probation report also states, "As Mrs. Caulfield has never had the care of the children, she does not have the warm affection for them that she would have otherwise. Her husband never provided a home for her, and she is in no position to take them now. She did not ask for custody or support of the children because she believed that they were well taken care of by the grandparents."

In June I came home carrying a report card with five Fs and told Gramma Caulfield that I would have to stay back and repeat the fourth grade—again. She said, "That's okay, Bobby. Just try harder next year." A year before, I would have thought it was a big joke, but this time I was hurt and embarrassed that I was staying back yet again. In my room I sat down and said to myself, "Nobody really gives a damn about me and what I do. If I'm ever going to do something with my life, I'll have to be the one to make it happen."

For some reason, something clicked for me that day, and this was a turning point in my young life. I'd been passed from relative to relative while my parents had grappled with their personal demons. My developmental years had been spent in the care of an uncaring and alcoholic grandmother in the inner city. I'd seen the worst life had to offer, on a daily basis, all of my life. Gramma and Grampa Caulfield were our kind new caretakers, but as wonderful as they were to Joe and me, they still weren't our parents. I couldn't help but wish that I had two normal parents at home like all of my new friends in Lynn did; but since I didn't, there was no use wasting time wallowing in self-pity. My tarnished fantasy of a loving mother, father, and their children all under one roof faded away long before the divorce. That dream had died on Ruggles Street. I knew how brutal death could be and how difficult life is. Staying back again made me determined to take the responsibility for my future into my own hands. This would be the last time I'd suffer the shame of repeating a grade.

My mother ended up moving to Lynn the same year I did, in 1940. She took a job as a housekeeper for a man named Raymond Freeman, whose wife had recently died. Mr. Freeman had four children, three daughters and one son about my age. Gramma Caulfield forced Joe and

me to visit my mother every Sunday. I hated going. My mother would make a big production out of making dinner while Joe and I played with the Freeman kids. My mother seemed to be putting on a big show. She was overly gracious and tried hard to be nice, but any interaction between us was forced and uncomfortable.

The fact that my mother and I were biologically related was the only bond we shared. She was a stranger to me. As I grew older, the faraway look in her eyes grew more intense. Agitated, preoccupied, and jittery, she made me feel nervous just being in her presence. Even her smile irked me. Her lips would curl back as if she were trying to put on a bright face after hearing some horrible news. Her health was forever fragile and she was always getting sick. One afternoon she met Joe and I in a restaurant in downtown Lynn and treated us to a spaghetti dinner. When we were walking down the sidewalk afterwards, she crouched over the gutter and threw up her meal. My meticulous mother was mortified, and so was I, as people walked past and looked at her with sharp, disapproving eyes. Over the next year and a half, our weekly visits with my mother switched to monthly visits, then every other month, finally withering to once in a while.

I began fourth grade for the second time in September of 1941. I was almost two years older than all of my classmates. This time around I approached my lessons and studies with a determination I'd never had before. No way in hell was I ever going to stay back again. I was also starting to show some real athletic skill. I could run faster than anybody in school except for my brother, and was pretty good with a football.

I made a great bunch of new friends. My best friend, George Carrette, was handsome, blond, and a real charmer. Even at that young age he loved the girls. The others in our inner circle were Edgar Waldron, a serious, muscular kid who was a terrific athlete; Don Savio, chubby, quick-witted, and loaded with personality; and Vin Vabucci, a redhead with a sly smile. Vin Vabucci was hysterically funny, and always cracking the rest of us up with his jokes. We were a carefree bunch, but in a flash could turn into a tough crowd if somebody was looking for trouble. In addition to my brother Joe, there were about ten or fifteen other guys who hung around with us on a regular basis.

Some of the nuns at school were genuinely taking an interest in my artistic development at this time, and would offer me encouragement. I basked in their admiration; I'd never known that kind of personal attention before, and I'm sure I wanted to please them and seek their approval.

The Christmas of 1941 was a watershed event in my life. Gramma Caulfield was also very attentive when it came to my drawings. She was always hanging them up on the walls around the house and proudly pointing them out to friends or family. Tearing into one of my presents on Christmas morning, I pulled out a beginner's set of oil paints. There were also some canvas boards, paintbrushes, and a sketchpad. From then on there was no stopping me. I either sketched or painted every day after school. These were the early years of World War II, and I couldn't wait to see Grampa Caulfield's latest issue of *Life* or *Look* magazine to study the work of my favorite combat artists, men like Fletcher Martin, Augden Pleisner, and most of all, Reginald Marsh. Their portrayals of the battlefield and life in the armed forces brought the war alive in my imagination with so much more power than photographs did.

Just before Christmas we had moved from Boynton Terrace to 29 Fayette Street, a two-family house a few blocks away, so that Gramma and Grampa Caulfield's suddenly expanded family could have a little more space. Joe and I shared a bed in a big sunny room overlooking a small backyard. Gramma and Grampa Caulfield and my aunts and uncles were always giving us toys. There were roller skates for summer, ice skates for winter, and all kinds of games and books. The Meadow, located nearby, was the practice field behind Lynn English High School where Grampa Caulfield had set off his impromptu fireworks display. Joe, my friends, and I hung out there after school. We especially liked watching the high school football players going through their practice sessions in late summer, dreaming one day of being just like them.

Grampa Caulfield worked nights as the head chef at Boston's famous Durgin-Park restaurant. He'd take the train into the city every afternoon, and return home around eleven-thirty every night. My grandfather had an incredible work ethic throughout his life. He worked over fifty hours a week until he was eighty-three. He and Gramma Caulfield opened their own restaurant in downtown Lynn in the early 1930s, but it failed due to Grampa Caulfield's inherent kindness. He extended credit and a free meal to anybody down on their luck, and everybody was down on their luck in the 1930s. It wasn't long before Grampa Caulfield learned some hard truths about capitalism when the restaurant went out of business.

My Aunt Mary, the baby of Gramma and Grampa Caulfield's family, lived a block away from us with her husband, Tony Mellis. They used to invite Gramma Caulfield, Joe, and me over for dinner every couple of weeks. Mary had never had any children. The day after one of these dinners

I came home from school and spotted all kinds of cars double-parked in front of our house. When I walked in the door, the apartment was jam-packed with relatives, friends, and strangers. Every single one of them were crying their eyes out. Gramma Caulfield took me aside and explained that Aunt Mary's husband Tony had dropped dead of a heart attack at work earlier that day. He was only thirty-two. I couldn't believe that this could happen to the jovial uncle I'd had dinner with the night before. I was absolutely stunned. I'd seen death and murder and every other conceivable horror on the streets of Roxbury, but the victims had always been strangers to me. I'd never personally known anybody who had died. It was a hard life experience to come to terms with.

It was too painful to stay in the house and absorb all of that grief, so I went for a long walk and thought about Tony. A few days later, Joe and I were dressed in suits and ties. In a black outfit down to her gloves, Gramma Caulfield escorted us to Tony's wake at a local funeral parlor. Everywhere I turned, people were bawling. I got caught up in the flood of emotion and cried a bit too. What a strange sight it was to see Tony lying in his casket, looking kind of the same as he did before he died, but not really. Tony's mother had come up from New York to attend the wake and funeral. Her entrance at the funeral parlor was quite unforgettable. As she staggered into the room, a high-pitched wail gurgled up from the depths of her soul, turning into a blood-curdling scream. She grabbed the side of Tony's casket, screaming, "Anthony! My Anthony!" Everybody gasped when she reached into the casket and pulled Tony's dead body toward her, cradling him to her chest and wailing. More than fifteen years would pass before I attended another wake.

Aunt Mary moved in with us in the apartment on Fayette Street a few days after Tony's funeral. The months that followed left a pall of sadness hanging over the house, the aftermath of one dying so young leaving a long trail of grief in its somber wake. Joe and I felt like we had to walk on eggshells, and for the first time I could remember, it was a relief to go to school each day. I avoided going home any sooner than I had to for a while. I preferred playing with my friends or spending time with my paints and my sketchpads.

Perceptive and sensitive to other people's emotions, I almost couldn't bear to be around Aunt Mary in the melancholy months that followed. It was as if all of her grief and the sorrow of everybody who came by to comfort her were collecting inside me. Whenever I saw Aunt Mary's sad face coming my way, I would disappear. I'd had enough misery in my life. Like any other kid, all I wanted to do was have some fun.

03
RUGGLES STREET

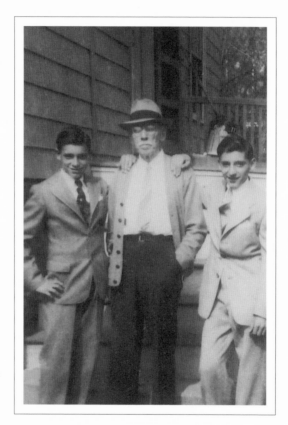

(From left) Me, Grampa Caulfield, and Joe.
Easter, 1944.

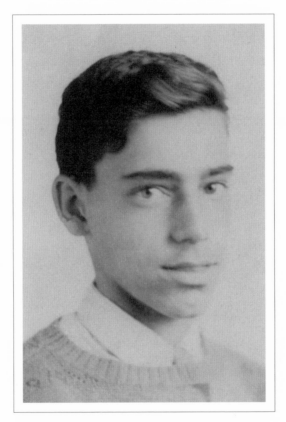

At age fifteen.
1946.

An Ordinary Moment

As the months passed, I became more accustomed to the middle-class surroundings Lynn offered, but my Roxbury-bred fighting instincts remained. While I didn't go out looking for trouble like I used to, I never gave a second thought to defending myself or my friends if we were threatened.

Dick Abbruzzese was a huge kid, as big as a man at age twelve. He was also a relentless bully. One day when his taunts fell on my brother Joe, I walked up to Dick and punched him in the mouth with all my eleven-year-old might. Stunned, he stood there and blinked, then chased me all over the neighborhood. He never came close to catching me. My brother Joe was the only kid in Lynn who could run faster than I could.

Joe and I still fought all the time. During a fistfight in Grampa Caulfield's garage, Joe pushed me through a window, sending me flying into the backyard in a spray of broken glass. Gramma Caulfield had a feisty temper when you got her going, and her temper went into overdrive that day when the sound of the breaking glass brought her running out the back door.

Early one Saturday morning, Joe started shoving me around on our way downtown. I don't know what mysterious forces were at work around me and glass that summer, but this time Joe pushed me through a nine-by-twelve-foot plate-glass butcher's shop window. I jumped to my feet inside the shop, shocked to see that I was unscathed, and bolted back out on the sidewalk. Joe grabbed my arm, and in a calm, confident tone told me to stay put. A window above the shop slammed open and the butcher hollered, "Who broke my window?" Pointing his finger to the corner, Joe said, "Two guys were fighting and ran off down that way." The butcher craned his neck and asked, "Which way did they go?" All I could think was, "Jeez, the butcher bought it." Joe walked away as nonchalant as could be. I followed him down the street, but for the next few blocks I was sure that at any second the butcher would run up and grab us.

Joe was always stoic and cool in a crisis, or so it seemed to me. I tended to be far more emotional, though we both had hot tempers. Being a year and a half older than me, the impressions our childhood left on his mind must have been heightened for Joe by the fact that he saw, and perhaps better understood, more of what had been going on around us during the Roxbury years than I did. Like me, Joe did his best to forget the terrible world we'd left behind, and focus on enjoying our shining new life.

My mother married Raymond Freeman, the widower she had moved to Lynn to keep house for, in October of 1942. Neither Joe nor I attended the ceremony, and only found out about it after the fact. A year and a half had passed since my parents' divorce. Whether or not love was a factor in this new marriage, I couldn't say. My mother's writhing hands and distant glare still suggested some persistent inner turmoil. I'd watch her fidget during our occasional forced Sunday visits at the Freeman house and wonder why she was so loving and warm to the Freeman kids, but cold toward Joe and me. With an uneasy smile, she'd encourage us to "go play with your new brother and sisters." That comment always made my stomach turn. My mother was someone I couldn't stand to be around by this point.

It was difficult not to be judgmental because I knew the woman trying way too hard to create a new family had never been a mother to Joe or me. She still wasn't one now, even though she'd act the part on the increasingly rare visits between us. I'd all but throw up when she'd hug and kiss the Freeman kids and call them her "dear, sweet children." There were so many things I wanted to ask her, but all those questions boiled down to why? Whether it was shyness on my part, or a fear of breaking social taboos, I never could bring myself to ask her why she had never loved us. The soul that lived beyond my mother's veneer would remain forever hidden from me. I can picture what my mother looked like. I know what her voice sounded like. I can recall her mannerisms. She was a stranger with a familiar face. A stranger I still happened to love.

By seventh grade in parochial school, I was already a head taller than Joe. I was a head taller than all the other kids in my class, too. Having stayed back twice, I was also a year or two older than most of them. It was embarrassing when my gang of friends and I would go to the movies. The ticket seller never failed to ask me for identification, not believing I was just thirteen or fourteen. Self-conscious, shy, and awkward in social situations, I was extremely sensitive to slights of any

kind. While the ticket seller looked on, I'd simmer with anger and fumble through my wallet for the same ID she'd seen a day or two before, when she had last given me a hard time.

I had kept my vow to do better in school. Though I wasn't headed for the honor roll, my grades would keep me from staying back again.

That fall I was out of my mind with excitement over attending my first big high school football game. It was to be a jamboree, where teams from surrounding towns would scrimmage for four or five fifteen-minute games. Joe and I walked all the way from Fayette Street to Manning Bowl, a concrete and steel stadium with a seating capacity of twenty thousand. Lynn had two high schools: English, which served middle-class East Lynn, and Classical, located in the more working-class area of West Lynn. Games were held on Friday nights and Saturday afternoons, and the two schools alternated in using the stadium. The closer Joe and I got to Manning Bowl that day, the more our excitement accelerated. Gramma Caulfield had called ahead for us to see how much the entrance fee would be. She had given us exactly enough money to get in and not a cent more. A miserable old man selling tickets informed us we didn't have enough money for the tax and wouldn't let us through the gate. Joe and I had no idea what to do. Sneaking in wasn't an option because of the guarded access to the stadium. We were crushed. We went to The Meadow to kill enough time so that when we got home, we could tell Gramma we went to the Jamboree and not embarrass her about not including the tax.

My desire to draw remained overwhelming. The nuns continued to encourage my artistic abilities, and a few times a week, I'd be taken from room to room to sketch one of the subjects from that day's lesson on the blackboard. Sister Constantius took a special interest in me, and was a supportive presence in my life. Tapping her ruler on the desk one day, she said, "Children, let's all pray for Robert. He has a God-given talent. Let us pray." Blushing three shades of red as I lowered my head to pray with everyone else, I felt the sting of a spitball on my neck. Looking behind me I saw my buddy Vin Vabucci with his cheeks puffed out, trying to stifle his laughter. I was an expert at avoiding the nun's wrath, so I controlled my own urge to laugh and prayed away.

My friends put up with my obsessive interest in art. They seemed sort of amazed whenever I'd show them my sketchpads. What they didn't realize was that my desire to succeed as an artist was growing

stronger every day. I didn't know what shape my dream would take, and I kept my aspirations to myself, even as the dream intensified.

I had a friend named Bob Collette. A tall, slight, and very solemn boy, he was also quite a talented artist. I thought he was far more talented than me, and I was somewhat in awe of his artistic ability and the natural precision of his drawings and paintings. He'd come over to my house every week or so with a sketchpad and show me his latest work. Sometimes we'd hop on our bikes and go to the beach to draw the huge rocks on the shore and the peninsula town of Nahant off in the distance.

The developments of the war pushed anything I was learning in school to the background. I listened to the radio whenever I could, and grabbed the neatly folded newspapers beside Grampa Caulfield's chair to catch up on the headlines every day. People were always talking about the possibility of the Nazis hitting Lynn Beach. My imagination would get carried away trying to devise ways to stop them. To prevent that from ever happening, fortifications had been built on Nahant. The gigantic guns out there fired shells that could hit a U-boat or a ship ten miles out to sea. Gramma Caulfield hated the colossal *Boom!* the guns made when they were tested. Every time the guns fired, the dishes in her china cabinet would rattle and something somewhere in the house would fall and break.

Heading downtown with my brother one day, I was crushed when he told me to walk on the other side of the street. He didn't want to be seen hanging around with his kid brother anymore. He said it was embarrassing to be seen with me. We had outgrown throwing punches at each other, but Joe meant what he said when he jabbed that remark at me. He distanced himself from then on, spending his time with his friends and keeping busy at his job in an ice cream parlor. Though Joe was cordial to me after that day, it was as if an invisible wall had gone up around him, and I was closed off from participating in his life.

By the eighth grade, when I was fifteen, I had grown so much taller than my classmates that I'd get off of the bus two stops before school and walk the rest of the way. I didn't want people to know that I was five foot ten and still going to St. Joseph's. My athletic abilities were becoming apparent to anybody who saw me throw a football or hit a baseball. By this time I was so fast I could even outrun Joe. I was not only filling out faster than the kids around me were, but I was bigger than most of the kids in high school, too.

My father had a new steady girlfriend named Frances, and any fantasies I might have entertained of a kindly new mother figure in my life evaporated the moment I saw her pinched face. She was a witch—a

ghastly, henpecking shrew. Anytime she was in my proximity, she would nag and nitpick until I thought I'd explode. "I don't like the way you're combing your hair, Bobby." "Don't you think you should wash those pants, Bobby?" And most irritating of all: "What are you bothering with that art jazz for? That stuff's for rich people and poor dreamers." Frumpy Frances viewed her new boyfriend's adolescent sons as excess baggage. Joseph and Robert, the two shipwrecked survivors of the catastrophic hurricane that was my father's first marriage.

A second try at matrimony didn't make my father any less distant. He seemed reluctant to have anything to do with Joe or me except shoot us a forced grin once in a while from across the void that separated us. When he would visit Gramma and Grampa Caulfield's, he'd always be his charming self during dinner, but when he was left alone with Joe or me, he'd pick up a book or a magazine and read, not saying a word to us. He was frozen. The only ties between him and his children were biological.

Gramma and Grampa Caulfield never said anything around me involving what had gone on between my parents. There were no explanations for why my jolly father, whose siblings were all happily married with children, wanted nothing to do with his two boys. Mentioning my mother around the house was something I instinctively knew not to do. A divorce was a secret shame best forgotten. I could no sooner have asked any of the adults around me why I had been abandoned by my parents than ask my father to carry me on his back to California. Social relations within families were far more formal at the time. You knew the boundaries of what could or could not be said, and you didn't cross them. The Catholic tradition of prim horror regarding these matters was also an issue. All of my friends had traditional two-parent families, and it seemed like most of them were content. Why couldn't my parents have been happy? None of it made any sense. Analyzing the situation only brought confusion and anger, so I kept any thoughts about my parents to myself.

Gramma and Grampa Caulfield were never anything but wonderful to us. I grew to love them both with all my heart. Gramma Caulfield was sunny and sweet, her personality enhanced by the occasional flare of her Latin temper. She and Grampa Caulfield genuinely made me feel loved. Sometimes it was embarrassing at school when a teacher would ask to have my parents sign something and I'd have to explain I lived with my grandparents. I knew that even though nobody said it, not having my real parents set me apart from the other kids.

Grampa Caulfield loved to read and did so whenever he could, but he always put his book down to make time for Joe and me. He never

spoke of Ireland and he never returned to that green northern island. Like most of the Irish who left home, Grampa Caulfield completely assimilated into American culture; he didn't have even the trace of an Irish accent.

When Grampa Caulfield had jumped ship all those years ago, his homeland had been under oppressive British rule for almost eight hundred years. The Irish have an interesting genealogical history. The first people to populate Ireland crossed the narrow channel separating Northern Ireland from Scotland about eight thousand years ago. The Celts arrived from central Europe about 700 B.C., followed by St. Patrick bringing Christianity in the early fifth century. Ancestors of the French arrived in Ireland during the Norman Conquest in the twelfth century, and Vikings from Denmark founded cities like Dublin. The Spanish washed up on shore after their disastrous attempt to invade England was thwarted by storm-tossed seas. Most of the Spanish survivors met the executioner, except for those who reached the area known as Ulster in the North. The Spanish intermingling with the locals resulted in olive-skinned offspring termed, "Black Irish." I find it interesting that my ethnic makeup as an American is so close to what it would have been had I been born in Ireland, with the mixture of Latin, French, and Irish.

The name Caulfield was originally spelled "Caulfeild," and is of Scottish derivation. During the Ulster Plantation era, beginning in the mid-1500s, thousands of Scottish and English Protestants were "planted" in Northern Ireland by the English crown during the reign of Mary Tudor, in an attempt to anglicize the native population and crush their Catholicism. Lands were seized, the native Irish segregated, and Gaelic surnames were replaced with foreign counterparts. My family's traditional Gaelic surname, Cathmhoil (pronounced *cah-veel),* was stripped away and replaced with Caulfield. Catholicism, however, remained my family's faith. The events of the Easter Rising in 1916, which led to the formation of the Irish Republic in 1922, along with the partitioning of Grampa Caulfield's homeland in the North, occurred decades after he had settled in New England.

My uncles grew closer to Joe and I, and we looked up to them as father figures. Looking back, maybe it wasn't all that bad having Grampa Caulfield, Uncle Fran, and Uncle Owen in my life instead of my indifferent father.

I had seen Grandma Stoner only a few times since I'd left Roxbury. Carrying a first-prize award I'd won in a school-sponsored art contest, I took the train back to the old neighborhood to show it to her after not

hearing a word from her in over a year. Aside from the shock I felt at seeing how small the seemingly immense block I grew up on actually was, it was jarring to be reminded of where I had come from.

I stumbled through the lot behind Champney Place and came upon a rusting old oil drum. The memory it brought careening back in my mind paralyzed me. I had been seven years old on a chilly April morning and walking right by here when I came upon a bunch of kids who had a roaring fire going in this very oil drum. I watched, stunned, as they poured gas on two squirming alley cats and threw them into the flames. One cat clawed its way out and took off in a flaming ricochet, while the other cat shrieked from the depths of the pits of hell. It was so awful, but I couldn't look away. I stood there transfixed. This sort of thing was not an infrequent occurrence around Ruggles Street.

The war years had changed nothing in the old neighborhood. The same sneaky cheap hustles were going on. Drunks, bums, pimps, whores, and two-bit gangsters were all parading through the sidewalk crowds of working people and servicemen. I realized how lucky I'd been to get off these streets. Most overwhelming of all was the smell of my old neighborhood. A gust of wind stung my nose with the stench of poverty, while the air itself reeked of booze and decay. I stopped at the top of Ruggles Street and my eyes looked over the pathetic stage my childhood had played out upon. It was all familiar and strange at the same time, as if I were visiting someone else's life.

I knocked at Grandma Stoner's door and was told by the gruff man who jerked it open that she had moved away. No, he didn't know where. I never saw her again. I climbed the steps to the "el" and got on a subway car. Looking back at the neighborhood through the train window's streaked glass, I had just one thought: There was no reason to go back to Ruggles Street ever again.

Aside from experiences that anybody alive at the time had, such as standing in line with ration coupons hoping to get some margarine or meat, the war had no direct impact on me. Gramma Caulfield would pull down the blackout shades at the first sign of sunset every night. Her cocker spaniel named Boots was always at her heels. Boots was mean and vicious and didn't care for a single human being on this earth except Gramma Caulfield. Everybody else he came into contact with got bitten, including me. Even so, I loved animals and tried to teach Boots to play catch with me.

Stepping into the backyard one afternoon, I noticed Gramma Caulfield waiting at the back door for me. Waving her hand, she motioned me

toward her. "Bobby," she whispered, "your mother is in the kitchen. Please, whatever you do, don't tell her where your father is. I think she wants to get back together with him." I promised I wouldn't say a thing.

It had been over a year since I had last seen my mother. I went into the breakfast nook adjacent to the kitchen and said hello. She was sitting at the table, looking like an immaculate society lady. "You're getting so big, Bobby," she said. Whatever I said back was equally bland; then I told her I had to get going because I was meeting some friends to play ball. With her shy smile, my mother unclasped her twitching hands just long enough to wiggle her fingers at me in a tiny wave good-bye. Then I headed outside.

Vin Vabucci told me he was quitting his job hauling newspapers at the *Lynn Daily Evening Item*. He put in a word for me and I was hired. He didn't warn me about how hard the work would be. After I got my Social Security card, I began hauling giant bundles of newspapers on my back from the *Item*'s printing facility to Central Square, about three hundred feet down the street. Trucks coughing noxious exhaust fumes would pick them up there and deliver them to neighboring cities. All that lugging and lifting added to my strength and muscular build. The job was dull but I stuck with it. Some of Grampa Caulfield's phenomenal work ethic must have rubbed off on me. I'd show up for work right after I got out of school every day. More often than not, at some time during my shift, my buddies would pass by, laughing their asses off at the sight of me lugging a bundle of papers almost as big as I was. I spent about two years at the *Item*, and during that time I gave every cent I made to Gramma Caulfield.

A new uncle came into my life when my Aunt Mary married a man she had met at a dance about a year after her husband's death. Uncle Leo had lost his wife during the birth of their second child, and his mother had been raising his infant daughter and toddler son. Aunt Mary and Uncle Leo married shortly before the war ended in 1945. Uncle Leo was a terrific man. Burly and strong with an incredible smile, he had a vibrant and warm personality. He was the type of person that everybody loves, and Joe and I were no exception; we adored him. Uncle Leo was a big, happy breeze that blew in and dispersed the pall of sorrow that had been lingering around our house since Uncle Tony's death.

In his youth, Uncle Leo had been a great football player at Lynn Classical. Known back then as "Iron Man Felteau" for his prowess as an interior lineman on the football field, he had also been named the

Massachusetts State Wrestling Champ. Whenever I'd flip through the pages of Uncle Leo's scrapbooks with him, I'd be wide-eyed poring over the clippings and the stories of Iron Man's glory days, dreaming about emulating his achievements.

In April of 1945 I walked in the door and found Gramma Caulfield sitting by the radio with Boots at her side, dabbing at her eyes with a handkerchief. "Bobby, President Roosevelt has died," she said. It was as if somebody said God had died. FDR had been in office almost since the day I was born. He had steered the United States through the catastrophic economic hardships of the Great Depression, and then led the country through World War II with unwavering hope and determination. In the days before cynicism about our governing institutions became the rule, he was adored and regarded with reverence. FDR had truly been a man of the people, and the people mourned his death as they would have any loved one in their family. I never forgot that when he fell ill on his last day in that Georgia cabin, FDR had been having his portrait painted by an artist.

V-E Day arrived on May 8, 1945, and there was riotous jubilation over the end of the war in Europe. Ferocious fighting was to continue on the Pacific against the Japanese for three more months until the cataclysmic atomic explosions on Hiroshima and Nagasaki forced the Japanese to surrender on August 15.

A man named Mel Pelumbo coached sports at Eastern Junior High, and he took a keen interest in my athletic abilities. Coach Pelumbo was short, bald, and wore glasses, and astonished many people with his physical strength and agility. There was no football in the public schools until the tenth grade, so I couldn't play that sport until my sophomore year. Because of my height, Coach Pelumbo encouraged me to try out for the basketball team even though I'd never touched a basketball in my life. During free periods I'd work with him on dribbling, shooting, and improving my overall technique. I was elected co-captain of the team that season. We went on to win the Essex County Championship.

We moved once again with Gramma and Grampa Caulfield and Aunt Dot to 67 Harvest Street in East Lynn. This larger first-floor apartment in a two-family house allowed Joe and I the luxury of our own separate beds, even though we still shared a room. The house's owner lived in the second-floor apartment, and I made extra money mowing the lawn for him in the warmer months. Sometimes I'd wake up in the middle of the night with a flashlight beam playing over my face. Gramma Caulfield's

nightly ritual included checking on Joe and me after we'd gone to sleep, to make sure we were still breathing, I guess. It was nice in a way; it made me feel safe.

During the winter months a coal furnace supplied our heat. Gramma Caulfield would go down into the basement and shovel coal into it day and night. She was adamant about not letting anybody else do this particular task. I think she was afraid that if she let Grampa, Joe, or I do it, we'd have burned the house down.

That summer I joined a group of boys from East Lynn who would travel around the neighboring communities of Swampscott, Marblehead, and Saugus playing sandlot baseball on Saturday mornings. Sliding into home plate one day, my left leg went out from under me and my knee popped. It was swollen for a few days and ached for a few weeks after that, but I kept playing ball through the pain. Little did I know that my injured knee was to dog me for years.

When we got tired of baseball, we played football. Some of the boys had helmets (the leather kind, without a face mask) or shoulder pads, but if not, it didn't matter. The football games were informal, with an emphasis on playing as hard and rough as possible. I'm not certain who organized everything for us kids, but those hot summer mornings spent learning to play football were a lot of fun.

My best friend George Carrette loved football too. We were goofing around one afternoon when I booted a football and it sailed sixty-five yards into the distance in a perfect spiral. The football smashed through a window across the street. An old man poked his head through the shards of broken glass and yelled, "You won't get your ball back until you pay for that window!" George and I were too amazed at the distance of the punt to care about the ball. A week later, Grampa Caulfield paid to have the window glass replaced and I got my football back.

All of a sudden I couldn't get enough of football. I listened to games on the radio all the time and followed the progress of all the football teams in the newspapers. Endless hours were spent copying the drawings of athletes in the sports section.

One Saturday we reached a tie playing sandlot football against an opposing team at The Meadow. With seconds to go on the clock, I faded back and threw a fifty-yard pass to my buddy, Edgar Waldron, which he caught and ran in for a touchdown. While my victorious teammates whooped it up and carried on, I noticed the park caretaker heading toward me with a big smile on his face. His name was Tom Keaney.

Years later, The Meadow would be renamed Keaney Park, after him. He introduced himself and asked my name, telling me that what he'd just seen was pretty spectacular, and that he'd put a word in with Carl Palumbo, the coach of English High. Coach Palumbo was no relation to my junior high coach, Mel Pelumbo.

After ninth grade, Joe had gone on to Saint Mary's Catholic High School, but I wanted to take a different path for ninth grade, and planned on transferring to the public school system. I enrolled in Eastern Junior High School primarily because I wanted to play organized sports, which were not offered in the parochial school system. I was also tired of kneeling down and praying every morning. The parochial curriculum was well ahead of the public school's at that time, making me practically an honors student. It seemed the teachers were teaching everything I had already learned the year before. Nonetheless, my awkward relationship with education continued.

The primary physical manifestation of my childhood was the fact that I stuttered. Around this time some of my friends asked me why I wasn't stuttering anymore. I couldn't tell them because I hadn't even noticed I'd stopped. Going to bed at night without cats crawling all over me, and not having to hear Grandma Stoner entertaining yet another friend downstairs, slurring her words and cackling late into the night, may have been part of it. Not having to worry about whether or not I'd eat dinner, not to mention how I was going to survive my next trip outside the front door—in Lynn, I had peace and quiet and three meals a day in a safe environment.

I wonder how much of my personality was formed by nature and how much was shaped by my environment. I had a quick wit and a fast mouth to match it, and was something of a wiseass. I was rambunctious and loved to have fun, but unless I was among people I knew well, I was terribly shy. Looking another person in the eye was impossible for me. Within months of moving to Lynn I had stopped practicing some of my less attractive traits, like shoplifting or going out looking to agitate some situation. My accomplishments in drawing and in sports were gratifying, but somehow, I completely lacked self-confidence. No matter how many times people complimented my artwork or my athletic ability, it didn't make a dent in my feelings of worthlessness.

While I got a lot of quiet encouragement for my drawings, I couldn't help but notice how my friends and even some of the adults watching our sandlot games would go absolutely nuts when I batted a home run or scored a touchdown. An athlete was regarded with real esteem and treated with genuine respect. Despite my insecurity, I was a true competitor and relished

winning. The strength of my will to survive had propelled me through the obstacles in my childhood. Now, I channeled that drive into competition. I'm living proof that changing a child's environment can have tremendous beneficial effects. If I had remained on the streets of Roxbury, I'm sure I would have been in prison or dead by the age of twenty-one.

My father declined my invitation to attend the Fathers and Sons Banquet held for the basketball team at season's end. Uncle Leo came to my rescue and accompanied me to what was probably the biggest night of my young life. When I returned to my seat after receiving an award, Coach Palumbo was sitting there discussing his dreams for my athletic future with Uncle Leo. The two men had known each other since they were kids. When Coach Palumbo left, I sat down and looked around at all the other boys sitting in the banquet hall with their fathers beside them.

Despite all my activity with sports, I made time for drawing every day. I filled one sketchbook after another with subject matter from newspapers and magazines. I copied page after page of a book on anatomy until I could reproduce any angle of the human figure from memory. Sketching portraits was also something I spent a lot of time doing.

It had now been over six years since Gramma Caulfield had given me that first set of oil paints for Christmas. I had a few painting lessons in school, but I also seemed to have an instinctive understanding of how to mix colors and how to achieve certain effects on canvas. I did a number of paintings based on the work of the combat artists' scenes of war from *Life* magazine.

Swampscott was and still is a more upscale suburban community just north of Lynn. There were some art galleries there, and I used to ride my bike over to look at the paintings in the windows. I was too shy or too intimidated to ever go inside and look around. A sign in the window of one of the galleries read PAINTING CLASSES. I signed up, and my first class consisted of sitting there while a stern woman propped a painting on an easel and told her mixed bag of six or seven students to copy it. During class she went around and gave everybody comments or criticism, except me. I thought, "This is stupid," and didn't go to any more painting classes.

One afternoon in July of 1946, I flew out the door of the *Item* after my shift hauling newspapers was finished, and ran off toward Central Square. I ran smack into Raymond Freeman, the man who had married my mother in 1942. "Bobby," he said, "have you seen your mother lately?" I shook my head and told him no, that I hadn't seen her in a long time. I told him how she had come by the house over a year ago, and that I'd only seen

her for minute or two. The far-off look in his eyes made him seem a bit dazed. "I came home from work one day about a year ago and your mother was gone. She just disappeared. I spoke to your grandmother about it at the time, but she told me she hadn't seen your mother for a few months herself."

Mr. Freeman and I exchanged a bit of small talk, and he asked that if I ever did see my mother, to please let him know. As I walked away I kept flashing back in my memory to the last time I'd seen her. She had been sitting there in Gramma Caulfield's kitchen nook, and she unclasped her anxious hands to give me a wave and a smile. Seeing my mother that day was one of those mundane moments you wouldn't think twice about. There was nothing extraordinary about it. She was dressed to kill as she always was, and I remember her smile. For some reason that day, when she smiled at me, her face lit up. Her smile seemed like a genuine expression of happiness, not the forced grimace she usually greeted me with. Subdued rays of sunlight caught her blue eyes and made them sparkle—and that's all I remember. I couldn't have known it then, but that moment in the kitchen would be the last time I ever laid eyes on my mother. In life, a seemingly ordinary moment can take on a more particular importance, only revealed in hindsight.

I wouldn't learn what became of her until almost sixty years later.

04
RUGGLES STREET

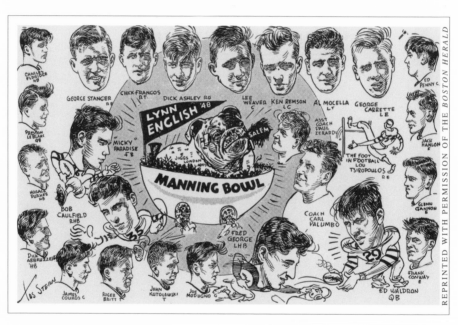

The Lynn English football team as depicted by T. Stern.
September, 1948.

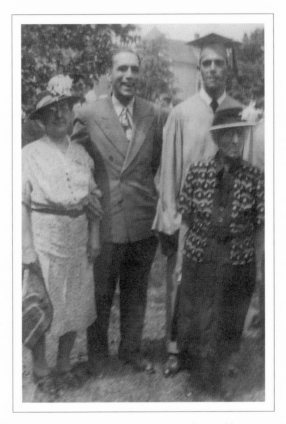

High school graduation—the day I thought would never come.
(Left to right) Aunt Rose, my father, me, Gramma Caulfield.
1950.

"An Ideal Boy"

While the quick pace of basketball was exciting, and I'd enjoyed winning the divisional championship in ninth grade, nothing could top my dream of becoming a football player. When baseball season rolled around in the spring of 1947, Coach Palumbo asked me if I wanted to work out with the varsity team. He probably wanted to see if I could hit a baseball as well as I could throw a pass or punt a football. John McQuillin was the varsity pitcher, and he later went on to pitch in the minor leagues. I was a good batter, but McQuillin's fastball often got the better of me.

In March of 1947 the following season's gridiron prospects were run through the usual round of practices in the gym four afternoons a week. These took place outdoors if the weather was accommodating. Coach Palumbo was hell-bent on making the Lynn English High Bulldogs the number-one football team in the state. I was on the track team and cut attending a meet to see what the football players were up to.

On a deadly hot August day a few weeks before I began the tenth grade, I tried out for the football team. All of my buddies from Saint Joe's were trying out with me, including some excellent ballplayers like Edgar Waldron and Mickey Paradise.

Today, Lynn English High School looks much as it did when I attended in the late 1940s and early 1950s. Its three-story edifice of gray stone is a solid municipal building with huge Doric columns at the front entrance. The ten acres of open field comprising what was known as The Meadow lie behind the school. While the word *meadow* conjures up imagery of rolling hills, flowers, and trees, this meadow was nothing but a vast expanse of lawn, much of it worn down to hard-packed patches of dirt. Streets jammed with two-family houses surrounded The Meadow. Sections of the practice field were set aside for a baseball diamond and a football grid, a portion of which was called "the pen," and enclosed within a chain-link fence. All the new kids trying out for the team had to pass through a gauntlet of jeering varsity players before being herded into the pen.

The tryout session was confined to sprints, grass drills, calisthenics, ball handling, and some interaction with the tackling dummy under a broiling sun in oppressive humidity.

Coach Palumbo surveyed the sweating new recruits along with Lou Bufalino, an ex-Cornell football star who was assisting Palumbo with the preseason drills. Coach Palumbo had been a high school football star playing tackle, and had served as captain of the University of Pennsylvania football squad before taking the position as coach of the Lynn English team. Tough, gruff, and no-nonsense, Coach Palumbo called everybody to attention and asked if any of the sophomores could punt. I shot my hand up along with a few other guys. The others went first and I watched them give punting a go. Their efforts brought forth less than stellar results. Coach Palumbo tossed the ball hard at me and said, "Let's see what you got."

I was in midfield, about fifty yards away from the end zone. I told Coach Palumbo that if I kicked the ball from the fifty-yard line, I'd boot it right out of the pen. Some of the varsity players laughed and shouted snide comments. Coach Palumbo rolled his eyes and said, "Take it to the forty and let's see you do that." When my foot struck the ball it sailed over the fence sixty yards away in a perfect spiral. Coach Palumbo told me to step back five more yards and try it again. Once more my foot hit the ball and off it soared, right past the fence again. My buddies were hooting and hollering encouragement for me. Coach Palumbo glared at them and told them to shut up. Handing me the ball, he said, "Come on," and led me to the seventy-yard line. I ran up to punt and *wham!* All eyes were on the ball as it shot toward the fence and fell to the ground a couple feet before clearing it. Coach Palumbo shrugged, and his stern expression relaxed for a moment. "Not bad," he said. The varsity players were no longer jeering. So began my high school football career. I was elected captain of the junior varsity team. The JV went undefeated that year, and we won the Essex County Championship.

Uncle Owen, my father's younger brother, was a sports nut. From the moment I made the team he never missed a practice or a game. He wasn't all that athletic in his youth, but made up for it with an obsessive enthusiasm for his favorite teams. Dark and handsome, Uncle Owen smoked cigarettes nonstop. His hearty smile and nods of approval from the sidelines meant more to me than he could ever know. My father never attended a practice or a game of mine.

A notation in my high school yearbook reads, "An ideal boy is a person who is friendly to everyone and well-liked by all; who deserves

this title more than Bob Caulfield, who is our ideal boy of 1950?" I'm getting a little ahead of events here. I wanted to point out that I have no idea how I pulled off that impression. When I entered high school, I was introverted to the point of being overcome with a sense of dread and terror whenever I had to talk to anyone I didn't know. I completely lacked any measure of self-confidence or self-esteem. My sporting exploits provided boosts to my ego on occasion, but they did nothing to stop a gnawing self-doubt that haunted me. My extreme shyness made making eye contact with anyone other than my family or close friends extremely difficult.

Gramma Caulfield's vicious cocker spaniel died, and the only one grieving Boots's loss was Gramma. It wasn't long before Grampa came home carrying a black puppy with white paws and a dab of white on his chest. We named him Skippy. Though he was supposedly the family dog, for all intents and purposes Skippy was mine. I took care of him and grew to adore him.

My lifelong love of dogs began with a mangy old Saint Bernard that Grandma Stoner had owned back on Ruggles Street. The dog was so big that Joe and I could take rides on his back. The poor thing was old and arthritic, and there were lots of tears when he was taken away to be put down. Grandma Stoner was inconsolable that day, sobbing and wailing long into the night, no doubt finding some relief from her grief in a bottle of whiskey.

Friday night, September 5, 1948, marked the beginning of my first varsity season. This was the date of the annual Joyce Jamboree at Manning Bowl, held at night under the lights. The Jamboree gave the fans a chance to preview what the various teams from surrounding communities had to offer each year. More than two hundred players competed in fifteen-minute scrimmages over a ninety-minute period. Lynn English faced neighboring Swampscott. In the last minute and a half of the scrimmage, Swampscott received, but in an attempt to kick on the last down, they lost the ball. Lynn English took over on the ten-yard line. I intercepted a pass from Buzz Robinson, running it in to score the second touchdown. Eighteen thousand fans in the stands roared. Looking out at that cheering crowd was a lightning-bolt experience for an insecure kid of seventeen. Lynn English walloped Swampscott, thirteen to nothing.

This event made football history, marking the first televised high school football game in the United States. Boston's Channel 4 had moved broadcasting equipment worth more than one hundred thousand

dollars to Manning Bowl. A crew of fifteen operated the TV cameras, which were optically designed for use in minimal light. Professional football games had first been televised in 1947, but the 1948 Jamboree marked the first time in television history that a camera was actually on the field of play in any sport, including pro ball. Of course, not all that many people owned televisions in 1948. Many barrooms had a television set, and quite a number of people would catch local games at their favorite watering holes. High school football games were also broadcast on the local radio airwaves.

In the late 1940s and early 1950s, it was common for Manning Bowl to televise up to five games every weekend. Teams from Lynn English, Lynn Classical, Saint Mary's, Salem, Marblehead, and many other North Shore communities fed the public's colossal appetite for high school football. The game itself was much more rough-and-tumble then. Players wore minimal padding and leather helmets without face guards. My buddy George Carrette got hit hard during a workout and was taken out for the rest of the season with an injured back. I played left halfback on offense, and linebacker on defense.

That first year playing varsity football was an enchanted one for me. Some press clippings from the *Lynn Daily Evening Item* explain why:

Hal Foster's Lynn English Sophs took St. Mary's High J.V. 27–0, yesterday at Memorial Park, with the winners putting on a strong attack in which Bob Caulfield, #35, was the outstanding performer for the Red and Gray. The first period was a scoreless session but in the second chapter Caulfield registered twice, once by a nifty 12-yard run and the other from a pass hurled by Edgar Waldron.

Bob Caulfield is a good-looking youngster with triple-threat possibilities, stamped himself as the boy who may be making headlines for Lynn English the next two years, when he personally set up the 13–7 victory which the English Sophomores registered over the Classical Junior Varsity before more than 2,500 excited fans at Manning Bowl yesterday afternoon. Caulfield, operating from the tailback slot in the single wing, put the Red and Gray yearlings in position to score the winning touchdown with a 45-yard flight early in the fourth period. His downfield voyage, which ended on the Classical 16 when Caulfield tripped and fell, was as thrilling as any run turned in at the Manning Bowl all season. Starting out around his own right end, behind beautiful blocking, Bob cut back sharply and sped through the Classical secondary.

The English High sophomore squad added another team to their list of victories when sparked by the fine running of Captain Bob Caulfield, they trounced the sophomore squad from neighboring Saugus, 25–7. Capt. Caulfield was by far the outstanding participant in Tuesday's game. Not only did he make two brilliant touchdowns by running around his own right end, his fine tackling and distance punting kept Saugus at bay during all the encounters.

Coach Palumbo would excuse me from class occasionally so that I could come to his office and meet football scouts from prestigious colleges like Harvard, Holy Cross, and Cornell. I'd sit slumped in a chair trying to look interested while Coach Palumbo extolled my exploits on the field. Then the visiting scout would ramble on about what a fantastic opportunity awaited me if I chose to go to his particular college or university.

A college football career was Coach Palumbo's dream, not mine. I didn't think I was good enough or smart enough to tackle the more stringent academics that college demanded. A college education seemed like something only brainy kids or the wealthy could achieve. There was a lot of talk about full athletic scholarships, but the lifting of the financial burden did nothing to ease my anxiety about the whole proposition. The few times I'd visited college campuses had been experiences in pure intimidation for me. No one in my family had ever gone beyond high school, and I doubt any of them had even considered it. I was only a few years removed from the soul-crushing poverty of Roxbury. Though I'd definitely made personal progress in the middle-class surroundings of Lynn, the soul of that wild boy from the streets, that boy who trusted nothing and no one, still lived inside me. I liked the social aspects of attending Lynn English, but I always hated the academic side of school.

My English teacher was a real busybody. I have no idea how she found out about the circumstances of my childhood, but she'd try to take me aside to commiserate with her about it a couple times a week. I didn't know what to do, so I'd tell her outrageous lies about my younger years to make it all seem even worse.

In a game against our rival, Lynn Classical, the *Item* had this to say: "Bob Caulfield, a promising young backfield man, paced the English yearlings all afternoon as he turned in two long runs, punted and passed good enough to bring victory."

The following Monday I was sitting in one of my classes when the teacher, a ninety-one-year-old woman named Miss Bartlett, said, "Children, let's all give Robert a hand because he played such a great game on Saturday." All the kids in class cheered and clapped while I almost died of embarrassment.

In the final game of my sophomore year we faced Lynn Classical before a crowd of over ten thousand people at Manning Bowl. I was lucky enough to make a couple of great runs for touchdowns, some key tackles, and some punts for extra points. Grampa Caulfield handed me the newspaper the next morning at the breakfast table. He looked as proud as I'd ever seen him.

The headline read, CAULFIELD STAMPED AS LEADER OF LYNN ENGLISH FOOTBALL FOR NEXT YEAR! An article beneath the headline described my achievements in the game the night before. Grampa Caulfield hadn't gone to Manning Bowl, but he'd listened to the game on the radio like he always did. Whenever I returned home after a game, he'd call out, "Great job, Bobby!" Football's violence was a bit too much for Gramma Caulfield, which is why she never went to any of my games. The thought of me getting hurt consumed her with worry. She wouldn't even listen to games broadcast on the radio, and almost had to be forced to look at the newspaper clippings.

It had been a superb first year of varsity football. In what was a minor miracle for me, the knee injury I'd suffered two years before while playing sandlot football had not been aggravated. I won a prestigious local award given to promising athletes by a shoe manufacturer that season. The headline in the paper announcing the award read, BOB CAULFIELD KICKING BIG FACTOR IN SPENCER SHOE AWARD. I won for my punting, which I nailed almost without fail at sixty to seventy yards.

A big personal event for me during sophomore year was meeting my art teacher, Miss Carlton. With all the talk of me going to college on a football scholarship, she was the only person who encouraged me to go to art school instead. She listened to me express what I truly dreamed about: becoming an artist. She often singled my work out in class and in her calm, motherly way, suggested that I consider becoming a commercial artist.

While sketching and painting still took up a lot of my time, sports were definitely taking a lead position in my life. Over the course of one varsity season I'd gone from being an anonymous student to becoming a football player everybody seemed to know; even strangers on the street would say hello and make small talk about my performance on the field while I stared at the ground and did my best to be pleasant. If I had been given the choice at that moment between success as a football star and success as an artist, I would have chosen football, without a doubt.

However, I remained torn about my future. I remember going to a baseball game at Fenway Park in Boston that summer. I looked at all the

people packed into the stands and thought, "I wonder how many of these people can draw like I can?" Despite my lack of self-esteem, and the competing pull of football, I had a strong ego asserting itself in the direction of my becoming an artist.

During the winter of 1948–1949, I played basketball again. A lot of my buddies made the team, guys like George Carrette, Edgar Waldron, and Mickey Paradise. George was sitting beside me on the bench during a game with Marblehead one day when the star players from the opposing team ran down the court. Nudging me, George said, "That guy's built just like you, but I bet you could take him." What George said shocked me, because in my own eyes I was a scrawny, pimple-faced, seventeen-year-old kid and the guy he pointed out had a powerful, muscular build. Like many adolescents, I couldn't look at myself objectively. My success in sports didn't make me think I was anything special. I was never cocky, though people often mistook my shyness for arrogance.

One winter night I was babysitting my nephew and niece at Aunt Mary's apartment when the phone rang. I'd had a strong appreciation for female beauty since the age of twelve, but I hadn't really bothered with girls up till then due to my involvement in sports and the fact that all the other guys I hung around with didn't have girlfriends either. I picked up the phone. The voice on the other end of the line asking for me belonged to Winifred Murphy, hands-down the most beautiful girl at Lynn English. Fresh-faced and sweet, Winnie's natural beauty was always compared to that of movie star Ingrid Bergman.

In cool tones, Winnie asked that I accompany her to a party the following weekend. Girls didn't call boys back then; it was just not a part of the rigid protocol regarding relations between the sexes. But what did I care? The most beautiful girl in school had called me and asked me out on a date!

To say the late 1940s in Lynn was a more innocent time is a cliché, but it's true. Nevertheless, the social rules regarding dating, or any interaction at all between boys and girls were puritanically restrictive. Sex was something all the guys laughed about, and although there was always a joker who claimed to have gone "all the way," none of the guys I knew had ever gotten past second base with a girl. In postwar America, sex didn't play the key role in popular culture that it does today; as a result, sex—and girls— were an infinite mystery.

George Carrette went to the party with me the following Saturday night. On the way we must have devoured three packages of breath mints

apiece, stopping every twenty feet to smell one another's breath. I'd never kissed a girl before, and the mere prospect of it made me delirious. I didn't end up kissing any girls that night either, but before long, Winnie and I were going steady, and I had my first kiss.

During February vacation in 1949, the Lynn English 1948 High School Stars football team went on a trip to Washington, D.C. On the return we stopped in Philadelphia and New York City. I'd never been south of Boston, so it was all incredibly exciting for me. After visiting the Lincoln Memorial, the White House, and the Capitol building, we headed for Coach Palumbo's alma mater, the University of Pennsylvania. We visited local sights like Independence Hall and Valley Forge, and attended a basketball game at Villanova.

Thursday, February 24, 1949, was the first time I set foot in New York City, a city I've had a love affair with ever since. My teammates and I watched a basketball game at the old Madison Square Garden and went to a movie at the Roxy. Ornate and immense, it made the Roxy back on the streets of Roxbury look like a closet. There were stops at Radio City Music Hall, the Empire State Building, and the Statue of Liberty. After a tour of NBC Studios at Rockefeller Center, our team sat in the audience of *The Arthur Godfrey Show*. We were a pretty rowdy bunch, and like all kids that age, we raised a lot of hell. The itinerary we were given at the start of the trip had this notation: "1:00 A.M. room check each night, and you had better be there!"

I went out for track again in the spring of 1949. My strong suit was the relay. I ran the 220-yard run in 24.6 seconds. Our team smothered archrival Lynn Classical in the last meet of the season on June 3, and I came in third in the 440-yard dash. By June 7 of that year I was playing center field for the Buccaneers in what was known as the Park "A" Baseball League.

By the time April showers brought May flowers, Winnie and I had broken up. In July I found a job at a downtown laundry. In a stifling back room, under a gigantic clock, I sorted through endless piles of dirty clothes. In all the years of my life I have never watched a clock the way I watched that one. The job was plain awful and paid only fifty cents an hour. On occasion I'd find some loose change in a pocket and every so often, a dollar or two somebody had forgotten. The second that my shift ended, I'd rush out the door and head for Fisherman's Beach over in Swampscott.

Fisherman's Beach is a small crescent of sand about a quarter-mile long. It lies between some rocky outcroppings common to the North Atlantic coast, and is backed by a road and a steep slope covered with

houses and apartment buildings. The beach was *the* hangout for the jock crowd during the summer months. I lived for the great times we had down there playing ball, swimming, and carrying on. I had an absolute blast that summer. I savored every moment of fun because I knew it was the last summer I'd have before graduation, before I'd have to face the uncertainty of where life would take me next.

05
RUGGLES STREET

1950.

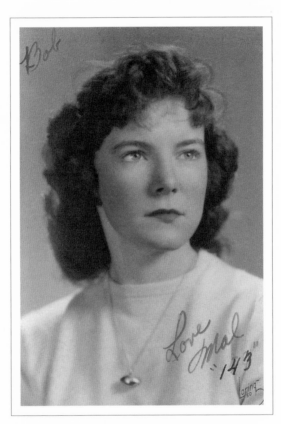

Marilyn, age 16, wearing the gold football charm.
"143" was our secret code for "I love you."
1950.

I'm Going to Marry You Someday

Summers along the Massachusetts coast can be muggy, a term New Englanders use to describe how it feels when the heat and humidity grow oppressive and there's barely a breeze. In late August there usually comes a day when, for the first time, a chill in the air and a difference in the sunlight's intensity suggest that fall isn't far away. The precious summer months always go fast in Massachusetts.

On one of those humid August days in 1949, my right knee took a nasty hit during a football practice session. The cartilage was torn and my knee was damaged so badly that it required an operation. I woke up in a groggy daze in the recovery room after the doctors were done, and soon fell back asleep. A curtain fluttering in the open window of my hospital room tickled my face and woke me up a few hours later. Perhaps it's a remnant of my accident-prone childhood, but I hate hospitals. That antiseptic, medicinal smell lingering in hospital corridors turns my stomach. All I could think about was, *Get me the hell out of here.* My right knee was heavily bandaged, but somehow I got dressed and made my way on crutches down a nearby stairwell.

A taxi brought me home to Harvest Street. When I hobbled through the door on my crutches, Aunt Dot was on me in a flash. She was frightened and angry because the hospital had called her three times in the last half hour to let her know I'd disappeared. The doctors had wanted me to recuperate in the hospital for at least three days. I calmed Aunt Dot down and headed to my room with my dog Skippy at my heels. Lying in my bed, all I could think about was how soon it would be before I could get back on the football field. This setback was hard for me to accept because I had been the top candidate for a starting halfback berth on the team. The doctors told me I'd be off the field for four or five weeks at least. Coach Palumbo had counted on me as his mainstay in the kicking and passing departments, and my injury left him searching for a quick replacement.

Although I missed the season's opening game at Lowell, by the end of September I was back on the field again. A jagged, five-inch-long scar on my knee and a dull, throbbing pain were constant reminders of the operation.

My Uncle Leo volunteered as an usher at Manning Bowl. He loved to flirt, and whenever a pretty girl caught his eye, he'd ask her if she wanted to meet his nephew. One day he asked a petite brunette if she'd like to meet me. "Bob Caulfield?" the girl said. "No thank you. He's much too old for me." I was only eighteen, but this particular girl was just fifteen at the time. Neither she nor Uncle Leo could have known it at that moment, but this girl would end up playing the most significant role of any female in my life.

I hadn't fully recovered from my knee operation, and my playing showed it. Disaster struck on October 28 when we were playing against Saugus. A clipping from Ed Cahill's sports column in the *Item* that day read: "Bob Caulfield, the big halfback who has been doing the punting for Lynn English the past two seasons, has probably played his last high school game for the Bulldogs. Caulfield aggravated an ankle injury suffered in basketball and has been forced to turn in his suit."

Actually, I had to turn in my suit, #44, because my ankle had been broken. Lynn English had been undefeated going into that game. Whatever bad luck was hounding me seemed to affect the team, because the Bulldogs lost for the first time that season. I was back on my crutches for the next six weeks.

Since school had started that September, I had noticed an adorable brown-haired girl hurrying through the halls with her circle of friends. She'd clutch her books to her chest, and by the way she averted her eyes, she seemed a bit on the shy side too. Her pretty face glowed, even though she wore no makeup. Once, when she did glance my way for a moment, I was struck by her beaming blue eyes. After asking around, I found out that her name was Marilyn Le Blanc—as it turned out, the very same girl Uncle Leo had met at Manning Bowl. Since she was a sophomore, and a few years younger than I was, I left it at that.

While I was on crutches I still attended every home game. It killed me to sit there on the sidelines watching my teammates play without me. I used the extra free time I suddenly had to concentrate on my drawing and painting. Miss Carlton, my art teacher, tried her best to persuade me to pursue a career in commercial art, but I was confused. I didn't want to be a commercial artist. All I wanted to do was paint.

In Miss Carlton's class we'd do the occasional still life or a series of figure drawings from plaster casts. I'd grow bored because my interests

were increasingly geared toward painting landscapes. Even as I dreamed of one day becoming a well-known artist, I didn't have the first clue about how to begin. Guidance counselors would lecture me about how difficult a career as an artist could be. I'd had enough hunger and privation in my childhood. The stereotypical starving artist's life certainly didn't hold any appeal for me. Maybe my father's awful girlfriend was right in thinking the art world was "only for rich people."

I played basketball again that season and performed well. Escaping another injury was my main achievement on the court. I turned nineteen on December 14, 1949, but felt like I was really getting old and still had no direction. High school was fast drawing to a close. I knew I had to do something with my life. Exactly what that would be, I had no idea.

Despite my injuries and my time off the field the previous season, I was offered full athletic scholarships from Holy Cross and Harvard. Coach Palumbo was jubilant. He pushed me to take the Harvard offer. Confusion and a complete lack of confidence in my academic ability made me let the offers slide. Coach Palumbo and my teachers were the only people I knew who had gone to college. No matter how much they tried to explain how wonderful an experience it would be for me, I resisted. It was intimidating to think of leaving the middle-class world of Lynn to enter the dark and mysterious world of rich kids and higher learning. I loved to read, but only if the book was about art or an artist.

There were many students at Lynn English who did go on to college. I wouldn't be one of them. I made the most of my last year of high school and was more social than usual, attending every party I could. I somehow made the honor roll the last two quarters.

I had won numerous awards for my artwork all through my school years. Being a dreamer involved a significant portion of my consciousness. I believed that if I pursued painting, no matter what the obstacles might be, sooner or later somebody would discover me and my art career would be off and running. Half of me was driven to become an artist at any cost. The more practical half was haunted by self-doubt. My anxiety was intensified by the apprehensions of those around me who considered an artist's life to be filled with risk and constant uncertainty.

I'd always seemed to do well in baseball. In the spring of 1950 I tried out for the Lynn Buccaneers again. I was more than happy to play center field in the less violent environment baseball offered, after all of my football injuries. One night after a game I was shooting the breeze with George. The prom was coming up, and we also needed extra money for our graduation pictures. George told me he'd heard that joining the

Marine Reserves was a good way to make some extra money. Reservists trained one night a week and maybe a couple of weeks during the summer months. The pay was minimal but it would help; we both decided to join, and my good friend Don Savio signed up as well.

The wellspring of sentimentality accompanying high school graduations was lost on me. I couldn't wait to grab that diploma and be done with school forever. Coach Palumbo put some last-minute pressure on me to accept the Harvard offer, but something inside me still resisted. I knew that college wasn't the way I wanted to go. Before I knew it, I was standing in line dressed in a cap and gown and being handed my high school diploma. Thus ended fourteen years of an education that had been, for the most part, torture for me. I was finally free of the constraints of teachers, homework, and ringing bells, and sitting in a classroom wishing I could be anywhere else. Gramma and Grampa Caulfield were so proud of me that day. They happily posed for pictures along with me and my father, who for some reason attended the ceremony.

Jobs were hard to come by in 1950. The best I could come up with after a week of searching was taking back my old job at the laundry. Once again there I stood, sorting laundry under that huge clock while an enormous fan rattled and circulated the stifling air. The moment my shift ended I headed for Fisherman's Beach. My crowd was a mixture of jocks like George Carrette and Preston Le Blanc, the captain of the football team, as well as old friends like Don Savio and Vin Vabucci. There were about twenty of us who'd stake off a section of the beach, toss a football, flirt with the girls, lie in the sun, and just cut up and have fun. Afterwards we'd pile into a couple of cars and head over to my house. Gramma loved it when we'd all come charging through the door. She'd serve us all tonic (soda) and graham crackers with peanut butter.

I enjoyed the Marine Reserves. The training wasn't all that difficult, consisting mostly of marching and drilling. We were also given M-1 rifles and taught how to shoot, take them apart, and reassemble them. During one of our weekly meetings the reserve sergeant mentioned Korea. Nobody in the regiment had ever heard of that country before.

Whenever I'd go to Fisherman's Beach, Marilyn Le Blanc, that shy girl I'd seen hurrying through the halls the previous school year, would be there. She had just turned sixteen in June and she was a stunner with her tan, shapely figure and beautiful blue eyes. On a Saturday afternoon in the last week of June, I looked over and spotted her in her aqua-blue bathing suit standing about forty feet away. Her back

was to me and she was talking to a friend. She turned my way but didn't look at me, sat down on a blanket, and rubbed some suntan lotion on her legs.

I was sitting on a towel beside my buddy, Preston Le Blanc. Poking him, I said, "Hey, Preston, see that girl over there?" He squinted and looked around. "Which one?"

"The one in the blue bathing suit."

Shading his eyes with his hand he looked her way. "Yeah, I see her. What of it?"

I smiled and said, "Someday I'm going to marry that girl." Preston collapsed into laughter. When he finally caught his breath he said, "That's Mal, for Christ's sake. She's my cousin."

Preston was too busy laughing, so I asked a friend named Biff Durkee to ask Marilyn if she'd go out on a date with me. I acted cool and disinterested while Biff headed her way. I watched him talking to Marilyn out of the corner of my eye. Things didn't look good. I saw her look my way, shake her head, and lie back down on her blanket. As Biff returned, I did my best to mask my anxiety. "What did she say?" Biff shrugged. "She said, 'If he wants to ask me out, then he can come over and ask me himself.' "

I summoned the courage, and went over and said hello. When Marilyn sat up, smiled, and turned those turquoise-blue eyes my way, I felt like I'd been struck by some incredible force. I stammered for a moment and then introduced myself. She smiled and said, "My name's Marilyn. Marilyn Le Blanc," and then turned her eyes away. It turned out that the pretty girl I'd seen around school the last year really was almost as shy as I was.

I didn't have a car at this time. Once in a while Aunt Dot would let me use hers, but she needed it on the Saturday night I'd asked Marilyn to go out. Biff had a car. This was the main reason I arranged for us to go on a double date with Biff and his girlfriend. They picked me up about six-thirty. We drove to Boston Street where Marilyn lived with her parents in a three-family house they owned. Marilyn's parents lived on the second floor with their youngest daughter, Rene, while Marilyn and her sister Dorothy lived in the apartment on the third floor. A couple named Dupuis lived on the first floor.

Biff waited outside in the car while I went inside to meet Marilyn's parents. Her father Leon was a man of average height, muscular and powerfully built. He reached toward me with one of his enormous hands and we shook and said hello. Leon wore a pencil-thin moustache and was movie-star handsome. I was dazzled by Marilyn's mother from the

moment we met. She was petite with auburn hair. A pair of warm blue eyes the same color as Marilyn's greeted me behind the eyeglasses she wore on her pretty face. Her name was Ivadelle and her manner exuded class, breeding, and femininity. After meeting her parents it was obvious to me where Marilyn's looks had come from. Marilyn stepped into the room wearing a cute pink dress. After some small talk with her parents, we headed out the door.

Downtown Lynn had six movie theaters in 1950. We went to the Paramount but I can't remember what we saw. After the movie, we drove to Doane's Ice Cream on King's Beach in Swampscott. Biff and I left the girls in the car while we went to get some ice cream. When we came back, I handed Marilyn her cone through the car window. The ice cream fell off, plopped onto her dress, and then rolled into her lap. Mortified, I apologized like crazy and handed her a few paper napkins, then ran back to the counter to get some more. When I returned, Marilyn had gotten the ice cream back onto the cone. She was dabbing at the stains on her dress— a dress which, unbeknownst to me, she had bought specifically for our date. I apologized profusely till Biff said, "All right, already. You're sorry!" With a sweet smile, Marilyn looked at me and said, "It's okay, Bob. It wasn't your fault."

Later we took a long stroll along the sidewalk above the beach. Moonlight twinkled on the ocean waves and illuminated the town of Nahant in the distance. We sat on a bench and Marilyn pointed to Egg Rock, a weather-beaten rock resembling the hull of an upside-down ship, about a half mile offshore. Marilyn told me that when her parents had first started dating, her mother's beach ball had been swept out to Egg Rock by the tide, and her father had swum all the way out there to retrieve it for her. I told Marilyn about my dream of becoming an artist. We seemed to hit it off right from the start. Marilyn was simply the sweetest, kindest girl I'd ever met. My physical attraction to her was overwhelming.

After Biff dropped us off at Marilyn's house later that night, we went around to the back steps and sat and talked some more. I said, "You want to know something? I'm going to marry you someday." Marilyn has the most adorable laugh I've ever heard, and she laughed pretty hard at that remark. I was nervous, so I asked Marilyn if I could kiss her, instead of just going for it. Our lips came together, and that's how our first date ended.

Before long Marilyn and I were seeing each other almost every day. We went to the beach all the time and we both loved the movies. I knew

I wouldn't be working at the laundry much longer but put off looking for a real job until the summer was over. On occasion I'd drop by The Breakers, a posh apartment house on the ocean, where Marilyn babysat a few nights a week for a local merchant. Gramma and Grampa didn't have a television set, so it was a real treat to go over there and watch TV between bouts of making out with Marilyn.

Girls were clearly categorized as "good" or "bad" in those days. There weren't many bad girls around Lynn, and everybody knew about the rare ones who had "gone all the way." With Marilyn there was absolutely no question of compromising her virtue. Like any young man, sex was on my mind every minute of the day. Actually acting on those urges was a line I never considered crossing with Marilyn. Sex was for after marriage, which is probably one of the reasons why people married so young back then.

Back when I was fifteen, I had gone into Boston with my brother Joe to see a Bruins game at The Garden. After the game we ended up strolling around Scollay Square a few blocks away. Razed in the 1960s in a wave of urban renewal, back then Scollay Square was loaded with nightclubs and cheap dives. Best of all, there were burlesque houses like the Old Howard and The Fox that featured strippers. We were walking by a place called The Casino when a barker strutted out of the lobby clapping his hands saying, "Last show tonight, boys. Better hurry up!" I was sure we'd never make it inside. I tried to act calm, especially when we handed our money to the ticket taker who sat beneath a big sign that read, NO ONE UNDER EIGHTEEN ALLOWED. Before we knew it we were sitting in the second row with our eyes popping out of our heads, watching a stripper shimmy through her bumps and grinds. The women didn't strip completely naked, but went down to a G-string and pasties. Even so, it was pretty hot stuff.

Comics would come onto the stage between strippers and do short routines. One old comic had a bit about a girl he was trying to impress. He said, "I'll buy a Kaiser to surprise her, a Frazer to amaze her, and a Tucker to fuck her!" I was shocked because I'd never heard that most flammable of curse words spoken in public before.

If Gramma and Grampa Caulfield ever wondered why I had suddenly become such a devoted attendee of Boston sporting events, they never mentioned it. For the next few years, I used the excuse of going to see the Bruins or the Red Sox any time I headed for Scollay Square. I usually had company, and more often than not, George Carrette, Don Savio, or

some of my football buddies would be sitting next to me in one of the front rows admiring the strippers. Before I was eighteen we'd seen them all: Gypsy Rose Lee, Ann Corio, Lili St. Cyr, Sally Rand (the fan dancer), and a hundred other girls.

At a banquet after my junior varsity season, I'd been given a fourteen-karat gold football charm, a little bigger than an almond. I mounted it on a chain and had given it to Winnie and maybe another girl or two before giving it to Marilyn. One day at the beach Marilyn twirled the glittering gold football around her finger and said, "Look what I had done, Bob." The charm was now inscribed with *Mal & Bob, 1950.* So much for passing that ball around anymore if things went south with Marilyn.

I continued playing sandlot ball that summer. In July I received a letter informing me I'd been chosen from a pool of players "who showed outstanding ability" to try out for the Grade A Hearst Sandlot Baseball Tournament Team, representing New England. Tryouts were going to be held at Fenway Park. My baseball glove was a ragged disgrace, so I borrowed one from a friend named Arnie Bernstein. He was a lefty like me, and his glove was brand new.

When my turn at bat came at Fenway Park, I hit the first ball over the wall in deep center field. A ripple of excitement buzzed through the jaded group of onlookers, mostly a bunch of crusty old men in suits and fedora hats. One of them stepped forward and said, "Pretty impressive. Let's give this young man another shot." The pitcher wound up and threw the ball. I hit that one far into center field. The man who had just spoken to me took me aside. There was all kinds of talk about me trying out for the minor leagues instead of the Hearst Team. I was told to come back the following week when some scouts would be there to take a look at me.

When I hit Fisherman's Beach that afternoon, I told everybody what had happened. We all fantasized about what it would be like to be a professional baseball player. Marilyn was thrilled for me. I got up to bat the next week at Fenway and only managed to hit a few pops. Any dreams of playing pro ball died right there on home plate. It wasn't all that bad because I was offered a position with the Hearst team in Revere, and they were semi-pro. I played center field for them the rest of the summer.

I fell hard for Marilyn. One night when she was babysitting at The Breakers, I told her I loved her. She just giggled and said, "Kiss me again." Marilyn was lucky to have a two-parent family. She had always enjoyed a stable, comfortable, and happy home life. Her beloved grandmother

had died of ovarian cancer when Marilyn was fourteen. She had been living in the house during her illness, and as awful as experiencing her death was, it was the only time Marilyn had been visited by tragedy. Marilyn's sister Dotty was a year older than Mal, as Marilyn liked to be called, and resembled her to the point where people often mistook them for twins, even though Dotty had auburn hair like her mother and dark blue eyes. Marilyn's sister Rene was nine years younger.

I never told Marilyn all that much about my childhood. I had no idea why my parents' marriage hadn't worked out, so I told anyone who asked that my parents divorced when I was a baby, and that I'd been raised by my grandparents. If Marilyn or anybody else tried to delve further, I changed the subject.

In early August of 1950 the reserves officer informed us that our weekly training sessions would be increasing from one to two nights a week. He explained that Communist North Korea had attacked South Korea, and the resulting conflict meant we would be called up for active duty. The next week brought rapid changes, as we were told we'd all be shipping out to Parris Island for basic training within ten days.

Active duty had been the last thing I'd ever anticipated when I joined the reserves. Extra cash and a couple of training days per week for two years—that was the extent of the commitment in my mind. George Carrette decided he'd rather enlist in the navy, and signed up with that branch of the service for four years.

My little world was collapsing. Falling in love with Marilyn was the greatest thing that had ever happened to me; every moment we spent together found me floating on the power of love I felt for her. I had been truly happy that summer. Now I had to leave and prepare to fight in a foreign country that most Americans had never heard of.

06
RUGGLES STREET

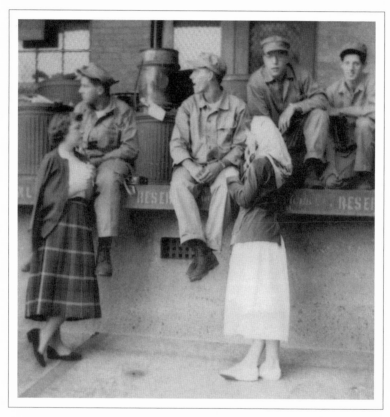

Moments before leaving for Parris Island.
Don Savio and his girlfriend Dot Emery are on the left.
Marilyn is wearing the kerchief; I'm sitting above her.
August, 1950.

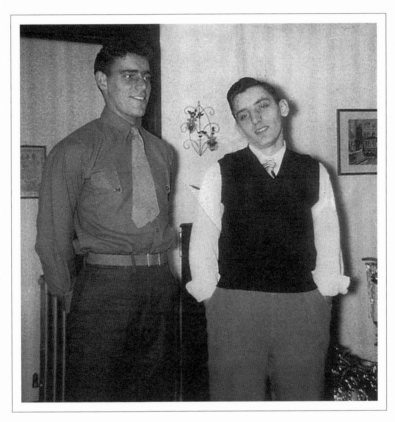

Home with Joe on a three-day pass from NAS.
December, 1950.

Knock With Your Head

I said good-bye to Marilyn on a soft August morning in 1950. After professing my love for her yet again, she leaned close and whispered, "I love you, too, Bob." It was the happiest moment of my life. We kissed, she cried, and that was it. I was off. I only looked back once. Marilyn stood there in the early morning haze with a pale blue kerchief around her hair, using a corner of it to dab at her misty eyes. It was the most difficult parting I had ever experienced. Since I was going off to war, I thought that it might be the last time I'd ever see her. I had fallen head over heels for this girl. And now I knew she felt the same way about me.

I met up with the reserve unit I'd been training with for the last few months. We organized and marched through Central Square past a crowd of cheering people to the train station. Our commander told us we'd be heading to a place called Camp Lejeune in North Carolina.

That train ride south seemed to take forever. I sat there during the two-day journey writing letters to everyone I knew as if I'd been gone for months instead of only one day. I missed George Carrette and wondered how things were going for him in the navy. My old pal Don Savio made the trip with me and he and some of the other guys in our regiment kept me company.

Following our arrival at Camp Lejeune, we joined a huge mass of about one thousand other men. New recruits were separated from veterans. Don Savio and I were told to stand in line with the men going to Parris Island in South Carolina for twelve weeks of basic training.

On the bus to Parris Island the guys were trading scary stories about what we could expect in basic. The stories were laced with doom and fear, and pretty much boiled down to the fact we were headed for three months of pure hell; that is, if we were man enough to take it and could last that long. One guy said, "They'll turn you into a man in twelve weeks or they'll break you forever."

I looked out the window as the bus headed over a long causeway connecting the mainland to Parris Island and thought, Whatever it is they're going to throw at us, I sure as hell can take it. It felt like I was going to prison on some exotic island right out of a Hollywood movie. One of the guys went on and on about how all the waters surrounding us were infested with man-eating sharks. We'd have to take long forced swims through these waters and then hike for endless hours through jungles where poisonous snakes lurked behind every rock and tree. His talk scared a lot of the other recruits, but not me. Nothing they were going to throw at me could be worse than what I'd seen around Ruggles Street.

I found out soon enough. Our bus pulled up in a cloud of dust in front of a row of barracks. Three marines stood by the road with stiff postures and fierce expressions. Each one held a black billy club they kept smacking into their palms. These were the drill instructors. The man in the middle was barely five feet two inches tall. It was hard not to laugh at the irony when we found out his name was Corporal Little. He was all barrel chest and cantaloupe biceps; he reminded me of the bulldog who had been our Lynn English mascot, except with a white-blond crew cut.

I followed the other recruits as we stepped out of the sweltering bus into the devil's steam room that is South Carolina in August. The drill instructors screamed at us to fall into a single line and then strode past, their eyes flashing with bully intimidation. All the men from our bus stood there under a burning sun as Corporal Little went from one man to another, screaming, "You know what it means to be a United States Marine, asshole?" He'd sputter and spew at his victim and then move on to the next in line. His eyes would look the new recruit up and down. In a moment he'd decide whether to move on, or shout and rant and rave. Corporal Little had an extensive repertoire of obscenities and these included a few I'd never heard before. On some level his vocabulary was kind of impressive.

The two other men with Corporal Little were assistant drill instructors and they joined him in shoving, pushing, hollering, poking, and prodding the new recruits with their billy clubs. A recruit standing one man away from me had a smirk on his face. "Something funny?" said Corporal Little. A lightning-quick left jab shot out of nowhere as Corporal Little punched the recruit in the jaw so hard he sprawled back onto the dirt, knocked out cold. I thought to myself, This is going to be a long twelve weeks. Don Savio was relegated to another company and I didn't see him again during the entire three months I was in basic.

Life as a "boot" commenced with having my head shaved and then being issued an oversized uniform and combat boots. Each day began at 4:30 A.M. The daily routine consisted of all kinds of exercise and training, being screamed at constantly in the hundred-degree heat till lights out at 9:00 P.M.

Marching, marching, always marching. Some guys even pissed their pants as they stepped along because breaking ranks was forbidden and it was easier to stand the shame than the pain if they'd asked to step out of line. I was placed at the end of the line simply because I was taller than a lot of the other men were. Corporal Little would call out, "Left foot ho!" And every time he did, five or six recruits would turn right instead. I couldn't help thinking, I'm going to have to go into combat with these guys? I didn't have trouble keeping time with cadence; my problem was rolling my shoulders. When I walked my shoulders swaggered. Time and time again Corporal Little would get in my face and scream, "Caulfield! Keep those goddamned shoulders straight!"

A sign in the mess hall read, TAKE ALL YOU WANT, BUT EAT ALL YOU TAKE. After a hard day of drills I'd often go back to the chow line for seconds and thirds. I'd never seen so much food in my life. Bitching about how lousy it was fueled a lot of the recruits' conversations, but I didn't complain. I just ate.

More often than not, the drill instructors would barge into the barracks about an hour before lights-out and slam the windows shut. The big fans that circulated the stifling air would be switched off. We'd put our winter gear on as Corporal Little called out, "Okay, you shits. Time for locker box drill!"

Locker box drill consisted of standing at the foot of your bunk, wearing a winter parka, and lifting your locker box over your head in unison with the rest of the squad as Corporal Little called out, "Come on ladies, up, down, one, two." Sweat poured down in rivers as the heat inside the barracks soared to over one hundred degrees. One night in the middle of this exercise I heard a weird, high-pitched giggle. Almost a squeal. Never breaking my rhythm, I looked over and saw one of the squad members taking baby steps as he walked down the center aisle. He giggled some more, then broke into sobs and called out for his mother. The next time I saw him, he was wearing a white sweat suit and sneakers and was being led into one of the infirmaries. Word went around that he'd suffered a breakdown and had gotten a Section Eight discharge.

I hadn't seen any rattlesnakes or killer sharks so far, but seeing men break like that was even more terrifying. I understood what the drill

instructors were doing. All of the insults and the brutal drills were simply preparation for the rigors of combat. Boot camp boiled down to a process of separating the wheat from the chaff. Some of my comrades couldn't grasp why things were so tough, and when the drill instructors weren't around, there was constant bellyaching among them.

If a day on the drilling field had gone badly, one of the punishments handed out by the drill instructors was forcing us to crawl underneath the barracks with our gear and rifle, through muck and cobwebs, again and again. One time a buddy of mine split his head open on a beam and had to keep going, crawling through the grime with blood streaming down his face and saturating his sweaty clothes.

Though I thought he was a pint-sized punk, I got along with Corporal Little pretty well. I took the path of least resistance, did what I was told, and accepted any punishment coming my way without complaint.

With barely a moment of free time, the weeks passed quickly. After lights-out, certain platoons would be called upon to march late into the night. I'd lie there in my bunk listening to their footsteps in cadence as they'd sing, "From the Halls of Montezuma." I'd think to myself, God help any country in the world going up against us.

I wrote to Marilyn every single day, filling page after page with my experiences on Parris Island and my undying declarations of love for her. She wrote me almost every day as well. Any time I received a letter from her at mail call, my day was complete.

A few of the men in my platoon were in their mid- to late twenties and had served in the army in World War II. Some of them were married and had left wives and children behind. They'd tell stories of their experiences in combat, describing anything but the valorous heroism you'd expect after watching a lifetime of war movies. Every one of these guys moaned nonstop about how they wished they'd stayed in the army and about what a huge pain in the ass the Marine Corps training was. I didn't disagree. After a few hours of marching, my eight-pound M-1 rifle always felt more like it weighed two hundred pounds.

As our time on Parris Island dragged on, we learned all the skills a military man needs to know—everything from basic survival tactics to how to clean your rifle and assemble it in a matter of seconds, to how to slit the enemy's throat with a bayonet in hand-to-hand combat. In a week spent at the rifle range we practiced shooting our own rifles, automatic weapons, .45 pistols, and tossing live hand grenades. I'd never held a gun before in my life, never mind shot one, although as with most things in life, practice brought a certain level of competence. I became an excellent shot.

I was lying in my bunk one night writing a letter to Marilyn when an officer approached me and informed me that Corporal Little wanted to see me in his quarters. Mopping the endless stream of sweat from my forehead—a constant since hitting South Carolina—I got dressed and walked over. I knocked on his door and heard, "Knock again, woodpecker. Knock with your head." I rolled my eyes and banged my head on his door. When I stepped inside he was sitting at his desk with his feet propped on top of it, fanning himself with a postcard. It was one of those moments where, in a split second, everything becomes instantly clear.

The postcard he was waving was one I had mailed to Marilyn the day before. I had written to her about how much I hated Corporal Little, calling him a little runt. Corporal Little glared at me and said, "We're not afraid of you around here, Caulfield." In a flash he was on his feet and in my face, once again dazzling me with his extensive obscene vocabulary. He walked in an ever-tightening circle around me for ten minutes or so, yelling nonstop. After taking a breath he tore the postcard into pieces and threw them in my face. "You can go now, private," he said. As I'd stood there stone-faced before his barrage of insults, all I could think about was that I was probably going to be court-martialed, or something equally dishonorable. I saluted him and flew out the door. Back in my bunk, while I breathed a sigh of relief, I still worried about whether what I'd written about him would single me out for future abuse.

Our squad commander was a six-foot-two, two-hundred-and-thirty-pound brawler from Georgia. He carried himself like a real tough guy. One night after lights-out, he locked the barracks door and grabbed a young, dorky black kid who was barely eighteen years old.

"You feel like dancing tonight, Sambo?" he shouted as he hauled the kid across the barracks.

A lot of the other marines sat up in their bunks and laughed, but I didn't think it was funny. The black kid was barely one hundred and fifty pounds. He had a ready smile and wasn't very bright—what was deemed "slow" back then—but he put his heart and soul into every task he performed. Slapping him around a bit, the callous squad commander kicked the black kid in the ass and made him climb up on a table.

"Dance, Sambo, dance!" he yelled. All the guys were laughing like hell. This sorry spectacle went on a lot longer than it should have, well beyond goofy jocularity into the realm of sadistic cruelty.

When the floor show was over, I approached the squad commander and asked him to step outside because I wanted to talk to him. He followed me out the door, muttering, "What the hell you got to say to me, Yankee?"

I told him what he'd done wasn't right. That he shouldn't pick on somebody who wasn't as sharp as a regular man, somebody he outweighed by almost a hundred pounds. "So what are you going to do about it?" he barked. Though he outweighed me by fifty pounds, I showed him what I was going to do. I beat the living shit out of him.

The next day, after hours spent drilling under the relentless sun, I was told to report to Corporal Little's quarters once again. Here it comes, I thought. Word had spread all over the camp about the fight between the squad commander and me. I knocked on the corporal's door, prepared for the worst. Corporal Little called out, "Knock with your head, woodpecker!" I knocked with my head and stepped inside.

Corporal Little got right to the point. He told me that he had heard all about what had happened the night before, including how the squad commander had tormented the black kid. He stared at me and paused for a long, awkward moment. "Caulfield, I'll tell you what. You're going to be the new squad leader." To say I left his quarters dumbstruck is more than an understatement.

So I went from the back of the line to the front, now carrying our squadron's flag. The chastened squad commander went not at all happily to the end of the line. My platoon went on to become an honor platoon, a remarkable achievement to me considering the way we'd started out, with half the men not knowing their left foot from their right.

By the time boot camp was over, my hatred for Corporal Little had turned into a sort of grudging admiration. He was standing there watching the men board the bus, and I thought about going over and thanking him for all he'd taught me. Another recruit beat me to it, and Corporal Little hauled off and booted him in the ass. So much for sentimental farewells. I had a ten-day pass before reporting for duty and was going home to see Marilyn.

The train ride back home seemed even longer than the ride down. The gray, dreary skies so common during New England falls and winters seemed refreshing after all that time in the South Carolina sauna.

My ten-day pass flew by like ten minutes. I crammed as much visiting with friends and family as I could into the time I didn't spend with Marilyn. My dog Skippy was at my side constantly, probably fearing I'd soon disappear again. I'd bought Marilyn a gold Bulova watch at the PX. It cost over one hundred dollars, a fortune to me at the time, but I wanted to give her a nice early Christmas present.

Marilyn was now in her junior year of high school. In the time we

spent together during my pass, I couldn't help noticing that she was just a slight bit distant. The big reunion I'd anticipated for months was a letdown.

I had walked through her parents' door with my heart pounding through my chest. Marilyn came into the living room, smiled sweetly, and said, "Hello, Bob." I had entertained all kinds of romantic notions of that moment for the past three months, picturing her running into my arms as I swept her up and kissed her with all the burning passion in my soul. Instead, I got, "Hello, Bob." On the surface everything seemed fine, but I sensed that maybe her feelings had changed. Nothing had changed for me: I was determined to one day make her my wife.

After another parting at the train station I was off to my first tour of duty in Norfolk, Virginia. I arrived there a few days after Thanksgiving 1950. My first assignment was a four-month stint doing guard duty at Gate Three at the Norfolk Naval Air Station, known as NAS. I thought I'd be shipped right over to Korea, but the Marine Corps had other plans for me.

The southern weather was a surprise. The warm, sunny winter I'd anticipated in Virginia was chilly and damp. It got very cold standing at that guard station, and it even snowed a few times. On occasion I'd pull duty in the color guard and greet dignitaries at the main gate. I spent my twentieth birthday that December reading the birthday letter Marilyn had sent me over and over again.

One night around 2:00 A.M., a car came careening toward the chain-link fence that comprised the gate and crashed right through it before striking a light pole. I drew my .45, cocked it, left it on the podium, and ran over to the wreck. The other guard on duty was a young man from Philadelphia. He stood there, deer-in-the-headlights–style, and didn't do a thing. Two drunken civilians climbed out of the car, swearing and cursing. They yelled at me and started swinging their fists. I tackled one of the guys and we landed hard on the frozen ground. Screaming in pain, the civilian was finally carried off by some MPs. In mess hall the next morning I took a lot of ribbing along the lines of, "Don't mess with Caulfield." I'd broken the civilian's leg.

A week later I was called into the major's office and informed that the civilian was going to sue the U.S. government for twenty-five hundred dollars. I felt pretty bad when the major told me the man I'd tackled was an ex-marine who had fought in World War II. He told me not to worry about it and commended me for reacting the way I did.

A massive, black Cadillac with two tiny American flags fluttering on

the hood pulled up at the gate one afternoon. When I asked the driver for identification, he nodded toward the backseat where a middle-aged man sat, clad in a medal-covered uniform. The driver explained that the man was the commander of the naval air station and didn't need any identification. He seemed agitated that I didn't know this. I wasn't being a hard-ass; my orders were that nobody came onto the base without proper identification or authorization, no matter *who* they were. I heard a car door slam and the medal-covered commander walked toward me.

"Follow me," he said. He led me into the guard shack and pointed to a two-by-three-foot framed photograph of himself on the wall. "That's my identification, young man." I stiffened and saluted him with a "Yes sir, Admiral."

While I was freezing my ass off on guard duty in Virginia, I'd get the occasional letter from my buddy George Carrette, who was stationed on the USS *Epperson* out of Honolulu. His letters always went on about Hawaii being an absolute paradise, and I hoped maybe someday I'd get to see those islands too. I still wrote Marilyn every day, though her letters to me had dwindled to one or two a week. I had grown close to Marilyn's mother, and it seemed I was hearing from her more than I did from my girl.

When issued a three-day pass, I wasn't supposed to go beyond Washington, D.C. Once a month I'd take a train to Philadelphia and hitch the rest of the way to Lynn to grab some time with Marilyn. This jaunt was about fourteen hundred miles, round trip. Marilyn's parents were always wonderful to me, especially when I'd show up at their place around midnight after twelve hours of hitchhiking, so that I could see Marilyn the moment I arrived. These quick visits were crammed with going to movies, taking Marilyn out to eat, and just spending every second we could with one another.

I tried out for the marines' baseball team in March of 1951. Skilled athletes were treated differently than regular recruits in the armed forces. Before I knew it I was traveling all over the southern states playing center field. I batted .363 and my teammates never stopped cajoling me into trying out for the major leagues. I'd smile and think about my failed attempt at doing just that at Fenway Park.

My stint at Norfolk Air Station was completed with thirty days on mess duty. It really wasn't that grueling because I only had to help prepare food for about a hundred marines stationed in our barracks, not the thousands of enlisted navy men. Plus, I could eat anything I wanted to.

There was a definite line between the northern Yanks and the southern Rebels. The Rebels hated the Yanks and vice versa. It seemed every guy I ran into who'd been born below the Mason-Dixon Line was still holding a grudge about losing the Civil War almost a century before. These men couldn't stop talking about losing the family plantation and how the glorious South would one day rise again. Weren't we all Americans? But then, I had been raised among the ancestors of the winning side of that terrible war, and never had to deal with the cultural history of loss and humiliation experienced by southerners. All the Civil War talk sparked a genuine interest in that period for me. I read as much as I could on the subject. During my travels with the baseball team I made time to visit the battlefields at Antietam, Bull Run, and Gettysburg.

During basic training I hadn't had any time to sketch or draw. The stringent regimentation imposed on us at Parris Island hadn't left any free time. Now that I had a little more freedom and was seeing a variety of new landscapes, I found my drive to draw and paint returning with a vengeance.

My hitchhiking trips to Lynn ended abruptly one weekend when I missed a ride and didn't make it to Monday-morning reveille. I reported to the major on base. I was honest about where I'd gone, and he asked me what in the world I was thinking, going to Massachusetts on a seventy-two-hour pass from Norfolk. I told him I was in love with a girl back home and didn't want to lose her. He let me off with a warning, but that marked the end of any more trips home in a three-day time frame.

In early May of 1951, I tore open a letter from Marilyn. When I read its contents, my world crashed. Though it began, "Dear Bob," it was a classic "Dear John" letter. Marilyn wrote to say that if I'd been at home it would be different between us, but she'd be turning seventeen in June, and with only one year of high school left, she wanted to enjoy it and have fun. Marilyn's letter broke my heart. Had that endless river of love letters been all about nothing? I couldn't believe that this girl I thought I'd spend my life with had dumped me.

After a week or two of feeling sorry for myself, I tried to see things from her perspective. For the eight months I had been in the service, she had sat at home while her friends all went out with their boyfriends. Mal's older sister Dotty was dating a boy named Don Hunt, and she'd watch them go out on Friday and Saturday nights while she sat at home with her parents and watched TV. Although it was difficult for me, I'd encouraged Mal to see other boys while I was away so that she wouldn't be lonesome. She turned down one boy after another

and remained faithful to me for all those months. Her high school years were supposed to be the happiest of her life. All I could offer was a phone call here and there and a letter every day.

In her letter, Marilyn told me she wanted to see me once more in person so that she could explain things more clearly. She also said that once I got out of the service, we could start seeing each other again; but my hitch wasn't up for another year. Hurt and angry, I kept telling myself I'd never talk to her again as long as I lived.

A black mood enveloped me. I became surly. I hated the world. I rationalized the breakup with the fact that Marilyn was so young. Maybe I had been foolish for thinking she could be as serious about me as I was about her. I loved that girl heart and soul, and thought she felt the same about me. In a letter I wrote to her mother, I poured my heart out and told Ivadelle that she and Leon were the sort of parents I'd always wanted.

As the one-year anniversary of my enlistment in the marines came around, I was informed that I'd be shipping out to California. My number had finally come up: I'd be heading to Camp Pendleton for combat training. Before I left Norfolk, my old buddy Don Savio showed up for a visit. After he'd finished at Parris Island he was undergoing training for amphibious landings at nearby Little Creek.

We went out on the town and had a blast. We compared our experiences in boot camp and reminisced about old times. I also filled him in on the state of things between Marilyn and me. Don encouraged me to go out and find a new girl. What I didn't tell Don was that although Marilyn and I were no longer a couple, I still loved her with all my heart—and knew I always would.

A different kind of canvas.
Marines, 1951.

Playing football while in the Marine Reserves.
California, 1951.

Lust for Life

I spent the summer of 1951 traveling all over the southern states playing baseball for the Marine Corps. Fair or not, athletes were more pampered than the average enlisted man. I was also promoted to corporal, which is only one rank above private first class, but then again, just below sergeant.

The Korean War did not bring forth the sort of media coverage that World War II had drawn before it, and that the Vietnam War would attract in the 1960s and 1970s. Most Americans had been involved in World War II either through direct action in fighting the war, efforts on the home front, or through rationing and recycling. By contrast, the Korean War seemed to be something most Americans didn't want to know about. Whether this was due to fears induced by the Cold War (the Korean Conflict "was where the Cold War had gone hot"), or a lack of understanding about what we were fighting for in such a far-off land, most Americans were emotionally removed from the reason so many men were dying so many thousands of miles away.

On occasion I'd hear about the staggering casualties the Koreans and the Chinese were suffering. These losses exceeded more than half a million each. For the most part, we didn't hear much about Korea at all. My focus was on playing ball, and preparing for my move to Camp Pendleton for combat training.

The flight west was certainly memorable. Somewhere over Arizona, our pilot's voice crackled over the loudspeaker, announcing that there was trouble with the landing equipment. We were going to have to make an emergency landing in Phoenix. As our plane approached the runway, I noticed fire trucks and ambulances were standing at the ready. The disastrous landing I'd anticipated was rough and bumpy, but we made it. We rented a fleet of cars and headed into town for the day while the airplane was repaired. It was exciting to see this part of the country. I can still picture the purple shades of the desert mountains surrounding the city when the sun went down.

After landing in Los Angeles, we made the final leg of the trip south to Camp Pendleton by bus. Los Angeles was a nondescript sprawl of buildings and houses wedged between mountain ranges and didn't look anything like I'd imagined. It was all oil derricks, bumper-to-bumper traffic, and smog. The air smelled funny and had a strange, almost burned quality. The ride south along Pacific Coast Highway was dazzling, with the shimmering blue Pacific, spectacular beaches, and endless rolling foothills as far as you could see.

Camp Pendleton lies about thirty-eight miles north of San Diego, and covers two hundred square miles of terrain that includes everything from beaches to mountains. With its tightly spaced towns and hills, Massachusetts doesn't convey a sense of endless expanse the way that California does. But all the glamorous sights and nonstop sunshine were lost on me and my broken heart. No matter how much I tried to push Marilyn from my mind, her beautiful image kept pushing back.

After entering Camp Pendleton our bus headed down a long dirt road toward the tent camp that was to be our new base. Row upon row of square, khaki-colored tents sat there in the heat and dust, each one designed to hold about ten men. Every tent rose to a peak, which was crowned with a white cone. During the day the canvas walls of the tents were rolled up to let air in and cool them off.

After a day of getting acclimated to our new surroundings, we went through an infiltration course. That was kind of fun—scaling walls, climbing ropes—and then there were maneuvers. If I had to define my experience in Southern California, the word maneuvers would do perfectly. These consisted mostly of marching. Marching in the morning. Marching in the afternoon. Up and down one hillside after another. We trained constantly, except when I began playing football as summer turned to fall. The football games were more informal than my baseball playing had been for the marines. We had a great time scrimmaging with other teams on the base, or in pickup games against the navy or army. I had been surprised by how cold it could get in southern states like Virginia. California was similar in that no matter how hot it was during the day, the nights were always cool, and sometimes the thermometer fell close to freezing.

I picked up a pipe and smoked it occasionally. I wanted to avoid getting caught up in the cigarette habit that so many others in my platoon had developed. One of the guys who roomed in my tent came back from a trip to San Diego with a puppy that quickly became the focus of

everyone's attention, as well as our tent mascot. He was named Raider, and he accompanied us everywhere.

Whenever I'd get a weekend pass I'd head up to Los Angeles with a bunch of other marines. Sometimes we'd head south to San Diego. One time in LA as we were passing the famous corner where Hollywood Boulevard intersects Vine Street, we saw Percy Kilbride standing there. He'd played Pa Kettle in the *Ma and Pa Kettle* movies for years. He stood on the sidewalk greeting anybody who passed by with a country bumpkin act honed to perfection, all the while saying, "Make sure you go and see my new movie."

I was killing some time in a bookstore on Hollywood Boulevard one day when I picked up a paperback copy of Irving Stone's *Lust for Life*, his biography of Vincent van Gogh. That book had a profound effect on me. I felt I could relate to van Gogh and his overwhelming desire to paint. *Lust for Life* opened up the world of French Impressionism to me. Before long I was reading anything I could on other Impressionists, including Gaugin, Renoir, Monet, Degas, and Toulouse-Lautrec.

One of the main reasons we went to Hollywood was the fact that we could stay for free in the missions there. After waking up in the morning, my fellow marines and I would attend an obligatory mass before enjoying a free breakfast. Occasionally we'd join the studio audience of a TV show, like Red Skelton's. When Hollywood got dull, we'd hitch a ride over to the pier or the beach in Santa Monica. I'd flirt with the pretty girls who were always there in droves, but my heart wasn't in it.

I attended a Catholic church near Camp Pendleton every Sunday. I couldn't help but notice a gorgeous blonde who came every week with her parents. Week in and week out, they'd always take the pew in front of me. The blonde and I made eye contact all the time. She'd smile and I'd smile back, but we never spoke a word. It was a mixture of shyness on my part, and more than that, a lack of motivation. I was still at the bottom of the pit where Marilyn had left me.

Del Mar is a San Diego suburb known for its fine ocean vistas. I'd take the bus down there when I had time off and paint small seascapes on canvas board. I sold quite a few of them to the other marines, who would ship them to their wives or girlfriends back home. I only charged a couple bucks, but it was gratifying to sell my work, even on such a minor level. I couldn't help but reflect on the fact that van Gogh sold only one painting during his lifetime. It's one of those ironic twists of fate, considering the impact of his legacy, that the greatest Impressionist

painter of his era—and one of the greatest artists of all time—struggled with schizophrenia and went unappreciated in his short, tragic life.

I sent Gramma Caulfield some money out of my paycheck every week. One time when I totally ran out of cash and canvas board, I painted a figure of a soldier on the back of my sweatshirt. Soon, everybody in my company was asking me if I could paint something on their sweatshirts too.

My Aunt Dot was visiting in California, and she dropped down to see me. We went to the Mission at San Juan Capistrano. It was wonderful to spend time with someone from my family. Dot was anxious about what fate might await me in Korea. Even as I assured her that I'd be fine, I didn't tell her about many of the returning veterans I had met—courageous young men who had been sent home from Korea to recuperate from what were often horrific war wounds. Many of them were maimed or crippled for life. When I talked to them I tried to avoid their eyes, knowing that the pain that lurked there might be something I would face in the not too distant future.

In the fall the hot, dry Santa Ana winds blow in from the Mojave Desert. These often stoke brush fires at the height of Southern California's dry season. Our platoon was brought up into the hills to help fight the flames that year.

Winter came with barely a change in the perfect weather, and January 1952 passed into February. In mid-March we were sent to Piclo Meadows in a convoy of Greyhound buses. Piclo Meadows was a winter training camp, six hundred miles to the north. Training in the rugged, snow-covered terrain in the mountains there would prepare us for the harsh climate we would face in Korea. We were put through maneuvers again, and then more maneuvers after that, all the time wearing heavy backpacks. There were no chow tents, only rations. The monotony up in that dry, frozen landscape was mind-numbing and seemed endless, even though we were only there for a week.

I was the leader of my squadron at Piclo. In one particular assignment, we had to capture three men posing as the enemy on an adjacent ridge. As we slogged through the snow in our heavy gear, the harsh winds only intensified the cold. I was glad when it was all over.

A day or two after our return to Camp Pendleton, I was lying in my bunk one day when a sergeant passed by. He shouted into a bullhorn, calling all the men outside. Everybody filed out and stood in line. The sergeant said, "When I call these names, step forward." I heard my name and thought, *This is it—I'm off to Korea.*

The sergeant waited until all of the men whose names had been called stepped forward, and then announced that all of these men had less than six months tour of duty remaining. Only those with six months or *more* would be going overseas to Korea. The sergeant explained that those who wanted to could sign up for two to four more years; those who didn't want to re-up could finish out their remaining time at Camp Pendleton. My stint in the marines had begun when I joined the reserves in 1950, so I only had four months to go before my two years were up. I didn't think about it for more than a split second: I was going home.

On my final day in the Marines Corps I was given $375 mustering-out pay. I didn't want to spend it on a train, bus, or plane ride home. Gramma Caulfield was still using an icebox back in Lynn and I planned on buying her an electric refrigerator. A buddy of mine from Lynn named Roland Deseletes was also finishing up his time in the service, and we decided to hitchhike home together.

Dressed in our uniforms, we had no trouble catching rides back East. Driving through the deserts of California, Arizona, and New Mexico into the endless scrublands of west Texas really makes you appreciate the vastness of the United States.

Outside Baton Rouge we grabbed a lift from two dapper black gentlemen in their mid-fifties. They were heading for Nashville and could not have been more gracious. We told them stories of our experience in the marines, and they talked about how things had been back in the 1920s when they were young. When we got to Tennessee, the man who had been driving let us know this was as far as they were going and got out of the car to say good-bye. When I leaned over to pick up my duffel bag, a dagger I'd been carrying for protection fell out of my jacket and clanked onto the sidewalk. My eyes met his and he looked absolutely shocked. I felt awful and went into motormouth overdrive, explaining I'd been carrying it since California, and it was nothing personal. Even in the glorious 1950s there were all kinds of stories about killers on the road; I had taken the knife along, "just in case."

Five days after leaving California, Roland and I were dropped off in downtown Lynn. New England is bleak and frigid in February, and Lynn was all monochromatic gray after the palm trees and sunny skies of California. Despite the dreary weather, it felt great to be home. It was wonderful to see Gramma and Grampa Caulfield again. My dog Skippy went berserk when I came through the door, running ninety miles an hour all over the house in his excitement after not seeing me for almost a year. When I walked into my old bedroom I realized how

much I had grown up in my time away. It may sound corny, but I'd left home a boy and returned a man.

I applied for a job at the General Electric plant, the biggest employer in Lynn. My three uncles all worked there, and had encouraged me to put my name in. After my interview, the man who had been speaking to me offered me a job, saying I could start the following day. When I tried to explain that I'd only been out of the marines for two days and had hitchhiked all the way from California, he said, "Be here tomorrow at eight in the morning, or don't come in at all." I was there at eight sharp.

On a freezing night in late February I headed down to catch a movie with a group of my old football buddies. When the movie was over, we walked through Central Square on our way to the bus stop. As we passed the Warner Theater a block up the street from the Paramount, I spotted Marilyn standing there talking to a friend of hers. Our eyes met, but I looked away as fast as possible. I was afraid my heart was pounding so loud that people would hear it. One of my buddies knew Marilyn's friend and stopped to chat. I said hello to the friend but purposefully ignored Marilyn. Anger at her dumping me collided with elation at seeing her once again. It was a huge relief when my buddies moved on. I kept walking and didn't look back. I was still furious over the "Dear John" letter she'd sent me almost a year before.

The next night the phone rang. The soft voice on the other end of the line was very businesslike. "Hi, Bob—it's me, Marilyn." I said hello and asked what she was calling for. "I'd like you to come over to my house so you can pick up your sweater and a few other things," she said. The following night it snowed like crazy, but I headed over to Marilyn's house on Boston Street anyway. Ivadelle answered the door. Her face lit up as she greeted me warmly, and invited me inside. I made small talk with Leon while Ivadelle went upstairs to get Marilyn.

While I was sitting there talking to Leon I could barely hear a word he was saying over the sounds of my heart beating and the blood rushing through my ears. Ivadelle came back into the living room and said that Mal would be down in a minute. She and Leon went into the kitchen and closed the door to give us some privacy.

I heard Marilyn's footsteps on the stairs. When she stepped into the room, all blue eyes and that sweet smile, I could barely breathe. She was only four months shy of her eighteenth birthday. In her hands she held my maroon varsity sweater, neatly folded, upon which lay my graduation picture and the gold football pendant she'd had inscribed, *Mal and Bob, 1950*. She didn't

say a word as she handed me the sweater. I was shaking and thought my knees might buckle as I stood up and placed the sweater on a chair.

Pulling her into my arms, I drew her close and kissed her. She kissed me back. That was it. We sat down amidst a flood of words as we tried to express what we'd been feeling during the year we'd been apart. The moment I had seen her in front of the Warner Theater the night before, I knew that my heart was linked with hers forever. Now, I knew that she felt the same way.

My new job at the GE plant was nothing exciting. I started "on the broom," where all the new hires began. My eight-hour shift provided a paycheck and that's about it. The plant in Lynn manufactured a number of products, among them engines for war planes. All day long I'd sweep the floor in the armature division. An armature is the rotating part of a dynamo, which contains a lot of copper wire. There were always a million fragments to sweep up. I wasn't on the broom for more than a couple of weeks. A supervisor told me I'd be spending two weeks in training to learn how to operate a forklift.

Instead of buying Gramma a refrigerator, I had spent what was left of my mustering-out pay from the marines on some clothes, and eighty-five dollars of it on a 1941 Nash. The Nash was a big, black, old tank of a car, broken down more often than it was running. Endless repairs exhausted the rest of my savings. I felt guilty for years afterward that I hadn't bought Gramma the refrigerator she so desperately needed.

I'd been among the first in my age group to go into the service. Now that I was back home, it seemed everybody I'd gone to school with was either enlisting or getting drafted. For the time being I was back in my old room at Gramma and Grampa Caulfield's house. My brother Joe had been married for over a year and lived in East Lynn with his bride, Joan.

Things went fast with Marilyn. I spent every moment I could with her, and in a matter of weeks we began talking about getting married. In May I asked Leon if I could have Marilyn's hand in marriage. Leon said yes.

One night in Marilyn's living room, while her parents were once again relegated to the kitchen, I got down on one knee, gave Marilyn a half-carat diamond, and asked her to marry me. It was a joyful moment when she said yes. Ivadelle was almost more excited than we were. Marilyn thought the ring was too extravagant a purchase on my wages, so she traded it in for a smaller quarter-carat ring.

Leon and Ivadelle owned a summer cottage, which they called a camp, on Great East Lake in Acton, Maine. Starting in late May when

the weather was getting warmer, Marilyn and I would hop into "ye olde Nash" and drive up to the camp almost every weekend. Marilyn adored her parents, and her family was extremely close. Camp was refreshing and relaxing, with picnics every day, swimming, sunbathing, and long walks in the woods.

Leon loved playing horseshoes. He was very competitive and very good at it. At night we played board games or cards as we sat by the fireplace enjoying her parents' company. Both Leon and Ivadelle were quite social. They had a wide circle of friends around the lake and people were always dropping by to visit.

Ivadelle was the sort of woman anybody would want for a mother, and she soon became a true mother figure to me. Born into wealth, a blue-blooded Yankee descended from the Breeds of Boston, she had roots that stretched back to 1630 in Massachusetts. Her family had lost everything they owned in the Stock Market Crash of 1929. Ivadelle would often talk about how devastating the Great Depression had been. It had broken her heart to see her father—a very successful architect who later worked on the Manhattan Project during World War II—come home at night after a hard day of digging ditches, or whatever day labor he could find, to put food on the table.

Ivadelle moved with a grace honed in the ballet and dance classes of her youth. She'd had offers to dance on the professional vaudeville circuit before marrying Leon in 1930, when they were both nineteen. "That was a short circuit," as Leon liked to say.

Ivadelle hated her name. She thought it was old-fashioned. It's funny in a way, because it's such an uncommon name and it was so singularly hers. I've never known anybody else by that name, just as I've never known another human being who could come close to Ivadelle in terms of her compassion, her kindness, and her empathy for others. She was one in a billion. Quick-witted and ferociously intelligent, she was so happy she used to hum most of the time. Her presence lit up the world. Ivadelle was quite interested in my artistic aspirations and could talk quite knowledgeably about many different artists and art styles.

That June I accompanied Marilyn to her senior prom. I wore my dress blues for the occasion, and Marilyn looked gorgeous in her pink strapless gown. We formally announced our engagement later that month, only a few days after Marilyn turned eighteen. An April wedding was something that Marilyn had long dreamed of, so we had chosen the month of April 1953 to get married.

Religion was the only stumbling block to our happiness. Although her father was Catholic, Marilyn had been raised Protestant, in the Baptist faith, and Marilyn refused to convert to Catholicism. My faith was strong and I couldn't imagine any alternative to getting married in the Catholic Church. These matters seemed almost insurmountable in the 1950s, and were regarded with the utmost seriousness.

One evening in the second week of July, I took Marilyn to see a priest at Saint Joseph's church on Union Street. We stepped into the priest's office in the rectory and took seats before his shiny oak desk. He smiled and greeted us. Then he asked, "Why do you two young people want to get married?" I said, "Because we're in love and we want to spend the rest of our lives together."

"That's wonderful," he said. "It always warms my heart to see two young members of the Catholic faith united in holy matrimony."

I corrected the priest, explaining that I was Catholic but Marilyn was Protestant. His warm manner instantly evaporated. Completely avoiding eye contact with Marilyn and glaring at me, the priest said, "Robert, go home and say an act of contrition. You'll have to forget you ever met this girl." Clasping his hands together, he leaned toward me. "If you marry this girl, it would be like taking a brand-new dollar bill and sticking it into your wallet beside an old dollar bill. You don't ever want to put those two together." I was stunned, not to mention offended in the worst way. I took Marilyn's hand and we bolted out of there.

The moment we stepped out of the rectory, Marilyn burst into tears. My Nash had broken down again so we had to walk home. I hugged her and helped her collect herself. I told her, "There's no way on earth I'm going to live my life without you. We don't need the church. Why don't we just run away and get married?"

Through her sobs, Marilyn nodded and said, "Okay."

08
RUGGLES STREET

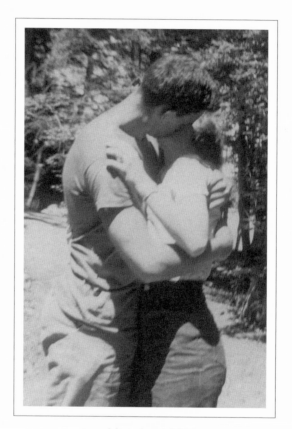
Me and my girl.
July, 1952.

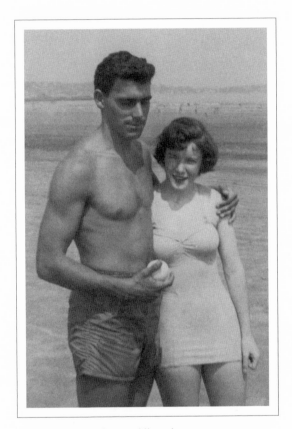

Our wedding picture.
August, 1952.

The Sweetheart of Lynn English High

On the nights that I worked second shift at the General Electric plant, I'd drive downtown to pick up Grampa Caulfield after he took the train home from his job as head chef at Durgin-Park.

One night in July, I pulled into the train station parking lot, only to find no sign of my grandfather. I parked the car and walked into the Pinecrest Bar. He was sitting at the counter, cradling a glass of beer in his hands. When he saw me he smiled and motioned for me to take the bar stool beside him. I ordered a beer and we made small talk about the Red Sox. I wanted so much to tell him how Marilyn and I were planning to elope. I wanted his approval or his advice, but I couldn't bring myself to say anything. Lifting a beer to his long, stoic face, Grampa Caulfield took a sip and gave me a wink. "Don't ever tell any of your kids when you have them, Bobby," he said, "but I started drinking beer when I was ten years old."

Every free moment I could spare was spent with Marilyn. The plans had been made and all systems were go for getting married on July twenty-fifth. We had worked out a code so that if we were in proximity to any family members who might overhear us plotting, they wouldn't catch on to what we were up to, and so far, nobody had.

The air hung humid and heavy one night, about a week before our elopement date. With one hand on the wheel of my bucket-of-bolts Nash and the other holding Marilyn's, we drove to Wyoma Square in East Lynn. Sleek streams of rain fell as I knocked on my brother's door. His wife Joan greeted us with her radiant smile and ushered us inside their tiny apartment. Formerly Joan Messina, my brother's wife came from a boisterous Italian-American family. Joan had a vibrant personality and seemed like a good match for my somewhat quiet and withdrawn older brother. We had some of the coffee and cookies that Joan set out for us, and then I took a deep breath. "Marilyn and I are going to run away to get married. We wanted to ask you both if you'd stand up for us and be our witnesses."

An almost perceptible shock wave passed through the room. I knew what their answer would be long before Joe and Joan began talking. Joe stammered a bit and a look of confusion muddled Joan's features. What they were trying to say all boiled down to "no." They both feared the wrath of my family would come down on them if they supported a mixed marriage of Catholic and Protestant. They also feared excommunication by the Catholic Church.

Tears stained Marilyn's cheeks the moment we left Joe and Joan's doorstep. I tried my best to console her by saying there *had* to be someone who would stand up for us. My brother and his wife had been my first choice, that's all. If they didn't want to support our marriage, it was their loss. Marilyn didn't want to ask her sister Dotty because they were living in the same house, and she was afraid her parents might suspect something. As he had done so many times before in my life, my good friend Don Savio came through for me. "Of course I'll stand up for you and Mal," he said. "When's the big day?"

Marilyn's plan revolved around the fact that her parents would be away at their camp on Great East Lake during the weekend of July 25. Marilyn usually went with them every weekend, but would claim she wasn't feeling well and back out of going this time. A good high school friend of Marilyn's named Carole Gregory agreed to be Marilyn's maid of honor. The coastal town of Seabrook, New Hampshire, a forty-five-minute drive north of Lynn, had been chosen as the wedding location. Marilyn knew of some other couples who had run off to a justice of the peace up there. Another benefit to getting married in New Hampshire was that a wedding notice wouldn't appear in the local papers.

Finally, Friday, July 25, 1952, arrived. Every second at work seemed like an hour that day due to my excitement over what we would be up to that night. I'd hidden a suit in the trunk of my Aunt Dot's big, black Oldsmobile the night before. Aunt Dot was on a trip out west, but before she left she'd agreed to let me use her car to go to Leon and Ivadelle's camp.

I said good-bye to Gramma and Grampa Caulfield, and Gramma handed me a plate of cupcakes to give to Ivadelle. I changed into my suit at Don Savio's place, and then we picked up Marilyn at her friend Carole's house. The secrecy surrounding the whole operation made us all somewhat paranoid. As we drove through Lynn, Marilyn would call out every fifty feet that she thought someone driving by in the opposite direction had seen us and would tell her parents we were running away. A fog of nervous tension clung to the entire ride.

On the highway we rolled the windows down to catch the breeze. Don did his best to keep the mood light, cracking one joke after another from the backseat. The night was clear, the traffic was light, and I remember glancing time and time again at Marilyn on the front seat beside me. Without a drop of makeup on, her fresh, vivid beauty was dazzling. The pale green and navy blue lace dress she'd chosen to get married in made her eyes seem even bluer. Marilyn was simply the most beautiful girl I'd ever seen. She was now just six weeks past her eighteenth birthday.

The reason August 1 is our wedding anniversary, and not July 25, is because when we arrived in Seabrook, the justice of the peace informed us that we needed a marriage license, as well as proof of blood tests, before he could perform the ceremony. It was a long ride home. Marilyn was disappointed in the extreme, and went on about how she should have known we needed a license and blood tests. I had thought that if you wanted to get married, you just went and did it. What did we know?

On Monday we went to Lynn City Hall and got our marriage license. We didn't run into anybody we knew, which wasn't the case when I stopped by my doctor's office to get a blood test. On the way out of the doctor's office I ran into Tom Hynes, a Lynn police officer whose brother was a good friend of mine. I almost dropped dead when he started asking questions. "What are you doing at the doctor's, Bob? Everything's okay with your health, I hope." My nerves were pretty frazzled. After coming up with an excuse, I left as quickly as I could.

Friday, August 1, was an exact replay of the previous Friday, only this time the mood on the ride up to Seabrook was a lot lighter. Marilyn came up with another excuse for not going to camp with her parents that weekend. She was effervescent and seemed almost giddy. Once again Don Savio did his best to keep us all laughing. We pulled into the justice of the peace's driveway shortly after 8:45 P.M.

The JP was an older gentleman with kind eyes. He smiled when we walked in and said, "Back so soon?" We all laughed. I handed his wife the marriage license and the blood test results. She looked them over and then sat at the organ and ran her fingers over the keys to warm up. I could barely breathe when she began playing the first few chords of "The Wedding March."

Before I knew it, Marilyn was standing beside me facing the justice of the peace. Clutching a white lace handkerchief, she kept giggling like a twelve-year-old. I wondered for a moment if my young bride really knew what we were getting into. There had been many heartfelt

conversations between us on our journey toward matrimony. I had told Marilyn flat out that if we married, it was going to be for life. Putting our future children through the experience of divorce and a broken home was something I wouldn't consider. I had known the worst pain that a child can possibly know—the empty feeling of not being wanted by one's parents. All children need the love of their parents, and I'd had to face the fact at a very young age that my parents sure hadn't needed me.

The justice of the peace said, "Do you, Robert, take Marilyn to be your lawfully wedded wife?" A clock on the wall read 9:05. Marilyn was still giggling when it came time to say her vows. She made it through, and the JP smiled broadly, saying, "You may now kiss the bride." Hugging Marilyn close, I kissed her soft lips. Here in my arms I held not only the most beautiful girl I'd ever seen, but also the sweetest and most sincere. Don Savio broke the silence with a hearty, "Congratulations, you two!"

We went out for a celebratory dinner nearby. The ride back to Massachusetts was a blur. Even though we were married now, we still wanted to keep it a secret for a while.

After dropping Don and Carole off in Lynn, I drove into Boston with Marilyn. We went to the Statler Hilton with our marriage license in hand and asked for a room. The most inexpensive room available cost twelve dollars, which seemed a bit steep. Next stop was the Lenox Hotel on Boylston Street; they wanted ten dollars for the night. Somehow we ended up on Tremont Street where we found a room at the Hotel Touraine for nine dollars.

Carrying Marilyn in my arms, I stepped over the threshold into the sweltering room. Marilyn switched the radio on, and "The Love Theme from *High Noon*," a number-one hit that summer, began playing. I turned the radio off and gave her a kiss. Not wanting to be seen carrying a suitcase, Marilyn had packed a few things into a brown paper bag. She went into the bathroom to change. I opened the window, hoping to get some fresh air inside our sweatbox of a room. In two seconds flat, I switched the lights off and was out of my clothes and under the sheets.

I had dreamed of this moment for so long that when Marilyn stepped out of the bathroom wearing a nightgown you might see on your grandmother, the look on my face must have made clear my disappointment. "What's wrong?" she said. Marilyn climbed into bed beside me and gasped when she saw I didn't have a stitch on. "Bob, why aren't you wearing anything?" In her innocence, Marilyn had thought that couples had sex only when they wanted to have a baby, and only one time for that. She thought sleeping together on your wedding night meant literally going to sleep in the same bed—period. I gave my naive young bride a crash course in conjugal relations.

A loud banging on the door woke us up around 4:00 A.M. I fell out of bed in a panic, yelling to Marilyn that her father had found out we'd consummated the marriage and had come to kill me. That fear faded when I opened the door and realized it was just some confused drunk who couldn't find his room.

When Marilyn and I checked out the next morning, I found a parking ticket on the windshield of my Aunt Dot's Oldsmobile. How was I going to explain being in Boston to her when I was supposed to be in Maine? I tucked it into my jacket and we drove back to Lynn. On the ride home Marilyn and I once again made a pact agreeing we would tell no one we had gotten married until the time was right. After a sweet kiss good-bye, I watched Marilyn head toward her front door carrying her little brown paper bag suitcase.

The Sunday after we got married we went to Fisherman's Beach with Don Savio and his girlfriend, Dot Emery. It was here that Don took what amounts to our wedding picture: a Kodak Brownie snapshot of Marilyn and me in our bathing suits at the water's edge. After a long day of sun and surf, we all climbed into the Nash to head home.

"Anyone up for an ice cream?" I said. There was a huge crowd of people at Doane's, and I couldn't find a place to park. I double-parked across the street and left Marilyn and Dot to watch the car while Don and I went to get the ice cream. As I was heading back to the car carrying our cones, I spotted a policeman talking to Marilyn. Getting closer I saw that Marilyn was laughing hysterically. The cop had asked her to move the car, and when she had shifted it into gear and turned the wheel, it had broken off the steering column, right in her hands. Dot was still in the backseat, and she was laughing even harder than Marilyn was.

My car's disintegration wasn't funny to me. I yelled, "What did you do that for?" and within seconds Marilyn and I were having our first fight. I told the cop I'd have the car towed and then continued arguing with Marilyn. She got out of the car and stormed off, sobbing, "I'll walk home." I watched her go and figured, that was it. I'd lost my wife of two whole days. We made up later in the week. Not long after that I bought a blue 1948 Ford on credit.

When you're trying to keep a secret as big as the one Marilyn and I had, you begin to worry that everybody suspects something. I went back to work on Monday like it was any other day. Marilyn had taken a job assembling electrical components in a factory in Danvers called CBS-Hytron. Our lives fell into a routine of seeing each other a couple nights a week, usually on the weekends. Sometimes it was just the

two of us, but more often than not we went out with a bunch of friends for a night at the movies.

Word about our marriage spread around our crowd pretty fast, but we kept it a secret from everyone else for almost two months. I know keeping our marriage a secret from her parents weighed on Marilyn. The fact we weren't living together as man and wife was eating me up as well. Our love was pure and true, but layered on top of it were the infinite complications of the societal pressures separating Catholic and Protestant. All of these outside forces were pulling at us. Half the time I just wanted to hop in the car with a couple of suitcases and take off for California or someplace where it would be just the two of us. We could start a life together without interference from anybody—but Marilyn wouldn't hear of moving that far away from her mother and father.

September came and I noticed that my pretty, young bride—the girl who had been voted "The Sweetheart of Lynn English High School" because of her sunny personality—was growing morose and depressed. Our secret was having the same effect on me. I came home from work one day to find Aunt Dot waving the parking ticket I'd gotten in Boston.

"What were you doing in Boston at three in the morning, Bob?" she said. "I thought you were going to take my car to Maine?" Aunt Dot was and still is an extremely shrewd woman. I'm sure she saw through whatever excuse I came up with, but she let it go.

Lying in bed that night, all I could think about was how ridiculous the situation with Marilyn had become. Here I was, married to the girl of my dreams, spending nights alone in my tiny twin bed in Gramma and Grampa Caulfield's house. Wide awake at 2:00 A.M., I noticed the beam from Gramma's flashlight bouncing down the hall as she made her middle-of-the-night rounds. Gramma Caulfield stepped into my room and shone the light on my face. I blinked and turned away.

"What are you doing awake, Bobby? Is anything wrong?" she said. I told her I was fine and she went on her way.

The next night I went for a long walk down by the beach. When I came home, Gramma and Grampa Caulfield were getting ready for bed. Their nightly ritual consisted of sitting on the edge of their bed while Gramma poured two shots of whiskey, which they'd knock back right before lights-out. I stepped into their room and said I had something I needed to tell them. They listened to me describe how Marilyn and I had run off and gotten married almost two months before. Grampa calmly asked me if we'd *had* to get married. I assured him that wasn't the case, that Marilyn had been a virgin on our wedding night. Grampa told me

that my father had to marry my mother because she had been pregnant with Joe, which I hadn't known until then. Gramma asked me if we loved each other. I told her I loved Marilyn more than anything in the world, and emphasized that it didn't matter to me that my wife was Protestant. "People in love should be together, not apart," Gramma said.

I told Marilyn about my conversation with my grandparents, and she said she'd tell her parents that night after dinner. When it came time to say something, she just couldn't do it.

With an intuition and a sensitivity that were a match for her remarkable intelligence, Ivadelle had known something had been eating at her daughter for weeks, even though Marilyn denied anything was wrong whenever she'd been asked. Not wanting to intrude, Ivadelle's opportunity to broach the subject came that night when she overheard Marilyn on the phone, calling about apartments listed in the paper. Ivadelle asked Marilyn if she were looking for an apartment because she had married me. When Marilyn sobbed and said yes, Ivadelle said she had suspected something was up back in July and August because Marilyn had been acting so strangely. They told Leon, and he was quite upset about what we'd done.

Ivadelle told Marilyn to call me. When I answered the phone, Marilyn said, "Bob, I told my parents that we're married. My mother says that a husband belongs with his wife. She and my father want you to come over."

I left Gramma and Grampa Caulfield's house that night. Marilyn's sister Dotty got a quick eviction from the apartment she had been sharing with Marilyn in Leon and Ivadelle's three-family, and moved back in with her parents. Marilyn and I began our lives together as man and wife in that third-floor apartment with her parents as our landlords. Our rent was twelve dollars a week.

On that first night together as Marilyn and I lay in bed, Marilyn told me something her mother had told her earlier that night after she found out we were married. Ivadelle's parents had also eloped to Seabrook, New Hampshire, over thirty years before. Oddly enough, the date they had chosen was August 1. Many years later I would discover that my parents had also gotten married by a justice of the peace in New Hampshire.

09
RUGGLES STREET

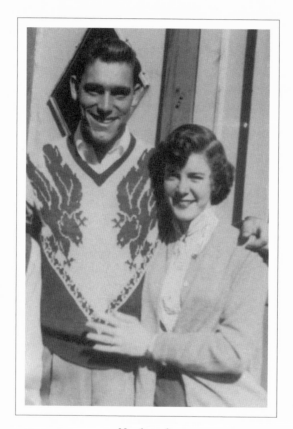

Newlyweds.
Autumn, 1952.

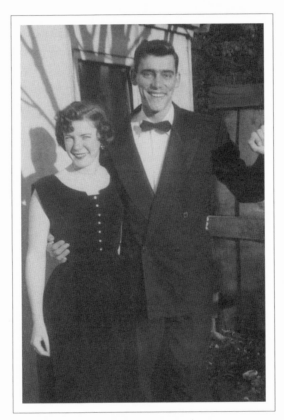

With Marilyn at a friend's wedding.
October, 1952.

Boston Street

Gramma and Grampa Caulfield never once said a word against our marriage, although there were a few relatives who would dial LY2–1523 and spew their bitter opinions on what a mortal sin I'd committed in marrying my Protestant wife. I was instantly excommunicated by the Church. There was no formal announcement or ceremony, only a complete revocation of my Catholicism. According to church doctrine at the time, if I didn't annul my outlaw marriage at once, I would face eternal damnation. One of Gramma Caulfield's sisters told me I was going straight to hell.

One late Saturday afternoon when Marilyn went to visit her girlfriends, I went to confession. The sliding door in the confessional booth cracked open with an angry snap. I glanced at the silhouette of a priest through the latticework and said, "Dear Father, please forgive me, for I have sinned. It has been nine weeks since my last confession. These are my sins. Father, I eloped. I ran away with a Protestant girl."

"*Protestant?*" The priest spat the word out like rotten food. He told me to go home immediately and say an act of contrition.

I left the cold stone walls of the church in a blazing fury. Those people had no idea how much I loved my wife. Church or no church, I was determined to spend the rest of my life with Marilyn. My excommunication meant I couldn't attend mass or receive the sacraments, including communion. To hell with their bureaucracy. I still went to church every Sunday and I still received communion.

The threats to my immortal soul didn't bother me very much. In the eyes of my family, my moral well-being was not going to be served in the long term by a marriage that would dilute the family's tradition of rigid adherence to the Catholic faith. My faith never wavered, because I knew God must have understood that our love for each other was truer than anything else we knew. Marilyn had a bit of a stubborn streak, but her opposition went deeper than that. Marilyn had been raised a Baptist, the faith of her mother, grandmother, and untold ancestors in her maternal

line stretching back generations. She was absolutely opposed to Catholic conversion. I didn't try to persuade her to change her mind; it was her decision to make.

Aside from those nasty phone calls and a few embarrassing confrontations when I ran into some vocal members of my extended family downtown, the first few months setting up house with Marilyn in that third-floor apartment at 11 Boston Street were the happiest we'd ever known. From the vantage point of an unwanted kid from the streets of Roxbury, this family life looked pretty good to me.

Marilyn's one dream in life was to be a wife and a mother. She decorated our apartment and hung some of my original oil paintings above our bought-on-credit, ever-growing furniture collection. We bought our first television, which was quite a big event in 1952 when not too many people could afford to own one. Her girlfriends threw a belated bridal shower for her and soon the apartment was crammed with all kinds of appliances and gifts. Ivadelle and Leon were beyond generous to us, and somehow managed to find a balance between giving us both advice, and as much privacy as possible. Leon and Ivadelle never came to our door unannounced.

My father showed up at our apartment one night with Frances, the henpecking girlfriend who had made my adolescent visits with him even more miserable. She was now his wife and my stepmother. Despite all the negativity we'd been confronted with from my side of the family, he and his wife were all for our marriage. He was his usual gregarious self, even more so than usual. I noticed the buttons on his double-breasted suit were close to popping from the force of the expanding belly beneath. He had gained at least thirty pounds since I had last seen him.

Before he left that night, he gave Marilyn fifty dollars as a wedding gift, promising that there would be another fifty forthcoming in a week or two. I can't begin to express just how much money a hundred dollars was to a couple of newlyweds from our backgrounds in 1952. I was taking home fifty dollars for a forty-hour week at GE. Marilyn's job at CBS-Hytron contributed twenty-six dollars to our weekly take-home pay. Like all newlyweds, we were investing in furniture, pots and pans, and all the things that go into making a home. Marilyn was very happy with my father's gift.

"Maybe your father's nicer than I thought after all," she said. I looked at Marilyn and said, "Are you out of your mind?"

We were doing our best to economize, yet there never seemed to be an extra cent between us. As the weeks passed and the other fifty dollars my father had promised never materialized, I told Marilyn it never would, and not to expect too much from my father—I sure as hell never had.

We never did see the other fifty.

All newlyweds have their moments of exultation followed by arguments over insignificant matters. We were no different. One night we ended up in a silly bickering match over nothing. Marilyn slapped me across the face. Reflexively, I slapped her right back, my hand barely glancing her cheek. The tears flowed and she ran downstairs to seek solace in her parents' apartment. Ivadelle told her hitting anyone for any reason was wrong, that she should never have slapped me in the first place, and that Marilyn deserved what she had gotten. Ivadelle also told her to go back upstairs to her husband. In over fifty years of marriage, that was the first and last time either Marilyn or I ever physically struck one another.

The old Nash had been gathering rust in the backyard ever since I'd bought my Ford. The day it went off to the junkyard, I still felt a pang of remorse that I hadn't bought Gramma a refrigerator instead of that car. Even though my Aunt Dot bought Gramma her first Frigidaire soon after that, my guilt about not buying Gramma Caulfield a new refrigerator persisted for years.

Winter came. In late February I arrived home from work to find Marilyn had prepared a wonderful roast beef dinner. She lit some candles and smiled. "Bob, what would you think about me quitting my job?" I told her if that's what she wanted to do, it would be fine with me. I could take some overtime or even get a second job if she wanted to stay at home.

"But what are you going to do all day?" I asked.

Marilyn giggled. "Knit baby clothes."

My head was spinning. I grabbed her and kissed her. "We're going to have a baby? When?" Marilyn smiled and said, "The doctor said it will be due sometime in September." I had turned twenty-two a few months before. Marilyn was going to be a mother at age nineteen.

The Korean War ended on July 27, 1953. By war's end, 33,629 American troops were dead, 103,284 were wounded, and 5,178 had been declared missing in action. From time to time in the year and a half I'd been out of the service, men would return from the war and begin a job at GE. Nothing was ever mentioned about what these men had experienced while fighting overseas. Now that they were back home on U.S. soil, it seemed as if they were expected to fall back into the American way of life again, the experience of war something to forget and bury in the past.

As her pregnancy progressed, Marilyn's waist expanded from its original seventeen inches to accommodate the twenty-five pounds she would gain carrying the baby. When the first labor pains came on, I was

a nervous wreck. My hands were shaking so badly, I didn't think I could drive Marilyn to Lynn Hospital, which was about a hundred feet from our front door. Running downstairs, I grabbed Leon, and after he heard the news he grew even more nervous than I was. He bolted down the stairs two at a time to get the car.

Marilyn's labor pains grew stronger. Five minutes ticked away. There was still no sign of Leon with the car when I looked out the window. Urging Marilyn to lie down, I flew downstairs and around the back of the house toward the garage.

Most cars in the 1950s had big, protruding chrome bumpers, and Leon's car was no exception. When he was backing out of the garage, he had locked bumpers with the first-floor tenant's car and was now straddling both cars, jumping up and down in an effort to separate them. I climbed up to help him; we soon freed the cars and were off to the hospital with Marilyn.

During the 1950s, hospital procedures for women giving birth seemed to deny everything human and natural about the process. Most women at that time were given anesthesia and delivered their baby while unconscious in sparkling clean and antiseptic surroundings. Breast-feeding was discouraged in favor of bottle feeding.

Marilyn's experience was no different. I thought her labor would go on for an hour or two, and then she'd deliver our baby. Poor Marilyn was in labor for almost twenty-eight hours. There were numerous times the doctors approached us while I sat in a chair holding Marilyn's hand as she lay in a hospital bed beside me. One doctor after another would recommend a cesarean section, emphasizing that Marilyn's hips were too small for her to give birth naturally.

Marilyn cried and cried; she knew that having a cesarean meant a woman could only have two more children safely. Marilyn wanted six children. She wouldn't hear of anything but a normal birth, no matter what she had to go through. In many ways Marilyn defines the word determination. Once her mind is set on something, there is absolutely no way anybody can sway her. There were visits from her mother and sisters, and I'd go for walks in the corridor while they all commiserated. Around the twenty-seventh hour of Marilyn's labor, I went home to get something to eat and fell asleep watching television. The phone rang an hour later, waking me up with the news from a doctor's lips that Marilyn had delivered a healthy, six-pound, four-ounce baby boy.

My first glimpse of my son was an event familiar to many men of my generation. The new father stood before a window of half-inch-thick glass fronting the rows of cribs in the nursery. I did the same while a

nurse ever-so-gently picked up my newborn son and tilted him toward me. It was truly one of the most powerful moments of my life. That little pink face with eyes swollen shut, all wrapped up in a blue blanket, was *my son*. I was filled with such a sense of pride and wonder and love that I felt I might shoot right through the ceiling just on the force of my elation. Though I was usually reserved and on the shy side, I grabbed anybody who came near me and chattered on and on about how I'd just had a son. I even passed out cigars.

Later, in Marilyn's room, we held the baby together for the first time and agreed upon his name: Robert Leon Caulfield. Neither one of us wanted to burden him with being a junior, so we settled on naming him after me and giving him Marilyn's father's name as a middle name.

I couldn't get home fast enough from work each night to spend time with my wife and new son. Bobby was a beautiful blond boy, with his mother's big blue eyes. I don't think I've ever seen a happier baby. Like any young father, I couldn't wait until he was big enough to play sports. I'd bring home gifts of footballs and baseball equipment when he was only a few months old. Marilyn would laugh and tell me I was going to have a long wait. Bobby hadn't even learned to crawl yet.

Marilyn's mother threw a baby shower, and after everyone left, it seemed we suddenly had every imaginable thing you could ever want for your baby—from hampers to clothes to a bathinet, and on and on, not to mention all the toys—all finding a place somewhere in our little apartment.

Marilyn spent her days taking care of Bobby and socializing with the growing number of her high school friends who had also gotten married and were having children. In that time and place and in our social circle, if a girl wasn't married by the time she was twenty-one, she was considered over the hill. In many ways Marilyn fit the ideal of the perfect 1950s wife: She kept a beautiful house, was improving day by day in the kitchen, and approached motherhood with an intuitive understanding. I couldn't believe that she always seemed to know just what to do with the baby, no matter what came up. But she was no pushover. She very quickly established the fact that our marriage was going to be a partnership, fifty-fifty all the way. Nobody, especially me, was going to boss her around, and Bobby was my baby, too, which meant hauling myself out of bed for bottle feedings at three in the morning.

I approached fatherhood with a gung-ho enthusiasm, but at times fatherhood was a very hard concept for me to grasp. The closest I'd been to a baby before was seeing one pass by in a stroller. For the first few months Bobby was home, I was afraid to even hold him. He was so tiny

I thought I'd squeeze him too hard and harm him. Marilyn was wonderful and showed me that all a baby needs is love and attention. Shortly after he was born, Bobby sat on Marilyn's lap while she posed with her mother and Ivadelle's father for a photograph. Unlike me, my son would be raised among generations of family who loved him.

My adherence to my faith remained rock-solid, and the fact I couldn't officially attend mass or receive the sacraments ate away at me. The considerations of Bobby's baptism were also weighing on my mind. I had heard about a local priest named Father Johnson, a progressive young man who was bringing interfaith couples back into the Catholic Church. After our last run-in with a priest, I was nervous about bringing up the subject with Marilyn, but she knew that excommunication had taken a toll on me and agreed to meet with him.

Father Johnson was warm and understanding. He won Marilyn over right away when he asked me why I had married outside the Church. "Because I can't imagine life without Marilyn," was my reply. At that he stood up and offered to bless the marriage. The blessing would have the same weight as a wedding in the eyes of the Church. There were a few provisos. Even though she wouldn't convert, Marilyn would have to take instruction in the Catholic faith and she would have to agree to raise the children Catholic. She agreed.

A month or so later, Marilyn and I were standing before Father Johnson as he blessed our marriage. My Aunt Dot attended the ceremony, as well as Marilyn's friend, Joan Andrews, who served as her witness because Marilyn's maid of honor when we eloped, Carole Gregory, was Protestant. Just like the first time we got married, my witness was once again Don Savio. It was a weekday afternoon and the ceremony was sort of a rushed affair in the rectory. We didn't even go out to lunch or dinner to celebrate afterwards. We went home where I changed out of my suit and back into my work clothes. I headed to the General Electric plant while Marilyn looked after Bobby. My excommunication was over.

I don't think I've ever known a daughter who loved her parents more than Marilyn loved Ivadelle and Leon. One day as we were sitting in their kitchen after Sunday dinner, with the cold, flat, late-autumn sun shining through gingham curtains, Leon told us he and Ivadelle had bought a hundred-acre farm up in Maine and were going to move there in a few months, with Marilyn's sisters Dotty and Rene. A bad case of arthritis was hampering Leon in his profession as a house painter. He and Ivadelle were going off to the country to raise turkeys in a venture with a farmer friend of Leon's.

In the end their decision to move wasn't as bad as it had first seemed

to Marilyn. They were moving to Eliot, a small town just over the border from New Hampshire, and only a little more than an hour-long car ride from Lynn. Before I knew it, Marilyn and I became homeowners and landlords when we bought the three-family we were living in from her parents, with a bit of help from the GI Bill.

After Marilyn's parents moved to Maine, Marilyn's best friend Sarah Goodwin moved into our old third-floor apartment with her husband Paul and their new baby son. We moved to the larger second-floor apartment vacated by Marilyn's parents and her sisters. The first-floor apartment was vacated not long after that when we raised the rent from twelve to fifteen dollars a week.

I still painted and sketched whenever I got the chance, but the opportunities dwindled as I was confronted with the very real need to support my family. In February of 1954, Marilyn became pregnant again. By that time I had been studying one night a week at the Practical School of Art in Boston—a small school on Huntington Avenue near the Boston Museum of Fine Arts—for almost six months. The classes consisted mostly of drawing still lifes, plaster casts of heads, feet and hands, and an occasional full-body statue. The art school was only a few blocks from where I'd grown up on Ruggles Street, and every time I drove in, I'd think about those wild childhood days that now seemed so long ago.

When I came to class one spring day, a 24-by-34-inch drawing of a plaster head that I had done was hanging in a glass display case in the lobby. It was a surprise and my pride soared. Getting a spot in the case was a real achievement, and considered an honor. I'd only been studying part-time for a few months. The school administrator was always encouraging me to come to school and study full-time days, but the responsibility of supporting my family made that prospect an economic impossibility.

I had exhausted the local library's stock of art books, so I began buying them whenever I had some extra money. Reading *Lust for Life* when I was in the marines had kindled my interest in Impressionism, which had since grown into an obsession. I read everything I could get my hands on regarding Impressionist artists. When I could grab some quiet time at home, I'd set up my easel on the kitchen table and copy works from the masters onto my canvas, re-creating their every brush stroke, studying their use of light and shade, design and composition.

Bad news arrived when I was laid off from my job at GE. Soon the artistic dreams that filled my head were pushed aside by dread and worry about how I was going to support my family. I couldn't afford to keep

taking art classes, so I dropped out of school. I dreamed of becoming a professional artist, but had no idea how to go about becoming one, except to keep on painting.

Abstract Expressionism was making its first strides into popular culture at this time. Articles on Jackson Pollock were in every paper and magazine. I was still interested in traditional landscapes, and I sometimes thought the art world had passed by my type of art. New York might be the answer. We could move there and I could study at the Art Students League, where great artists like Thomas Hart Benton had studied and taught. I kept thoughts like that to myself, however, because I knew Marilyn would never move that far from home. Whatever form my artistic aspirations were going to take, they would have to be developed in Lynn. I often felt dejected and thought about abandoning my dream. I certainly felt that way when I dropped out of my studies at the Practical School of Art. Just how you'd go about beginning a career as an artist would have to remain a mystery to me for now.

Two or three weeks after my layoff from GE, I was talking to Leon when he was down visiting. I told him how unsuccessful my job search had been, and he said I should go and put my name in at the Gas Company. He had a friend who worked there, and had heard they might be hiring. It would be a very secure job; no matter what state the economy is in, people need gas to cook and heat their houses. A week later I found myself shaking hands with a foreman named Pat Gilooly, accepting a job as a truck driver for fifty-two dollars a week.

Playing ball for the Cushman All Stars.
1953.

With Marilyn on Boston Street.
April, 1957.

Another Struggling Artist

The Lynn Gas and Electric Company straddled a large acreage between a four-lane road called the Lynnway and the marshes and estuaries that lead to Lynn's beaches. Two huge round towers held the local supply of natural gas within a framework of rusty latticework. These were the tallest structures in the city. My job as a truck driver involved rigorous physical work: digging ditches for gas pipes, jackhammering through asphalt and concrete, and moving immense amounts of soil and stone. I threw myself into my new job and took any overtime that I could. The short period I'd been laid off had filled me with dread. I didn't want to go through that anxiety again, or the humiliation of filing for unemployment and waiting in line for a government check—especially with our second child on the way.

My new job was exhausting at times, especially in the heat of summer when I first began, but I loved it: I worked with a great bunch of guys who were all roughly the same age as me and we had a hell of a lot of fun. One of my coworkers, Jack Seelley—a handsome young man fast becoming a close friend—moved into the first-floor Boston Street apartment with his wife Jean. Our three-family was filled with newlyweds, their newborn kids, and nonstop youthful energy.

One night after an argument, Marilyn locked me out of our apartment. I wasn't about to stand in the hallway all night, so I broke the door down. The next morning I was sitting in the kitchen having breakfast with Marilyn after we'd made up. Sarah came down the hall stairs from her apartment, smiled at us through the shards of wood hanging where the door had been, and said, "Good morning." I shook my head in embarrassment at Marilyn and she laughed. I took a closet door and used it to replace the one I'd broken. Marilyn never locked me out of the house again.

There were five or six work crews in the Lynn division of the Gas Company. I'd be assigned to drive a certain truck and follow one of the

crews for a week or two, then switch to another crew. The foremen and supervisors were all men in their forties and fifties, and every one of them was a character. Every day, no matter where the job was located, we'd stop downtown before heading to the work site. All the young men on the crew would grab coffee or some breakfast in the coffee shop while the older men would go to a bar next door and have a shot of whiskey and a beer at 8:00 A.M. The older men were all stern and strict on the surface, but underneath they were a bunch of twelve-year-old boys. Pat Nagel was the oldest of the bunch, a deeply religious man who took me under his wing and became a sort of father figure to me. He was funny and wise and wonderful to be around, and always gave good advice when asked.

Marilyn's second go-round with labor pains began during dinner one night in December of 1954. Once again we were off to the hospital, me with an empty feeling in the pit of my stomach as I wondered how long Marilyn would have to suffer this time. Equally worrisome was the fact I had no idea how I was going to pay the hospital bill. We no longer had health insurance because, out of the blue, I'd been laid off from the Gas Company for the winter. Unable to be put under anesthesia because she had just eaten a full meal, Marilyn was taken to her hospital room to await the baby's delivery. We agreed that instead of staying by her bedside for another twenty-eight hours like the first time, I'd go home.

I walked in the door twenty minutes later and the phone rang. It was Marilyn's doctor calling to congratulate me with the news that I was the father of a new baby girl. Our second child had been delivered after only one and a half hours of labor. We named her Cynthia.

Before I returned to the hospital to visit Marilyn and our new baby daughter, the nurses were busy getting Marilyn settled into the four-bed room where she'd been taken after delivery. One of the nurses said, "If there's anything else we can get you, Mrs. Caulfield, just ring the buzzer."

The young woman in the bed next to her had also just given birth. She sat up and said, "Excuse me . . . are you any relation to Bob Caulfield?"

Marilyn said, "Yes, I'm his wife."

The woman introduced herself as my stepsister, one of the daughters of Raymond Freeman, my mother's second husband.

When I walked into Marilyn's room a short time later, I recognized the young woman immediately. "Oh, my God," I said. Even though it had been ten years or more since I had last seen my stepsister, I recognized her the moment I stepped through the door. After I gave Marilyn a kiss and some flowers, I asked my stepsister if she had heard anything about my mother's whereabouts.

"No," she said. "She left home one night and never came back again."

We talked about my mother for a few minutes; my stepsister's main childhood memory, like that of so many others, was that my mother always wore beautiful clothes. It looked like whatever had become of my mother was going to remain a mystery.

When Marilyn asked more questions, I changed the subject. Later I told Marilyn that even if my mother wasn't dead, she was dead to me. I didn't want to talk about her anymore.

When I went to take my wife and the baby home a couple days later, the people in the payment office gave me a terrible time. After much back and forth it was agreed I'd pay the three-hundred-dollar delivery bill in weekly installments over the next nine months. I never thought I'd get out of there with my wife and baby.

Christmas was joyous that year as we made the rounds, visiting family and friends with Bobby and our new baby girl. Marilyn and I went overboard and showered the kids with presents.

Leon and Ivadelle drove down from Maine for the holidays. Their appearance at our door always brought a smile to my face. We had made Leon and Ivadelle grandparents at age thirty-nine with Bobby's birth. Ivadelle barely looked thirty and retained the grace achieved through her dancer's training. Leon always looked ten years younger than his actual age, as well.

Cindy was baptized a few days after the New Year. The fact that we were raising the children in the Catholic faith had long since silenced any discord from my side of the family regarding my interfaith marriage to Marilyn.

After searching for work and having no luck whatsoever, I took an under-the-table job driving an oil truck. The guy who began breaking me in on the hulking old rig dropped dead a day later at age fifty-two, before I was fully trained. I found myself alone, driving this huge truck with no experience, easing the creaking monster up narrow streets and down icy inclines to deliver oil to people's homes on frozen white mornings. Once a week I'd stand in a long line to pick up my unemployment check in a downtown office. Somehow we managed to make it through those months. Thankfully, Marilyn was always a wiz when it came to managing money.

In the spring, the phone rang with offers to return to work from both General Electric and the Gas Company, not one day apart. I chose the Gas Company, and never went near that oil truck again. The Gas Company won out because I liked the variety of the work, and I enjoyed working outdoors. Our crews were always driving all over the North Shore fixing

broken gas mains or digging trenches for new ones. I preferred being on the move to the repetitious factory atmosphere at GE.

Having heard of my former athletic glory, the manager of the Cushman All Stars, a semi-pro softball team, approached me about playing center field. This wasn't some half-assed outfit; the team was lethally competitive, and we played a number of other teams around New England on weeknights and weekends. Never that comfortable playing softball, I wished I could have been playing baseball instead, but playing center field for the All Stars was a good outlet for my athletic energy. We had a good team and went on to win the New England Championship. My time with the team ran out after two years when I broke my ankle sliding into first base.

I couldn't believe my luck. Marilyn and I had just gotten to the point where things were running more or less smoothly in the financial department. Now I was going to be laid up for six to eight weeks and wouldn't be able to drive the truck at work. Pat Nagel came to my rescue and gave me a desk job for the period of time I was hobbling on crutches with my leg in a cast. This event pretty much marked the end of my athletic aspirations. Though I did play in a city basketball league for a few more years, I couldn't jeopardize my family's security by getting hurt again on the ball field.

The 1950s are always portrayed in pop culture as a golden era: Eisenhower and Edsels, Marilyn Monroe and Elvis, Chevys and malt shops and pounding rock 'n' roll. I remember driving around with my son one day twenty years later when he asked me if the '50s were really as cool and romantic as they seemed, and if we realized as much when we were going through them. I told him that from what I'd seen, life is lived in the moment, day to day. As cool as the 1950s might appear, we also lived through oppressively rigid social structures, the McCarthy hearings, and the ominous fear imposed by the Cold War. The nostalgic halo surrounding past decades is generated only in retrospect. The fashions and attitudes and slang change, but in the end, day-to-day life was pretty much the same then as it is today.

A wild spirit still burned inside me. Despite how happy I was with my family life, at times I felt trapped in a middle-class prison of mediocrity. Any artist is going to battle with turbulent emotions from time to time, and I was no different. I had a temper, and it didn't take much to trigger the anger lying just beneath my working-man veneer. There I was, a twenty-five-year-old father with three other mouths to feed, and completely cast adrift from any kind of creative community. My working days were spent among a great group of guys, but not a one

with interests beyond the standard-issue sports and pretty girls. Sometimes I wondered why I was even pursuing art. Was I deluded? Should I just focus on the hard realities of getting ahead, American-style?

Doubt nipped at my conscience, but I never stopped painting. Whenever I'd walk through the door after a long day at work and see Marilyn's smiling face, all my doubts would evaporate. Our love for each other seemed to grow deeper and stronger with the passage of time. I loved my children more than life itself, and no matter what lay ahead, I was determined that they would have a far better life than I'd had. If the way to provide them with that life was going to be working for the Gas Company, then so be it.

About the time Cindy started walking, Marilyn took a part-time job working nights in a sandwich shop. I'd hurry home at four-thirty on the nights Marilyn worked. She'd rush out the door to be at work by five o'clock. After feeding the kids, keeping them entertained, and then getting them to bed, I'd catch some time at the easel I'd set up in our bedroom before Marilyn came home.

Once or twice a month in the summer, we'd pack the kids into the car and drive up to Great East Lake to spend the weekend with Leon and Ivadelle at their lakeside camp. We were rarely the only visitors. Marilyn's sister Rene was always there, and her sister Dotty would often come along with her new husband, Don Hunt. When Dotty and Don had married, Don was in the army, and he had been stationed in Germany soon after their wedding. Dotty had gone to live with Don in Germany, but returned a few months before giving birth to their baby son, who was almost the same age as Cindy. They moved into the apartment in our three-family that Jack and Jean Seelley had recently vacated.

Up at camp, Don and I would help Leon with such tasks as putting the wharf back into the water at the beginning of the season, or giving the cottage a coat of fresh paint. If Marilyn and I weren't at camp on the weekends, we'd take the kids to Lynn Beach. Marilyn and I also began taking an annual summer trip together without the kids. It was wonderful having some time alone on long weekend trips to Acadia National Forest in Maine or the White Mountains in New Hampshire.

When fall came, Ivadelle and Leon would drive down to visit once or twice a month. We'd reciprocate and make the drive to the farm about that often, too. Leon's plans for a turkey farm had fallen through. His arthritis had let up, so he had returned to his profession as a house painter.

Leon rented some of his acreage to the farmer next door, who had a herd of black-and-white Holstein cows. The kids loved petting the cows,

especially one called Sweetheart, a gentle cow with a perfectly shaped white heart in the middle of her black forehead. Once in a while Ivadelle's father would come up for a visit with his second wife, Marie. Leon's parents, known as Mammy and Pappy, had moved into an apartment next to the main house. During one of these weekend visits, Leon mentioned that he had met a local art gallery owner and had told him about me and my artwork.

In November of 1956 I had my first solo art exhibition at the Walter Kessler Art Gallery in York, Maine. Mr. Kessler had renovated an old barn to serve as an exhibition space. When I walked through the door and saw all of my paintings hanging on the walls, half of me felt proud and the other half felt I wasn't ready for something like this yet. I've never found get-togethers like gallery openings easy to get through. I was so nervous that night, I had to continually step aside from the opening-night crowd just to take a breath. Luckily, Marilyn was there for me as always.

The exhibition ran for a month and I sold six paintings. The prices were in the fifty- to one hundred-dollar range. Then, as now, there was a fifty/fifty split between the gallery owner and the artist, but any extra money was always appreciated with our growing family. I couldn't help but remember the time when Marilyn and I had first taken the second-floor apartment on Boston Street, and had had trouble coming up with the twelve-dollar weekly rent.

"You sure found enough money to pay for those art books you're always buying," Leon had said. I smiled at that memory, because thanks to his efforts arranging my first exhibition, I finally felt I might be on my way.

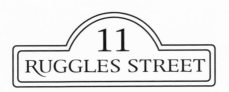

11

RUGGLES STREET

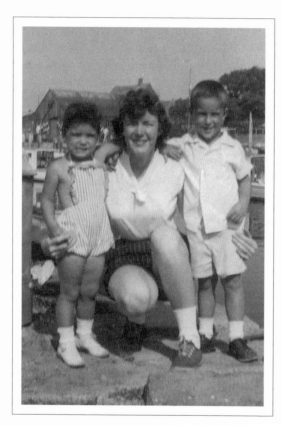

Marilyn with Cindy and Bobby in Rockport.
Summer, 1957.

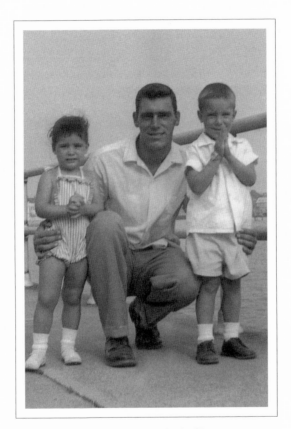

Me with Cindy and Bobby in Gloucester.
Summer, 1957.

Shroud of Grief

At age one, Cindy had already been up and walking for three months. She was a child of exceptional beauty. While Bobby was blond and blue-eyed, Cindy had striking blue eyes with olive skin, all offset by curly black hair. Any time Marilyn and I headed out the door, we could be assured of being approached by one woman after another remarking on young Cynthia's loveliness. Cindy was also the most rambunctious child I'd ever come across, and she had a will of iron. She and her brother Bobby were extremely close, and by the time Cindy was two, Bobby was one of the only kids in the neighborhood that she wasn't beating up on a regular basis. Marilyn kept both children immaculate, and Cindy especially was something of a fashion plate.

The kids loved Leon and Ivadelle's farm and would all but explode with excitement whenever we'd pack them into the car and head off to Maine. A few acres on the farm were covered in gnarled old apple trees, and I painted this scene one spring when the trees were in bloom. In fall the kids would have fun catching rides with Leon on his tractor, petting the cows, or playing with their cousins and jumping into piles of leaves. A flock of bantam hens, a couple roosters, and some geese and ducks called the farm home as well. A little pond on the property was infested with leeches, and only the bravest soul would hazard a swim in its cloudy waters.

Bobby and Cindy loved a little amusement park in the White Mountains of New Hampshire called Storyland. For years, we'd make a trip there every summer. A zoo on the grounds held animals like bears, deer, and elk. No matter how many times we admonished Cindy to heed the warnings posted and to not stick her fingers through the fence holding the animals, she would manage to do so in that fraction of a second when no one was looking. Cindy seemed to have inherited the reckless and wild spirit that had infused my childhood. At the same time, she also had the biggest heart of any child I ever knew.

Nahant Beach is a long expanse of hard-packed gray sand adjacent to a causeway stretching from the mainland along the peninsula that leads to the town of Nahant, a mile offshore. It was our favorite beach at the time because of easy parking and its short distance from home. Any time we went there we'd run into old friends from high school, and enjoy comparing notes on our growing families.

At times the winds on Nahant Beach can gust pretty heavily, sending blankets and towels sailing and sheets of sand blasting into your skin. In August of 1956, when Marilyn was two months pregnant with our third child, we had taken the kids to the beach as usual. As the day progressed, the wind gusts blew harder, covering us and our picnic lunch with sand. I was lying next to Marilyn on a blanket when I said we may as well leave, because it seemed the wind wasn't going to die down. When she sat up, a beach umbrella tumbled out of nowhere at great speed and the point of it struck Marilyn in the stomach. I made sure she was okay. There was a red welt where the umbrella had made contact, but no bruise and no pain. On her next visit to the gynecologist, Marilyn told him what had happened. Her doctor assured Marilyn she would be fine, emphasizing that the developing baby was barely larger than a peanut at that point and well-protected inside her body.

Ivadelle had offered to take the kids for the Labor Day weekend, soon after, and Marilyn and I planned a trip to Quebec City. A pall hung over that short trip. Marilyn was moody and testy, consumed with all kinds of strange food cravings. This was completely unlike her previous pregnancies, when her sunny personality had never dimmed. While driving around the outskirts of Quebec City we witnessed the car in front of us strike a young boy who had dashed out in front of it to grab a ball. Screaming bloody murder, the boy lay there by the road as the car sped away. I pulled over and ran to offer help. The boy's cries brought forth a crowd of people, not one of whom spoke a word of English. I tried to explain that I had stopped to help, motioning with my hands, but to no avail. The crowd seemed to think I was the one who had hit the boy, and people were screaming at me in French and making threatening gestures. The hit-and-run driver stopped at the next hill and stepped out of his car. I pointed to him and finally the people in the crowd understood that he was the driver who had hit the boy. They all took off running and yelling and looked ready to tear the man apart if they caught him.

When I got back in the car I put my arm around Marilyn and said, "How do you feel about going home a day early?"

By the fall of 1956, with two growing kids and another on the way, it had become clear we needed more room for our family. In December we bought our second home—at 24 Falls Street in East Lynn—for seventeen thousand dollars. Our three-family on Boston Street was located right in the middle of a business district with a huge cemetery across the street, the hospital down the block, and Boyd's potato chip factory next door. We sold the three-family to Marilyn's sister and her husband. So ended our life with Dotty and Don in the apartment below us, but our close friendship with them has remained strong for over fifty years.

Falls Street was only two blocks over from where Gramma and Grampa still lived on Harvest Street. It was a nice neighborhood—quiet, suburban, tree-lined, and safe. Marilyn was in heaven. We went from a two-bedroom walkup to a six-room house with one and a half baths. There was a backyard and a garage, and the hardwood floors throughout the house were my pride and joy. For years I never let anyone walk on the mirror-polished floors with their shoes on. We bought a cocker spaniel and the kids named him Freckles. An army of children lived in the neighborhood. Soon Bobby and Cindy were surrounded by loads of new friends.

After painting for the last few years in the kitchen or in a corner of our bedroom on Boston Street, I set up a studio in the basement of the house and now had plenty of room for my easel, paints, and canvases. In those days I used to love painting outside and only used to do finish work in my studio, so the lack of natural light wasn't a problem. I was always on the lookout for new art books, and especially anything on the French Impressionists. I'd study theory, critical interpretations, and composition, and then try to apply this knowledge to my own work.

Camille Pissarro was beginning to supplant van Gogh as my favorite artist. I felt an affinity with the world that existed in his serene landscapes. Like me, he was also of Portuguese descent, and his artistic and creative drive impressed me. Pissarro underwent tremendous struggles in his youth and throughout his life. When he was in his seventies and nearly blind, he would set his easel up in his apartment and paint the view from the window. It's this kind of passion that separates a true artist from the run of the mill.

At the end of his life Pissarro was somewhat wealthy. Durand-Ruels Galleries in Paris and in Boston had represented him for years, and he certainly didn't need to paint to earn more money. Yet he continued painting, creating some of his finest work at the end of his life. What I had found most compelling about van Gogh was his almost supernatural drive to paint. Call it what you will—all true artists have this compulsion

to make something. I simply wanted people to look at what I was doing and enjoy my work as much as I did.

So many of the art movements of the twentieth century have been intellectual. There was really nothing intellectual about the way I painted—it has always been an instinctive process. My formal art education was minimal, allowing me to rely on personal experience and emotion. I've always had to feel what I'm painting. The French artist Matisse perfectly expressed the emotional aspect of painting when he said: "I am unable to make any distinction between the feeling I get from life, and the way I translate that feeling into painting."

My drive to paint wasn't constant. There were periods when, try as I might, I could not summon the will to sit or stand in front of a bare canvas. This could last from a few days to a few months. At other times, I would work on two or three paintings at once; during these almost frenzied bursts of creativity, I lived and breathed for my artwork.

One thing we never told the kids was that the previous owner of our new house, a middle-aged woman, had hanged herself from one of the basement pipes. She had been a nurse during World War II, treating the wounded on Iwo Jima and Corregidor. Any time Marilyn went to the basement to use the washing machine, she'd get the willies. I have to admit there were times I got them too. When I was busy painting, I might hear a noise that would send shivers down my spine or make the hair on the back of my neck stand up. I always wondered if the horrors she'd seen in the war had driven the woman to kill herself that way—and, on a more curious level, which pipe she had hanged herself from.

Oftentimes at work I'd daydream about succeeding in the art world and chucking my job—but providing for my family always came first. Marilyn's most recent pregnancy led to her leaving her part-time job at the sandwich shop and our family not having that extra income. I took every opportunity for overtime at the Gas Company; this sometimes meant working in subzero weather till four in the morning, but I really didn't mind. Providing a lifestyle for my wife and kids—one that I never could have imagined back on Ruggles Street—was pure pleasure for me.

Although at times Lynn seemed like it was a thousand miles from the nearest art center, in reality it was surrounded by some of America's most popular art communities. Marblehead was only one town away, and Rockport, located on the coast of Cape Ann, was known nationwide for its thriving community of artists. Bearskin Neck in Rockport was home to a number of art galleries. I admired the work of many of the artists based there, including Paul Strisik, Tom Nichols, Emil Gruppe, and

Stanley Woodward. Based in Western Massachusetts, Steve Maniatty was another artist I looked up to. Once in a while on a summer Sunday I'd head to Rockport with Marilyn and the kids. It was probably while strolling along the crooked, quaint streets of Bearskin Neck that my dream of one day owning my own gallery began to take root. The kids would rather have been anywhere else than following us into yet another boring art gallery, so we'd treat them to an ice cream and a trip to the park at Salem Willows afterwards.

In preparation for the birth of our third baby, we had sent Bobby and Cindy off to Maine into the capable hands of Ivadelle. We thought that having the two older kids out of the house for a week would make it easier for Marilyn to adjust to having the new baby at home. By this time it seemed we had the birth routine down to a science. When the labor pains were coming every fifteen minutes or so on that windy Sunday in mid-March, I packed Marilyn into the car and drove her to Lynn Union Hospital. After kissing her good-bye, I went home to await the phone call telling me that our third child had arrived. Grabbing the opportunity to have some painting time without any interruptions, I headed down to my basement studio.

A few hours later the phone rang, and I bolted up the stairs two at a time. The voice on the other end of the line said, "Robert, this is Doctor Allison. I'm afraid I have some very bad news." It was as if a supernova exploded within my chest. I shouted, "Did something happen to Marilyn?"

"Your wife is doing fine," he said, "but I'm afraid she lost the baby. I'm so sorry."

The news was so far out of the realm of anything I had been prepared to hear that my knees buckled and I dropped to the floor.

Three days after the birth, I brought Marilyn home. The grief that shrouded our tiny house was so overpowering that we could barely speak to each other. Through her sobs Marilyn told me what had happened.

She had been wheeled into the delivery room and the nurses had begun preparing her for the baby's arrival. For whatever reason, though he had been called over an hour before, her gynecologist, Dr. Allison, hadn't yet arrived. Monitors were placed on her stomach, and the nurses began drawing little red Xs with a marker on Marilyn's stomach as they monitored the baby's movements. Tension filled the room and Marilyn sensed that something wasn't right, that the baby was in distress. Still, the nurses waited and waited for Marilyn's doctor to arrive and kept telling her not to worry.

When an anesthetist came into the room and saw how far the delivery had progressed, he yelled, "Why hasn't she been put under?" By this time it was too late to proceed with putting Marilyn under anesthesia. She'd have to give birth naturally. The doctor finally arrived, and the baby lost its struggle to live only moments before it made its entrance into this world. The baby's tiny, lifeless body was whisked out of the room before Marilyn ever got a chance to set eyes on her second daughter.

The baby had suffered a severe birth defect. Her intestines had formed outside of her body. One must remember that this occurred decades before the ultrasound was invented and used to chart a fetus's growth, in the dark ages of modern medical care. It was standard procedure for women to be strapped to the delivery table and put under while delivering their babies in the 1950s. Very few women even considered having a natural birth.

Marilyn was extremely vigilant about prenatal care, and had never missed a doctor's appointment. She watched her diet closely during each of her pregnancies, and wouldn't even take an aspirin for fear that it would harm the developing baby. In our sorrow we could not understand how this could have happened. Why hadn't the doctor known that something was wrong? To make matters worse, Marilyn knew a woman who had given birth to a baby girl with the very same defect the year before. That baby's problem had somehow been discovered before her birth; she had survived, and the defect had been surgically repaired.

Dr. Allison's feeble attempts to comfort us did no good. He told Marilyn that the baby was better off having died, that it was God's way; that had the girl lived, she would never have been able to bear children. "But she would have been alive," Marilyn countered. The doctor also said the fact the baby went full-term was a testament to Marilyn's superb health—that if she hadn't been so physically strong, she probably would have miscarried the baby long before. When he had first called me with the awful news, Dr. Allison asked if I wanted to see the baby. He said the baby was beautiful and looked exactly like Marilyn. I couldn't bring myself to do it.

There was no funeral. The administrators at the hospital explained that having never drawn breath, our daughter was considered a stillbirth and therefore not due a proper funeral. Marilyn and I were too distraught to argue the matter. Marilyn wasn't allowed to leave the hospital for three days. Nobody was there to say good-bye to the baby except the faceless men who buried her in Pine Grove Cemetery the day after the tragedy.

When Marilyn was released from the hospital she was anxious to see the baby's resting place. We went alone to visit the baby's grave. Marilyn and I laid flowers on a numbered metal plaque that marked where the girl known only as Baby Caulfield rested. Unbeknownst to us, Dotty and Donny stood on a hill nearby looking down at us, giving us silent moral support.

Ivadelle came to stay for a week, and her effect on Marilyn was almost miraculous. With wisdom, kindness, and love, she helped Marilyn begin to see that she could get past this horrible event and move on. Gramma Caulfield had lost a few young children to childhood disease, and she was wonderful to Marilyn as well.

Bobby and Cindy were both so young that clear explanations for what had happened weren't needed. Sorrow cloaked that house for many months. Marilyn and I had no idea how to come to terms with what had happened. We were completely alone in our grief. We'd hear, "You're young. You can have another baby," from family and friends and doctors. It was as if no one wanted to confront it, as if the baby's death had been some awful dream that had never happened. People didn't seem to understand that we were not just grieving the death of our baby, but also the life the baby would never enjoy—all the birthdays and day-to-day events that mark any child's life as they grow to adulthood.

As we stumbled through those first few weeks, the biggest saving grace was Bobby and Cindy. Having to care for them forced both of us to get on with our lives. Marilyn was so depressed that she didn't want to leave the house, terrified somebody would ask her about the baby yet again. Though I did everything I could to console her, on some level she thought that what had happened was her fault. For months the sight of another pregnant woman would start tears rolling down Marilyn's cheeks.

To make sure what had happened had not been due to something wrong with me, I went and had my sperm checked. Everything was okay, as pointed out by the old doctor who motioned me to look into the lens of his microscope. "Look at all those soldiers," he said. "That's nature's way of sending an army to do one man's job." He assured me that the reason behind the death of our third child had nothing to do with any defect on my part. Marilyn also endured a number of diagnostic procedures. In the end, the baby's birth defect was one of those anomalies that can't be explained.

I had never liked dealing with numbers, and Marilyn had long taken care of our family's finances, including paying the monthly bills. She had often mentioned that she wanted a new desk, and a month after we

lost the baby, I bought her a colonial-style upright desk of solid maple. Marilyn hated it because she thought that it was some kind of consolation gift to help lift her spirits after losing the baby, which in truth, it was. She didn't go near it for almost a year. As the months passed and our sadness began to grow less acute, she began using the desk. She still uses it to this day.

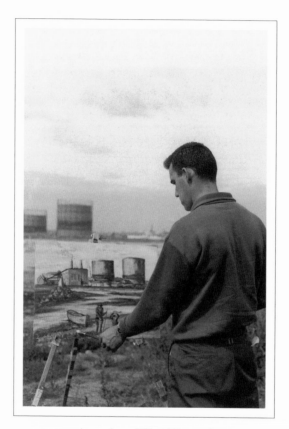

At work on "Clam Diggers."
1958.

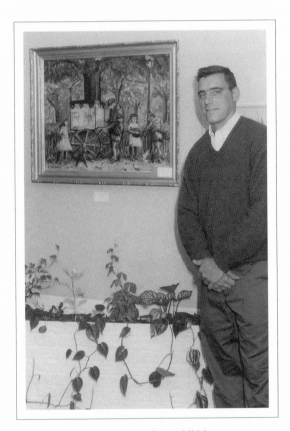

Attending my first exhibition
of work at the Coronet Gallery.
September, 1958.

Artistic Expression

In the end, a painting is a work of expressive craftsmanship made up of light, shape, and color. In the nineteenth century, the French Impressionists smashed the traditional methods of painting that had been practiced for over four centuries. Their search for uncompromising realism resulted in works of art that were considered radical when they were first displayed in public. The term *Impressionism* itself had initially been a derogatory one foisted on the group of artists that were searching for new modes of expression.

The powerful, vibrant style of Auguste Renoir would dazzle any viewer standing before one of his paintings. Like me, most people probably believe that the moment the movers and shakers in the art world first encountered Renoir's work, they realized that this artist was possessed of an extraordinary gift. It was a surprise to discover that this was hardly the case. Renoir had hustled his work with nonstop zeal when he was starting out, only to be met with disdain from prospective gallery owners who might have shown his work. This seems to be a universal experience for most artists.

Vincent van Gogh is the gold standard of the struggling artist. One of the greatest artists in history, van Gogh faced heartbreaking poverty and endless emotional suffering in his short, tragic life. His genius would go unrecognized until long after his death by suicide at age thirty-seven. His brother Theo was instrumental in offering support and encouragement to Vincent, but he too died young. During his lifetime Vincent van Gogh sold only one painting, and that was for a paltry sum.

Learning more about these artists reinforced an important message: Nobody in the art world was going to come looking for me. If I wanted to succeed as an artist, I was going to have to go out into this world and promote myself. The prospect of doing so filled me with dread. Although I was approaching thirty, I still struggled with a shyness that at times almost

paralyzed me. The thought of approaching gallery owners and others in the art community did nothing to alleviate that anxiety.

By this time, I had been involved with the Lynn Art Association for a few years. This involvement took the form of monthly meetings with a group of other local artists. After one of our meetings, a group of four artists in the association approached me with the idea of joining them in opening a local gallery to showcase our work. It was agreed that we would all chip in a certain amount of money each month to cover such costs as rent and electricity, and that we would take turns staffing the gallery as salespeople. Marilyn and I certainly didn't have the extra funds to invest in a fledgling business, especially one as risky as an art gallery. Somehow or other we scraped together enough to invest in the business along with the other artists. We planned on using the income generated from paintings sold in the future to keep the gallery afloat.

The Coronet Galley opened in a shopping district in West Lynn in September of 1958. Three paintings by some of the other artists had been sold before the opening-night party. I got a lot of compliments on my paintings, but nobody was buying them. It couldn't have been the prices, which were only in the fifty-dollar range. For the first couple of months things couldn't have run more smoothly at the Coronet. All of the artists involved chipped in their allotment for rent, electricity, heat, and insurance. Everyone went out of their way to make sure the gallery was properly staffed and supplied with paintings. We even offered painting and drawing classes at night. Fifty percent of the profits on paintings sold went to the artist and fifty percent went toward maintaining the gallery.

In October I finally sold a painting of a church in Marblehead for forty dollars. A few months passed, and the overwhelming excitement that had launched the gallery began to fade as our romantic dream collided with the day-to-day realities of work, family, and tight finances. The passion and altruism underlying the gallery's launch withered into complaints about the fifty-percent cut for the gallery, and grumblings about time constraints and job pressures. Six months after it opened, the Coronet Gallery closed its doors for good. We hadn't set the world on fire, but the enterprise had been quite an education in the business aspects of being a painter.

While driving a truck around the North Shore for my job at the Gas Company, I'd sometimes come upon a scene that would strike me as good subject matter for a painting. If I had the time I'd stop to make some

quick sketches, or return on the weekend with my easel. My permanent daydream revolved around one day waking up in the morning and painting for a living.

I had been writing short biographical sketches on various members of the Lynn Art Association for a year or two. These appeared in the *Daily Evening Item* on a regular basis. Not long after the Coronet Gallery closed, I was approached about becoming president of the association. I accepted, and over the course of the next year I balanced the responsibilities of this role along with my job at the Gas Company, which included ten to twenty hours of overtime every week, as well as my duties as a husband and father.

Much of my free time was swallowed up in dealing with the politics involved in running any organization of that sort. Art exhibitions were set up in Lynn, Swampscott, and Marblehead, and finding free time to paint became increasingly difficult. As my yearlong term wore on, I became more and more disenchanted with handing out awards and socializing, when I could have been using that precious free time to paint. When my presidency came up for renewal, the association's members were unanimous in urging me to accept another term. I declined, although I remained a member for a few more years.

There was an upscale restaurant in Marblehead in the 1950s called the Molly Waldo. It was owned by a woman in her sixties who absolutely loved my paintings. She displayed them in the lobby and the dining room and they sold quite well, averaging about fifty dollars apiece.

A few months after the Coronet Gallery went out of business, I was approached by the owner of a small gallery in Marblehead. Soon I was displaying my work there as well. A local bank president was a fixture at every Art Association event, and he agreed to exhibit about ten of my paintings in his bank in Swampscott, the town where Marilyn had been born.

One day I drove to the bank with Marilyn and the kids. A large painting of mine titled "The Popcorn Vendor" had been placed in the window with a price tag of two hundred dollars. The kids almost lost their minds at the prospect of making so much money on a painting. For a few days after that, you couldn't drag Bobby and Cindy away from their watercolor sets.

I knew that becoming wealthy wasn't going to be the end result of selling my paintings at the bank, or in any other venue in Lynn, but the exposure was nice. I had bought an eight-millimeter movie camera a few years before to record events in the kids' lives. Marilyn and I took it

along to the bank in Swampscott, which was across the street from the beach. We sat on a wall and I shot footage of people stopping to look at my paintings in the window. We thought it would be fun to watch it someday in years to come; unfortunately, when I brought the film in for developing, it was lost.

On the job one afternoon, a coworker told me he had run into an old grade-school chum of mine. This guy had said, "Caulfield's got some nerve. He drives a truck for the Gas Company, runs a goddamned jackhammer, and sells his paintings down at the bank for two hundred bucks!" The boy who had hated slights still lived in the man, and I was furious for a while. If I had run into that guy, I would have told him off in a big way. There's always somebody who's going to resent it when you strive to do anything beyond the realm of the everyday. For the most part, I received nothing but support from people, especially the men I worked with. They all encouraged my dream of becoming a professional artist.

During one of our talks, Ivadelle explained to me that some people didn't want to see others rise above them or their social group, and this resentment often fueled envy. Ivadelle never had a bad word to say about anybody, ever. She had a profound understanding of human nature. I didn't know a soul who had money, and though Leon and Ivadelle were far from wealthy, Ivadelle had been brought up in the lap of luxury in Swampscott; she understood the world of the rich. Her father had lost his job as a prominent architect, as well as his fortune, in the Stock Market Crash of 1929, when Ivadelle was sixteen. Money can go, but class and breeding are indelible; Ivadelle was the epitome of both of those attributes. Only seventeen years older than me, Ivadelle still retained her delicate beauty as she approached the age of fifty. In many ways, she had become the mother I never had.

In February of 1959 Marilyn became pregnant with our fourth child. She switched doctors and was more vigilant than ever in watching her diet and in seeing her new doctor regularly as the pregnancy progressed. I knew by her overcautious manner and the way she rubbed her stomach that she must have feared she might lose this baby too. I did everything I could to keep her attitude positive, helping her around the house and with the kids.

That summer, Leon and Ivadelle sold their camp on Great East Lake and bought another summer cottage in Milton Three Ponds, New Hampshire. One of the benefits of going to camp was that the kids could burn off their incredible energy. There were some open fields behind our house on Falls Street, and these adjoined some wooded areas interspersed with

small homes. This open space didn't always provide the same outlet as our summer visits to camp, although on one occasion, it was the scene of some excitement. A week or two before beginning first grade in parochial school, Bobby and his friends were playing in the field behind our house and decided to make a campfire. Cindy came along and wanted a campfire for herself. A gust of wind spread Cindy's fire into the tall grass and began burning wildly out of control. There were fire engines and a couple of acres of scorched field and woods in the end, but luckily, no houses were damaged. That was the last time the kids burned their energy in such a literal way.

Cindy's eyes had changed from a striking blue to an equally striking hazel when she was about two years old. She kept Marilyn and me on our toes like any child her age, and she was as stubborn as ever. Marilyn always dressed Cindy in beautiful clothes even though Cindy was more of a tomboy and preferred casual play clothes and sneakers. One day, Marilyn forced Cindy to wear a pair of brand-new white shoes she didn't want to, so Cindy ran upstairs and stood in the toilet bowl to ruin them.

I had considered naming our next child Claude Monet Caulfield if it was a boy, but the moment I laid eyes on the son Marilyn gave birth to in October of 1959, I changed my mind. He was a rock-solid, blue-eyed blond, weighing almost nine pounds. We settled on naming him Craig after looking through a book of names, because it's an Irish name meaning "rock" or "crag." Bobby and Cindy were thrilled when their new brother came home. Being so young, the trauma they must have sensed when Marilyn lost the previous baby was now a distant memory.

Reflecting on Craig's arrival years later, Cindy said it was like Mom went out the door one day and came back the next with a baby boy.

Bobby enjoyed painting and drawing like most kids do, but I didn't see the creative fire in him that had burned in me when I was his age. Sports fueled Bobby's passion, especially baseball. This equally thrilled me because Bobby was showing genuine talent in that game. Although it didn't consume him, Bobby did have artistic talent. I was bursting with pride when a painting he did, titled "Ma's Windy Dance," won first prize in the Archdiocese of Boston competition of Greater Boston Parochial Schools.

A year later I was driving to work one morning when I saw twelve nuns carrying umbrellas on their way to church in the rain. The image struck me, and I couldn't wait to get home to begin making sketches before turning the scene into a painting. It would have been great to have inspiration like that every day, but mine seemed to come in spurts.

In December of 1960 I turned thirty. My jet-black hair had begun to show traces of gray during my late twenties. My brother Joe had two sons by this time, and he and his wife Joan agreed to be godparents to our new son. As the 1960s dawned, life had never been happier for our family. Some terrific new friends came into our lives on Falls Street: our new neighbors Marge and Fran Crist, and Mal and Bob Mills.

Now in their early eighties, Gramma and Grampa Caulfield loved having the children around. Their house was always busy with visitors, and sometimes with all the kids, their apartment on Harvest Street seemed more like a crowded carnival midway than a quiet home for seniors. Aunt Mary, Uncle Leo, and their children; Aunt Dot, Uncle Fran, and Uncle Owen and their wives and kids, my brother Joe and his family— all of them would be there every Sunday.

Once in a while my father would drop by. He'd take the train in from Boston because he never learned to drive. During one of these visits, I overheard Bobby asking him where my mother was, and he quickly changed the subject. I was struck by the fact that it had been almost twenty years since my mother had disappeared. I had long ago learned not to ask anyone in my family any questions about her, because whenever I had, I'd been met with silence or complete indifference. Whatever had gone on between my father and mother—in my family's eyes—was entirely my mother's fault.

1940s – 1960s

·PLATE 5·

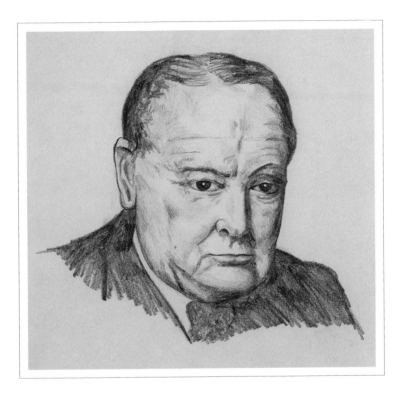

Winston Churchill
·1945·

·PLATE 6·

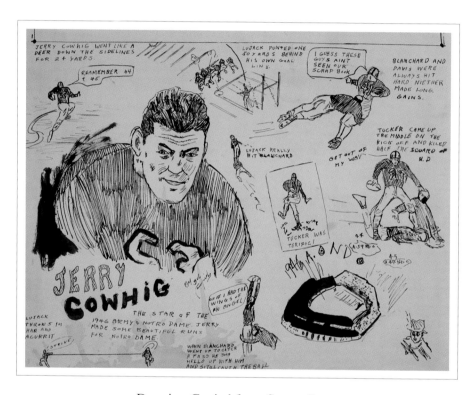

Drawing Copied from Sports Page
·1946·

· PLATE 7 ·

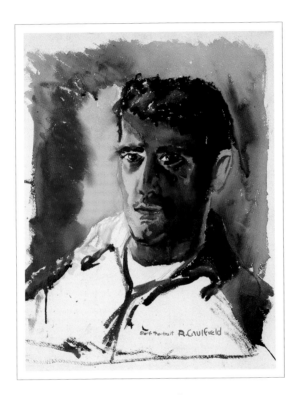

Self-Portrait
· 1950s ·

·PLATE 8·

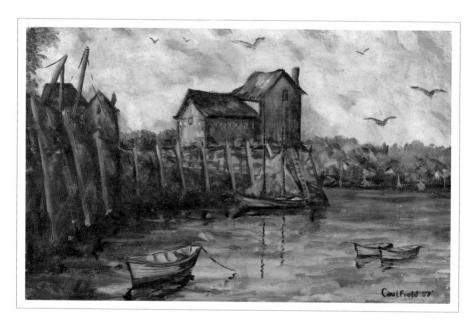

Motif No.1, Rockport, Massachusetts
·1957·

·PLATE 9·

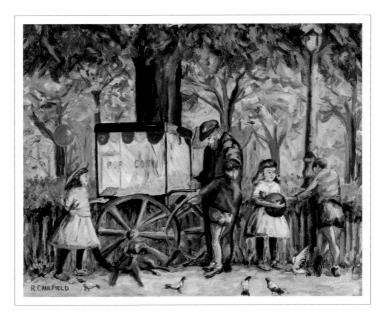

The Popcorn Vendor
·1950s·

·PLATE 10·

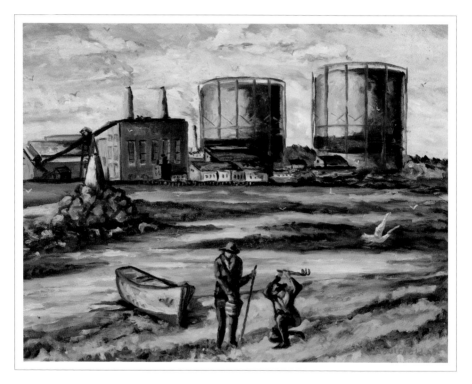

Clam Diggers
The Lynn Gas Company towers rise in the background.
·1958·

·PLATE 11·

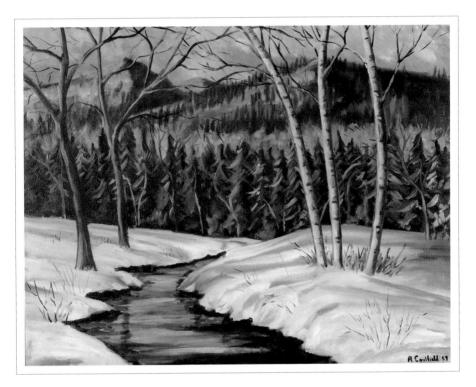

Leon and Ivadelle's Landscape
A mainstay in Leon and Ivadelle's living room for over forty years.
·1959·

· PLATE 12 ·

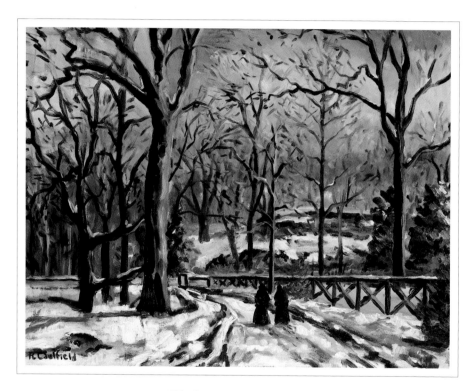

Blytheswood in Winter
· 1960 s ·

·PLATE 13·

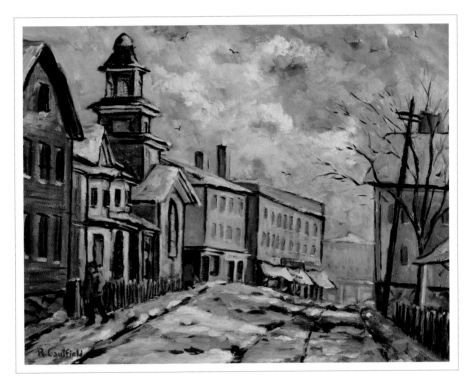

Marblehead
·1960s·

·PLATE 14·

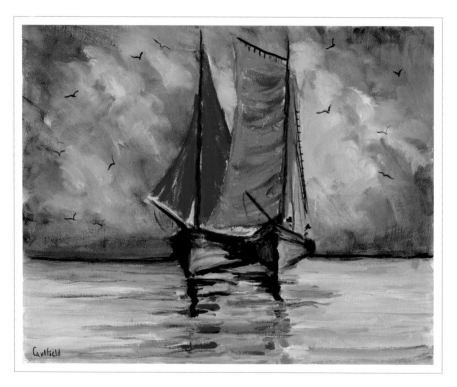

Orange and Red Sails
·1960s·

·PLATE 15·

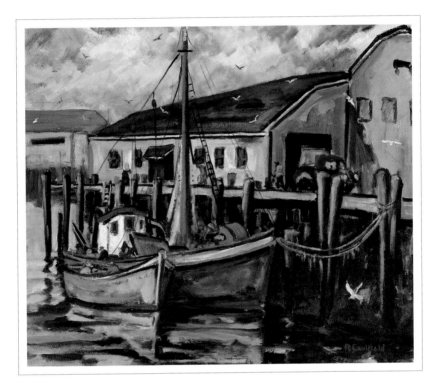

Gloucester Docks
·1960s·

·PLATE 16·

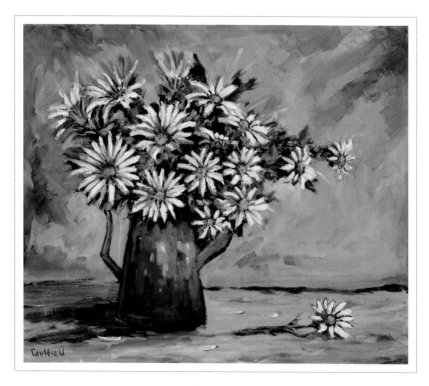

Wild Daisies
·1960s·

·PLATE 17·

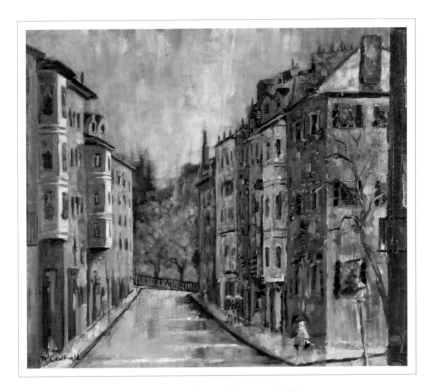

Chestnut Street, Beacon Hill
·1960s·

·PLATE 18·

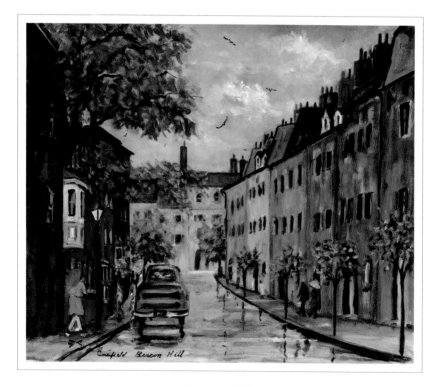

Beacon Hill
·1960s·

·PLATE 19·

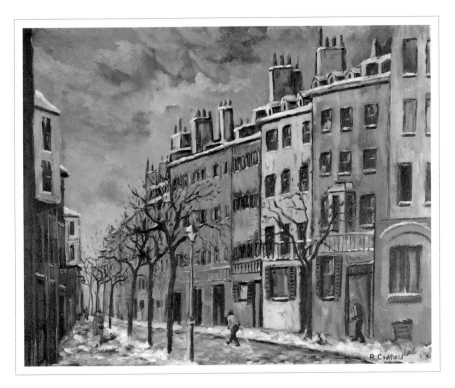

Beacon Hill, Late Winter
·1960s·

·PLATE 20·

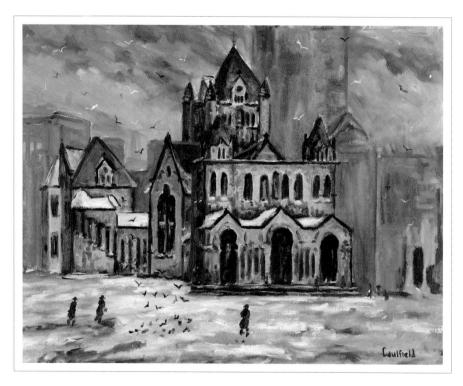

Trinity Church, Copley Square, Boston
·1960s·

·PLATE 21·

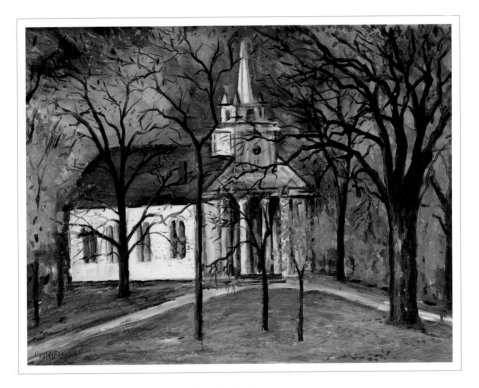

Church in Autumn
·1960s·

·PLATE 22·

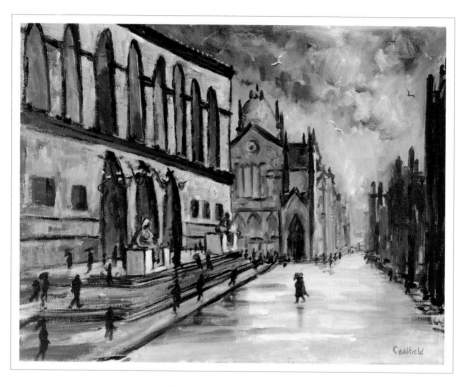

Boston Public Library
·1960s·

·PLATE 23·

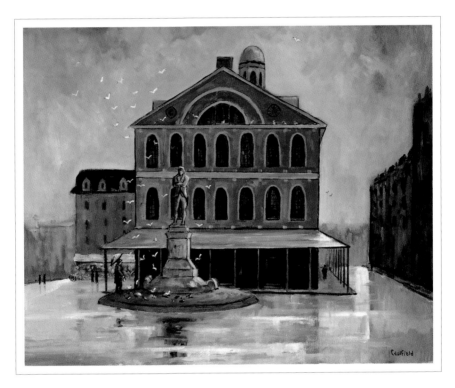

Faneuil Hall, Boston
·1960s·

·PLATE 24·

Wakefield Common
My first national exposure in an American Mutual calendar.
·1960s·

·PLATE 25·

Wakefield Common in the Rain
·1960s·

·PLATE 26·

Gloucester House
·1960s·

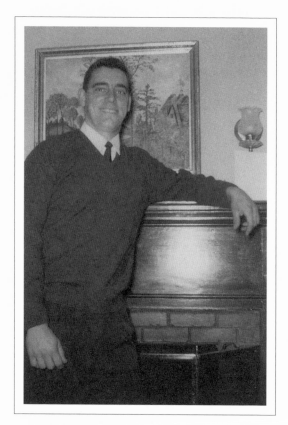

In the living room at Falls Street.
Christmas, 1958.

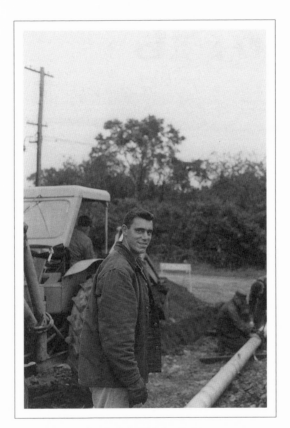

On the job with Lynn Gas.
Early 1960s.

A Darker Palette

The Beacon Hill neighborhood in Boston is where the city's wealthy and privileged citizens have made their homes for hundreds of years. Many of the period characteristics of its eighteenth- and nineteenth-century beginnings are preserved among winding cobblestone streets lined with three- or four-story brick buildings. In 1959 I began work on a series of paintings there. Known for its public squares, the finest of these is Louisburg Square. (Bostonians pronounce Louis as in Joe Louis, not the French *Lou-ee*). The Greek Revival and Federalist row houses surrounding the small square were soot-covered and neglected back then.

Through the years I have painted Louisburg Square from every conceivable vantage point. One time in the spring of 1960, I was painting at my easel when a window banged open above me. An old woman called out and asked if I wanted to come up for lunch. I said, "Yes, that would be nice," and made my way to her third-floor apartment. We sat by the window and ate finger sandwiches as she told me stories of her life. All through the meal I kept one eye out the window to make sure no one walked off with my easel.

These scenes of Beacon Hill were the first paintings of mine to attract attention from local art critics. A gallery owner from Wellesley contacted me after seeing my work and arranged to exhibit a number of the paintings. The paintings proved popular with buyers and sold well.

Looking back at my Beacon Hill scenes and many other landscapes I did at that time, it's clear that I was using a darker palette. Although sunny skies appear in many of the paintings I did in the 1950s, the skies in paintings from the 1960s and 1970s are especially dark and foreboding. I never realized this until years later when it was pointed out by a gallery owner. On one level, my work was reflective of my temperament. I was extremely happy in my home life with Marilyn and our children, but I was still overwhelmed by worry.

Aunt Dot, Aunt Mary, and my father would tell me that being a worrywart was a Caulfield trait, which didn't help matters. I worried about money, insurance, and every other detail involved in supporting a family. I especially worried about what would happen to us if I ever lost my job at the Gas Company. Stomach problems brought on by nerves became a regular facet of my life. My apprehension may have been attributable to the insecurity of my childhood, when the rug had been yanked out from under me so many times. The only certainty I'd ever known was uncertainty.

Reaching the age of thirty made me feel that perhaps I might never succeed as an artist on the scale I had hoped for; was I just another dreamer coming to realize that there was no way out of the comfortable, middle-class existence I'd attained? There wasn't much time for self-pity or excessive introspection. Somehow I worked sixty-hour weeks and still found time for Marilyn, the kids, and my artwork.

The election of John F. Kennedy in November 1960 threw a national spotlight on the state of Massachusetts. Kennedy's "New Frontier" ideology seemed to infuse the country with a boundless enthusiasm and belief in what Americans could achieve. My old friend, George Carrette, was able to experience the Kennedy era firsthand.

After completing his stint in the navy, George had married a southern girl and settled down outside Washington, D.C. He worked there on the police force for a short time before taking a position on the White House guard detail under President Eisenhower, continuing on through the Kennedy years. We spoke on the phone now and then, keeping each other up to date on the details of our lives, such as the fact that by January of 1961, Marilyn was pregnant again. Marilyn had been sitting for a portrait when we got the news. I had read that turpentine vapors can harm a developing baby, so I put the portrait away and never finished it.

One day at work, my crew was assigned the job of installing a new gas line in Marblehead. There was an underground pumping station at the work location, a concrete vault about twelve feet high and fifteen feet wide. Over the next few hours, my crew dug a trench and installed a new gas line. The final step after installing a gas line was to check it for leaks. We used a soapy fluid to coat the pipe joints, and would then watch to see if any air bubbles formed. This was usually a time-consuming process.

One way to speed things up was to light a match and hold it over the newly threaded joints. I had seen this done hundreds of times in the past by foremen, laborers, and many other men on the crews. If

there was a leak present, the match would ignite a tiny purple flame, similar to that on a kitchen stove's pilot light.

Pulling a stepladder off the truck, I stepped inside the pumping station to check the lines that were installed about twelve feet up, near where the ceiling peaked. I lit a match. A flash was followed by a tremendous explosion, hurtling me into the wall. Somehow I crawled outside while the gas feeding the fire inside the vault burned itself out. There was total panic among the crew.

Collapsing on the grass, I rolled over, looked up at the blue sky, and gasped for air as the most excruciating pain imaginable coursed through my body. The men on the crew helped me tear off my burning shirt, taking long strips of skin from my face and arms along with it. They pulled me into the truck and sat me between the foreman and one of the crew members. My body radiated with a burning agony so intense, I never would have believed it possible. The truck sped off and I kept repeating, "I think I'm going to pass out."

When the truck pulled up at Mary Alley Hospital, my skin was still smoldering. Hospital attendants placed me on a gurney and wheeled me into an operating room. The doctor assigned to my case had served in Korea and was quite familiar with treating burns. I was given medication to ease the agonizing pain, and my burns were attended to. When I woke up after dozing off, I was astonished to see a priest standing over me, intoning the sacrament of the last rites of the Catholic Church. I knew I was burned pretty badly, but the thought of dying had never entered my mind.

What I hadn't anticipated when I climbed the ladder toward the pumping station ceiling was that gas vapor would have collected there. Unbeknownst to me, the vault was solid and had no ventilation ducts. When I struck the match, a vortex of fire enveloped my head and arms. One of the doctors who visited my room told me that breathing in superheated air might have permanently damaged my lungs. Luckily for me, in the instant the explosion occurred I had yelled, forcing the air out of my lungs rather than drawing it in.

As I lay there alone in my room, I began to worry about getting fired from my job. This couldn't have happened at a worse time now that Marilyn was approaching the last trimester of her pregnancy. I begged the nursing staff not to tell her what had happened, fearing the shock might harm the baby or cause Marilyn to miscarry.

It wasn't long before the president of the Lynn Gas Company stepped into my room, along with the superintendent. They had rushed over as soon as they heard what had happened. Both men were dear

friends of mine. After I told them my concerns about losing my job, they assured me that I had nothing to worry about.

A nurse brought me a hand mirror. When I lifted it I didn't recognize the reflection. My ears were swollen to twice their normal size. My eyes were slits within my outrageously swollen face. Both of my arms were heavily bandaged. A short time later, Marilyn came to my door, looked in at me, then turned around and walked away. A nurse soon led her back to my room. I said hello and her eyes welled with tears. My face was so swollen and distorted that when she had first seen me, she'd thought she had the wrong room.

The next day the doctors told me I had been very lucky. My wounds were second-degree burns searing the upper layers of my skin, rather than the lower layers where new skin cells are regenerated. I would have no permanent scars. The throbbing pain persisted for days, along with the putrid smell, as my burnt flesh began to heal.

I was filled with relief on the day I was released. The swelling had subsided after a week's stay in the hospital, which would be followed by a few weeks' recuperation at home. Marilyn picked me up, and when we pulled in front of the house, our three children were all standing at the curb waiting to greet me. I stepped out of the car and a look of horror came over eighteen-month-old Craig's face. He took off into the house, screaming. Later he told me he'd thought his mother had brought a monster home. In the remainder of my years with the Gas Company, neither I, nor anybody else, ever lit a match near a gas pipe again.

One of my friends gave me an art book as a gift while I was recuperating. The book was about the Ash Can School of American artists, and had a big effect on me, opening up a new world of artists such as John Sloan, William Glackens, George Luks, and Robert Henri.

Petite, sweet, and the quietest baby we'd had yet, our fifth child was a daughter born in September. We named her Lorelle. Marilyn had breezed through both the pregnancy and the birth. Once again it was a monumental relief and a blessing to have a healthy baby.

More good news came in December. A local department store chain, the Jordan Marsh Company, sponsored an annual spring exhibition of contemporary New England artists. There were over two thousand entries in categories like "Portraits," "Landscapes," and "Modern," of which only two hundred twenty-eight were chosen for exhibition. My first submission was "Nuns on a Misty Morning," the painting I had done after seeing a group of nuns walking in the rain. I was floored when this whirl of black-habited nuns, black umbrellas, and wrathful gray

skies was displayed between works by Emil Gruppe and Stanley Woodward, two well-known professional artists from Gloucester.

The American realist painter, Edward Hopper, personally chose the finalists and judged my entry one of the "Best in Show." On top of that honor, "Nuns on a Misty Morning" was one of the few paintings that sold in the exhibition. This pat on the back from one of America's greatest living artists provided a huge boost to my confidence; the seventy-five dollars I received for the painting was almost incidental. My smile didn't fade for weeks. My head was always filled with dreams, and now those dreams of success as an artist seemed like they might have a chance of coming true.

My life revolved around my family, my job, and my painting. Time to paint was what I needed, but time is scarce when you have a family and loved ones you want to be near. At age eight, Bobby was wild about baseball and one of the best players on his Little League team. I spent as much time as possible with him, practicing hitting and catching. Cindy and Craig were developing interests of their own, as well. Our rusting car was breaking down every other day, so I bought a secondhand Chevy station wagon. The kids loved riding in the back with our cocker spaniel, Freckles.

One day I pulled into the driveway and watched the kids hop out of the car. "Where's Freckles?" I asked. Bobby gave me a funny look and said, "He jumped out the back window a couple streets ago." I yelled and ranted and raved and asked why he hadn't said anything. We got back into the car and eventually found Freckles trotting along the sidewalk not far from home. It was my belief that Bobby had given the dog a shove on his way out the window, but whenever I'd ask, he'd just give me a funny smile and say he hadn't done anything. Bobby had a mischievous streak, but compared to the bad boy I had been at his age, he was a walking angel.

My skin was sensitive for quite a long time after I was burned, but the doctors were correct in their prediction that I wouldn't suffer any permanent scars, a fact for which I am eternally grateful.

I began taking life-drawing and watercolor classes part-time nights at the New England School of Art in Boston. Even though I had seen a lot of naked women in the burlesque houses of Scollay Square back in my teens, it always amazed me when a model would step onto a raised platform, drop her terrycloth robe, and pose nude for the class. There were quite a few ex-servicemen in the class, attending on the GI Bill. Their motives seemed more geared toward snickering and leering at the naked women than in learning the finer points of anatomy and composition.

Trying to be the serious artist, I'd sketch and paint diligently.

I saw my brother Joe pretty much every Sunday when the family gathered after church at Gramma and Grampa's house. During one of those visits, Joe told me that he, too, was having severe stomach problems and had gone to see a doctor. Joe's ailment seemed far worse than my own stomach problems, and it was causing him great pain.

A letter I wrote to the art director of *Life* magazine around this time gives insight into what I was thinking and seeking in my art:

Dear Mr. Quint,

My name is Robert Caulfield and I live in the city of Lynn, ten miles north of Boston. It is quite fitting to be near Boston, for one can go and gaze at the well-known galleries on Newbury Street and dream of someday having one's own paintings hanging in one of these gallery windows. I consider myself an artist. Just how good, only time will tell. I am still young, only thirty years old; although, at thirty, Signac and Lautrec were already proving their genius. How good am I? This is a question which often plagues me. In a day when our society demands strict education and tutelage under name instructors in art, could it be possible to do it all alone, by one's self? When I approach art galleries about showing my work, the first question I'm asked is, Who have you studied with, followed by, What art school or college did you graduate from? True, these might seem essential, and it would be wonderful to have that background, but do these attributes make a painting of quality or is it the hard work, time, and effort given by the artist that makes a painting excellent?

I have been painting in oils since I was eleven years old, long before the sudden craze for art and Sunday painters. I was always told never to copy other paintings. Here again, if an artist is personified by his desire to be really different and have a style of his own in art, teaching is of no importance. The teachers I've had have all screamed, "Create!" "Be yourself!" Vincent van Gogh was ardent in his copying of Millet, and many other artists through the ages learned to create and have a style of their own through personal desire—something inside them had to come out.

I come from a broken home and was raised in part by nuns, so it seems fitting that the first time I entered a painting in a New England exhibition that it would be of nuns, whom I have a fond love for. To my astonishment, the painting was accepted and I thought to myself, Here is my painting hanging among such artists as Gruppe, Woodward, Ballanger, and Strisik. I began wondering what I could do if I painted for a living? Just how good would I become? Maybe I could really make a name for myself and still support my wife and four children. I am in the process of doing a series on

Beacon Hill, Boston street scenes. This year, one of my Beacon Hill scenes of Louisburg Square was selected for the Jordan Marsh exhibition. I wonder out of the thousands who entered, how many had degrees and still weren't accepted?

I know *Life* every now and then has selected subjects on everyday life. That is why I am writing this letter to you. If you ever do an article on art today and want to portray a young family man in the middle-income bracket, struggling to make a name for himself in art, maybe you'll consider me.

Sincerely,
Robert Caulfield

This letter is a good indication of my beliefs and thought processes at the time. Many people are under the impression that art springs up out of nowhere—that art is some sort of wild passion or reckless inspiration leading to the creation of something astonishingly new. In part, this is true. I am a very emotional painter, and I have to feel something when I'm painting. But the rules of painting are rigid, no matter what form a painting takes. These rules must be mastered before anything new can evolve. Up to this point, my art education had been scattershot, so I drew more and more on the drive that compelled me to paint in the first place. My instincts led me to follow more traditional forms of painting such as landscapes, rather than abstractions, and I found a forum for my self-expression within these traditional forms.

The art editor from *Life* sent me a snippy reply in which he suggested I should go into Boston and show my paintings to the big gallery owners there. He was probably right, but I felt I was still a few years away from being good enough for Newbury Street.

Before the advent of art curriculums in schools of higher learning, young artists through the centuries were apprenticed to a master artist for a period of years in which they would learn the traditions of anatomy, perspective, color, design, and so on. Many artistic concepts reach back to the ancient Greeks, though oil painting on canvas is a relatively new art form. It arose during the sixteenth-century High Renaissance in Italy, and gained prominence with one of its first and greatest practitioners, Titian. Titian used the new medium of oil paints because the damp climate of his native Venice wasn't conducive to the use of wet plaster, the medium Michelangelo used to paint the frescoed ceiling of the Sistine Chapel.

To look at it through the medium of verbal expression, a writer first has to learn the rules that govern language before he can create a story. I missed out on having this kind of all-encompassing artistic education.

By combining what I had learned in my studies with what I continued to learn from reading art books, my style evolved into one that was satisfying to me.

In my years of playing sports, I had never for a moment doubted my athletic ability. I was a fierce competitor on the playing field, and I reveled in victory. In sports it seemed easy to separate those who had talent from those who didn't. The proof was absolutely in the athlete's performance. In the art world, things are not so cut-and-dried; too many subtle factors can separate a good artist from a bad one.

Overtime at work was cutting into my class time at the New England School of Art. This, along with economic pressures involving the new baby, led me to quit my studies. It was a big disappointment and seemed like a replay of when I'd had to drop out of the School of Practical Art a few years before for the very same reasons. I haven't had a formal art lesson since.

14

RUGGLES STREET

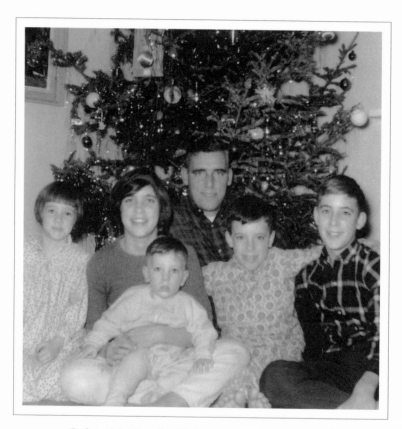

(Left to right) Lorelle, Cindy, Wayne, me, Craig, Bobby.
Christmas, 1966.

574 Main Street, Lynnfield, Massachusetts.
The display case for my artwork
can be seen to the left of the front door.
1969.

Seismic Shift

Grampa Caulfield never lost the faculties of his sharp mind, even as he approached the age of ninety. I still consider him one of the most well-read, intelligent men I've ever known. By 1962 the apartment he shared with Gramma Caulfield and Aunt Dot on Harvest Street had become too big for their needs. They moved to an apartment in a two-family house on steep Bellevue Road, in the hilly section of East Lynn. Aunt Dot continued living with them in their new second-floor apartment while Uncle Leo and Aunt Mary took the apartment on the first floor.

While Grampa remained lucid, Gramma Caulfield had been suffering episodes of confusion and forgetfulness for a year or two, the first telling signs of what would be diagnosed as Alzheimer's disease. In those days the memory loss that characterizes Alzheimer's was called senility. Increasingly as I walked through the door on our Sunday visits, Gramma Caulfield wouldn't know who I was. The kids got a kick out of it because one week she might call me "Harpo" and one of them "Bozo," or some other name she'd picked up watching television. The matter was treated with acceptance in the family. Her failing memory was viewed as an inevitable aspect of her great age, and we were thankful her physical health was still good. Gramma and Grampa Caulfield loved their great-grandchildren dearly, and it was always wonderful to see their faces light up when the kids came charging into the living room every Sunday. But seeing my beloved grandmother slowly fade away before my eyes was still difficult.

In April of 1962 I was promoted to Working Foreman of the Gas Distribution Department, a promotion that carried a small annual raise. The move into management and the additional money I was earning did nothing to alleviate my financial worries. It was always something: new clothes for the kids, ever-increasing grocery bills, something breaking in the house and needing to be fixed, or a problem with the car. The endless stream of bills running through our mailbox never came close to running

dry. It seemed impossible to keep pace with the unrelenting financial pressures, never mind getting ahead in the world.

I continued to enter my paintings in the Jordan Marsh exhibition, and every year my work was accepted. I also entered work in the Boston Arts Festival, but faced only rejection from the committee there. Finding time to paint was never easy. Overtime not only extended my workdays Monday through Friday, but often took up Saturdays as well. I often felt that while I was living a very full life with my family, my ambitions as a painter were going nowhere.

A bright note during this time was meeting an artist named Max Gordon. Max had taught art for many years in the Lynn school system, and had retired in his fifties to pursue painting as a full-time vocation. He had become quite successful on the local level and was one of the better-known artists at the time in Massachusetts. He was a kind and generous teacher, and I learned a lot from him. Marilyn and I would visit him at his home and spend hours discussing art. I used to dream that one day I might take his place in the local art scene. I shared my doubts about ever having any genuine success as an artist because I was already in my early thirties, and too old. He laughed and said I was just a kid; he assured me I still had plenty of time to make my mark on the art world.

On a Friday afternoon in late November of 1963, I was getting ready to break for lunch when one of the members of my crew came running over, yelling, "The President's been shot!" Within the hour we knew that John F. Kennedy had died in a Dallas operating room. The next few days were a mixture of grief, fear, and disbelief for the entire world. I was sitting at home with the kids watching a live NBC broadcast from a Dallas jail on Saturday, November 23, when Jack Ruby blasted Lee Harvey Oswald from this life. One must remember these events all took place in an atmosphere perpetuated by the height of the Cold War—an atmosphere that defined the word paranoid. It seemed as if chaos had become the governing principle of the world.

The nation was united during the dismal days following Kennedy's assassination, as millions watched the president's funeral live on television. Kennedy's assassination is often referred to as "the death of America's innocence." I don't know if such a broad statement is true or not, but that man's death was certainly the end of the zestful idealism that had pumped through America's veins since the end of World War II. The people of Massachusetts had lost one of their own. Kennedy had served as a symbol of pride for Catholics and people of Irish descent the world over. His loss felt like a personal one.

Cataclysmic events like the death of JFK are few and far between, and though they have an effect on the mass psyche, daily life continued on exactly as it had before. The kids still went off to school every day, and I still went to work and continued painting. In February of 1964 we watched the Beatles perform on *The Ed Sullivan Show* like everyone else in America. The kids loved them. Although I liked their music, all I could see through the hype and hysteria were four young guys who needed haircuts, singing and playing in a band. I didn't realize I was witnessing the beginning of a seismic shift in American culture.

For years George Carrette had been asking Marilyn and me to come to Washington. In April of 1964 we drove down to visit George and his wife, Skippy. The events of the previous November still occupied every other conversation in the capital. We stood in a long, meandering line for hours with thousands of other mourners at Arlington National Cemetery to pay our respects at Kennedy's grave. The president had been buried on a steep hillside. A short, white picket fence surrounded a small marble headstone on the left and a small white cross on the right. In between these lay what appeared to be a pile of moss and sticks, on top of which burned an eternal flame. Floral tributes and wreaths covered the rear of the picket fence. Many of the mourners were sobbing and crying. It was all so profoundly sad.

That night after dinner George took me aside and told me tales very few people had heard at the time. John Kennedy had not been the devoted family man portrayed in the nation's press. George told me that Kennedy "was the biggest ass man in Washington." I was absolutely stunned as George went on about nude swimming parties in the White House pool, screaming matches with Jackie Kennedy, and an endless parade of girlfriends. This was at least a decade before any of these aspects of Kennedy's life became common knowledge.

George's position as a White House guard facilitated his arranging a VIP tour of the White House for us. It was great to spend time with him again and reminisce about the old days in Lynn. Now, as we approached our middle thirties, here we were—both family men with wives and children. Marilyn and I saw the Washington tourist sites like the Smithsonian and the presidential monuments, and I never said a word about what George had told me until we were in the car on our way home. Marilyn had a tough time accepting the revelations about Kennedy as fact. Our generation had never questioned their government or the media's representation of public figures, and having one's belief system shattered in the extreme was hard

to accept—especially considering that at the time, Kennedy was idolized and almost worshiped as a martyr.

Marilyn had always wanted a large family. Lorelle had turned three in the fall of 1964, and we felt it would be nice to have another baby around the house. Now aged thirty, Marilyn had some doubts. By the standards of the time, she was afraid that she might be too old to have another baby and worried about possible complications. Nevertheless, by December she was pregnant. In August of 1965 she gave birth to our last child, a blond boy with blue eyes we named Wayne.

Even before Wayne's arrival, our little house on Falls Street had grown too crowded for all of us. Marilyn and I began spending weekends looking at larger homes. Marilyn's sister Dotty had moved her family to an adjacent town called Lynnfield the previous year. Where Lynn was a sprawling city with lots of industry, Lynnfield was a quiet and classic New England town of leafy streets, broad lawns, and colonial homes, founded in 1814.

In November of 1965 I came home just before Marilyn was putting dinner on the table, when the power surged and the lights went out. They stayed out until the next day in the worst blackout up to that time. It affected the entire Northeast from Buffalo to New Hampshire, and left thirty million people without electricity. Even though I worked for the Gas Company, we had an electric range and oil heat in our house. Our neighbors Marge and Fran Crist had a gas oven, and with their help Marilyn kept us all fed until the power came back on the next day.

Another cultural event of 1965 impacted our lives directly. Three years earlier, Pope John XXIII had begun the Second Vatican Council. Pope John envisioned the Catholic Church being brought up to date and adapting to meet the challenging conditions of the modern era. His wish centered on the Church confronting the needs of modern life, remaining old and new at the same time. These wishes and the subsequent councils resulted in the sweeping reforms adopted by Pope Paul VI and Vatican II in 1965. Among the numerous changes, Catholics were no longer required to eat fish on Fridays, and Mass and the sacraments (such as communion, confirmation, and penance) could now be administered in English rather than Latin. The greatest impact Vatican II had on my life was its ecumenism: The Catholic Church now reached out to all Christian faiths and acknowledged them, including Marilyn's Baptist faith. Prior to Vatican II, all other forms of Christianity had been disavowed and Catholicism had been considered the one true faith by the Church.

Religion had never been an issue between Marilyn and I. Vatican II didn't bring any changes to our personal lives, but it did affect the way society and other Catholics perceived our union. All of the children were baptized in the Catholic Church. Bobby, Cindy, and Craig attended parochial school, and by this time, Bobby had been an altar boy for a couple of years.

One autumn afternoon found us looking at an eight-room house in the town center of Lynnfield, not far from the two hundred-and-fifty-year-old town meeting house and the white-steepled Congregational Church. This particular house, at 574 Main Street, was itself over one hundred and fifty years old and had once been a parsonage. Twenty-four different Congregational ministers and their families had lived there in the years from 1839 to 1955. There were some wonderful features in the house, including a fireplace in the master bedroom and a large backyard abutted by hundreds of acres of conservation land; but on the whole, the house needed a tremendous amount of work. The wallpaper was shabby throughout, all the floors, woodwork, and ceilings would have to be redone, and the kitchen was an absolute disaster.

As we were leaving with our realtor, another realtor passed us with two other prospective clients, on their way in to take a look. We were back in the real estate company's office discussing the steep $25,000 selling price when the phone rang. It was the other realtor calling to say that her clients wanted the house. While it seemed like a setup, the realtor assured us that it wasn't, and as expensive as the house might have seemed, it was a bargain in the Lynnfield market. Marilyn loved the house, and was constantly talking about what it could become. The asking price gave me a few sleepless nights. Not only would we be saddled with higher mortgage payments for the next thirty years, but where would we find the money for all of the renovations that needed to be done? Somehow I pushed my doubts aside, and we bought the house.

I had to work overtime the night before the big move, and didn't return home until 7:00 A.M. This was only a week before Christmas. I went to sleep in one of the kids' beds, and when I woke up, the house didn't have a stick of furniture in it. The movers had taken everything around me except the small twin bed I was sleeping in. It was snowing as we all hopped into our station wagon. As I pulled away, the kids all waved good-bye to 24 Falls Street.

On the surface, the border between Lynn and Lynnfield is almost imperceptible. Socially, Lynnfield is a world away. Most residents were professionals living amid understated affluence in the middle- and upper-

class neighborhoods that composed this town of around ten thousand people.

After the movers had set the kids' beds up and they had all gone to sleep, I lit a fire in our bedroom fireplace and Marilyn and I made a toast to our new home and to each other. In thirteen years we had come from nothing and had built a comfortable life for ourselves and our five children. Our marriage had grown stronger with each passing year, and so had our love. For someone who had never had much of a family life, I now had it all. There was only one thing left that I wanted to achieve. I had just turned thirty-five, and was determined to make some sort of mark on the art world by the time I turned forty.

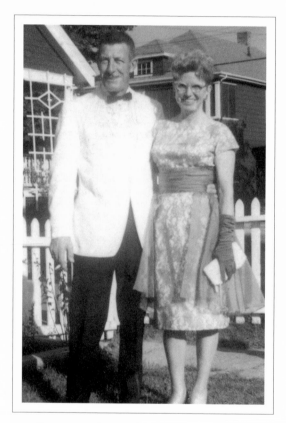

Leon and Ivadelle.
Lynn, 1965.

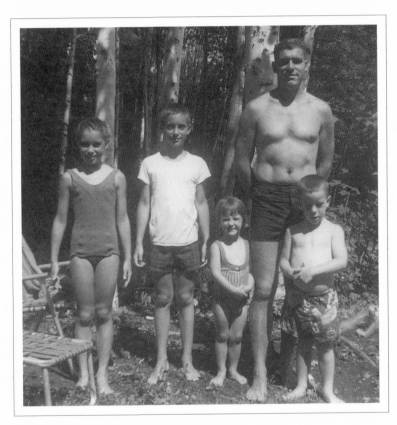

At camp.
(Left to right) Cindy, Bobby, Lorelle, me, Craig.
Summer, 1965.

A Golden Era

The fact that my children were growing up in a safe environment free of day-to-day material worries, in a suburban town filled with endless opportunities for fun and personal growth, brought me a deep sense of happiness. The Lynnfield public school system was among the finest in Massachusetts at the time. Along with the move to the new neighborhood, Bobby, Cindy, and Craig transferred from parochial to public school. The kids made lots of new friends, but our family remained at the center of all our lives. We still headed to Nahant Beach on summer weekends when we didn't head up to Leon and Ivadelle's camp. The kids would pile into our station wagon with none of today's concern about children's car seats and wearing seat belts.

The comings and goings of five kids and all their friends made our house a haven for youthful chaos at times. We experienced all the bumps and bruises, sicknesses and traumas, good times and bad times that kids go through, and although our finances were always tight, we were all very happy.

The move to Lynnfield added a little extra time onto my commute, and it now took about a half hour to drive to the Gas Company on the Lynnway. The secondhand Chevy station wagon that I'd purchased years before had served us well, but it was now on its last legs. I'd have to stop once on the way to work and once on the way back to fill it with transmission fluid. It got to the point where we were putting a lot of money into the car every week just to keep it going, so we bought our first new car, a pale green Ford Country Squire station wagon. In the years since, I've owned Volvos, Audis, and Mercedes, but nothing came close to the happiness and pride I felt the day I drove that Ford off the lot. What a joy it was to look out the window every morning and see my brand-new, shining green machine. I loved that car until the novelty wore off a few months later, and it became just another vehicle.

We still spent at least an hour every Sunday visiting Gramma and Grampa Caulfield. Gramma's Alzheimer's disease had completely obliterated her memory by this point. She would sit in her big stuffed chair muttering inane things during our visits. One time Grampa shook his head, took hold of her hand, and said, "May, we've lived too long."

Enclosed in an ornate pine cabinet, our color television was the first one to appear in our neighborhood. The kids had their friends over for the annual showing of *The Wizard of Oz* that first year so that they could all enjoy the color sequences. It was an incredible leap in technology considering the fact that fifteen years before, the standard black-and-white TV had a blurry, round, eight-inch screen. I was dazzled by the color programs that appeared among the majority still broadcast in black and white.

Every fall, we would pay a family visit to an apple orchard in Peabody called Brooksby Farms. One day, as we left the orchard with all the kids in the back of the station wagon chomping on apples, Lorelle suddenly gagged and choked. In a panic, I pulled the car over and pried a piece of apple out of her throat. After warning her not to touch another one, I drove off. Not two minutes later, she was choking again! Another stop, another episode of yanking a piece of apple from her throat. That was it for apples that day.

When anybody has the good fortune to look back on their life from the vantage point of seven decades, there will always be a portion of time in that span that seems golden. In terms of pure happiness and fun, for me, the mid- to late 1960s were that time. This is ironic in a way because the country was undergoing some of the most radical social transformations in its history: the civil rights movement, Vietnam, the youth movement, the feminist movement, equality and ecology—I followed the progress of each on television and in the newspapers.

Still working sixty- to seventy-hour weeks, spending as much time with Marilyn and the kids as I could, and then making time for painting left little time to dwell on all that turmoil. Lush Lynnfield lawns only felt the effects of sun, rain, and snow, not the blood and anguish that flowed onto so many of our nation's streets during that decade. I'd watch the events unfold on the nightly news, and it all seemed like it was happening somewhere else. It didn't touch our world in any direct sense. The war in Vietnam was a big concern for anyone whose kids were nearing eighteen years of age because the longer the war went on, the greater the possibility that their sons might get drafted. Bobby was fast approaching that age.

The night Martin Luther King Jr. was assassinated, somebody drove

through town and fired a bullet through the window of Worthen's, the local grocery store. I heard the rifle crack and the glass shatter—but that was the extent of any unrest in our peaceful neighborhood.

The most shining part of this golden era was the time we spent at Leon and Ivadelle's camp in New Hampshire. On those weekend trips, we'd try to leave Lynnfield by around four o'clock on Friday afternoon. Marilyn would have spent all afternoon getting the car packed with food, and all the clothes and toys that went along with the kids. I'd fly home from work and we'd be off in a matter of minutes.

After an hour of fighting highway traffic, refereeing the kids' arguments, and listening to them say "Are we there yet?" for the hundredth time, we'd pull onto the country lanes of New Hampshire. These rural roads led to a dirt road cut into the forest. In the distance, the high-pitched hum of a motorboat would be competing with the buzzing of cicadas up in the treetops. I'd navigate my way around the potholes, and if you looked to the right through the trees, down a slope, you'd catch glimpses of a shimmering sun sparkling on the sapphire-blue lake. The kids would be out of their minds with excitement now that we'd almost arrived at our destination.

Having heard our approach, Leon would always be standing on the dirt road in front of the cottage he called "Birch Haven," usually with a cigarette or a cigar in his hand. He'd serve as traffic cop and help guide the car into one of the moss-covered parking spots that had been cut into the side of a steep hill covered with birch trees. The kids would be out of the car in a flash, hugging and kissing Leon, then dashing off on a search for Ivadelle. More often than not, Marilyn's sisters Dotty and Rene and their families would come up for the weekend. It's hard to imagine that the little five-room cabin could hold eight adults and ten kids, but we managed. The camp also had a long, screened-in porch that faced the lake, and Leon and Ivadelle slept out there all summer long in the chilly night air, under an electric blanket.

When he was first learning to speak, Bobby had trouble saying "Grampy" and called Leon "Bampi" instead. Leon was forever after called Bampi by all of the children. The kids called Ivadelle "Nana." Leon had a sweet old black dog named Duchess, and the kids never tired of playing with her or catching rides on her back. At night after everybody was in bed, Duchess would walk around the cabin, the click of her toenails on the linoleum floors all that could be heard in the night silence. The raccoons up there were as big as dogs, and hardly a night went by when the racket they made while raiding the garbage cans didn't wake me from a sound sleep.

Days at camp were spent swimming, boating, waterskiing, hiking, and socializing. Leon still loved to play horseshoes and never tired of beating his opponents. There were always huge meals and cookouts, often served outside on a picnic table by the shore. Leon taught all of his grandchildren how to dive from the wharf his sons-in-law had helped him build. The camp had no television, and didn't have running water until around 1969. Until then we had to use an old-fashioned hand pump outside the kitchen door. The camp never had a shower and you had to soap up and jump into the lake to bathe.

At night the kids would play board games like Parcheesi or Monopoly, toast marshmallows, or make popcorn in metal baskets that were held over the flames in the massive stone fireplace. There was an old wind-up Victrola record player, and the kids never tired of playing all the old 78-rpm records within its mahogany cabinet. One in particular was an old novelty song called "The Milk Bucket Boogie," which included the sound of a cow mooing at various parts in the melody. Through the years I must have heard it played five thousand times.

When it came time to leave on Sunday afternoons, I hated going more than the kids did. After all the good-byes, we'd drive away waving to Leon and Ivadelle as they stood on the steps leading to their summer paradise. It always felt like leaving some sort of enchanted land as we drove out of the sun-dappled forest back into the workaday world.

One time on our way home, Bobby, Cindy, and Craig were way in the back of the station wagon goofing around like they always did. What I didn't realize was that this particular time, they'd collected a bunch of tiny pinecones in the woods, cones about the size of a raisin, and were sticking them in one nostril, then covering the other nostril and snorting them out at each other. When all the laughter stopped, I looked in the rearview mirror and saw blood pouring down Craig's face. He'd sniffed a bit too hard and a pinecone had gotten stuck in his nose. None too happy, I pulled the car over and somehow got the pinecone out with a bobby pin. The station wagon had an electric back window that was open about an inch, and when we pulled away I pressed the button to roll it up. Craig got his fingers jammed in it and yelled like hell, so it wasn't the best day he ever had.

My job paid an average salary, and a large portion of my paycheck went to taxes. Going out to dinner or even a movie was an event for us at this time because it was so rare to have any extra money; even with Marilyn's new part-time job selling lamps at Jordan Marsh in Peabody,

we just couldn't afford this type of luxury very often. We kept close with many of our friends from Lynn and still do to this day. There were lots of wonderful new friends who came into our lives in Lynnfield, as well.

Peace and good feelings were in the air and coming to full steam during the "Summer of Love" in 1968. For us, that summer meant a road trip to Niagara Falls with the three oldest kids. Lorelle and Wayne were still too young for that long of a trip, and a long trip it was. Cindy was in the throes of teenage rebellion at thirteen and a half, and leaving her new boyfriend behind for a family trip was something she loathed doing—a fact she relentlessly shared throughout the endless drive. Although the car didn't have air conditioning, the summer heat was eased somewhat by keeping the windows rolled down. The Falls were spectacular, although nothing struck me enough to want to paint it. We went on the catwalks and the *Maid of the Mist*, and saw as much of the tourist side of things as the kids could stand. I returned from that trip more exhausted than when I'd left.

We were strict but fair in raising the children, but as the '60s wore on, it seemed every social norm that had been rock-solid and unquestioned by our generation was turned on its head. I grudgingly let the boys grow their hair longer and wear bellbottoms. The new social mores weren't all that thrilling to Marilyn and me as we worried about the effects of such radical change on our two teenagers. The worst fear of all was drug use. When I was in high school, drugs weren't a part of our reality. There may have been a few kids who smoked pot or sneaked some of their parents' pills, but I never knew any of them. I didn't have my first taste of alcohol until I was in the marines.

Looking back it seems impossible that we were that square or clean-cut, but we were. Hippies, drugs, premarital sex—parents felt a lot of fear about what was going on—fear that was intensified by worry over their children's future. The local young people who had adopted the hippie ethic used to gather at "the wall," a stretch of old granite stones that faced a colonial-era cemetery in Lynnfield Center. Whenever I'd drive past, I'd look at the young kids with their beads and beards and wonder how many of them truly believed in their peace and love proselytizing, or if they were just following fashion. Who am I to say? By 1970 I was sporting long sideburns, longer hair, and bellbottoms, too.

Coming home after a twelve-hour workday one night, the phone rang and my Aunt Dot was on the line. She told me they had brought Grampa Caulfield to the hospital earlier that afternoon, and she suggested I go to

see him because he wasn't doing well. Marilyn was working at Jordan Marsh, and I was watching the kids. Finding a babysitter would have been a hassle on such short notice. Besides, Grampa Caulfield had been in and out of the hospital more than once in recent months for arteriosclerosis and problems with his eyes. He always pulled through. I put off going to see him until the next day.

When the phone rang early the next morning as I was getting ready for work, I was told that Grampa had died in his sleep. He had reached the age of ninety-one and a half years.

I was crushed by such a wave of guilt and sorrow it almost knocked me off my feet. This fine, decent, and kind man had helped save my life and that of my brother. On the cold January day they lowered his casket into the earth of his adopted country, my grief was absolute. It took me a long time to forgive myself for not saying good-bye to the man I considered my true father. You can never overcome a loss like that, only come to terms with it.

Gramma Caulfield often claimed people were stealing her money, which was funny because she had no money to steal. She had placed a tray of light bulbs in the oven one Sunday and hollered that somebody had stolen her pot roast when the red-hot bulbs were discovered and taken out. Even in her severely diminished mental state, Gramma was adored by her children and all of her family. Aunt Dot was especially adamant that Gramma Caulfield remain at home and not be placed in a nursing home.

I became involved with the Lynnfield Art Association at this time, one of the most active art associations in Greater Boston. There were weekly meetings and regularly scheduled exhibits. Through the Art Association I became involved with the American Mutual Insurance Company in Wakefield, Massachusetts. American Mutual was a generous sponsor and patron of the arts. Once a year, an art show would take place in the sleek slate-and-glass lobby of their modern offices on the shores of Lake Quannapowitt. This show included paintings submitted from artists all over the country.

In addition to their local patronage of the arts, each year American Mutual published a national calendar featuring a different painting for each month. Thirteen artists were chosen to illustrate the wall calendar, with the most prestigious honor going to the artist who landed the cover. There was no payment involved—just the distinction of national exposure. One of my paintings, "Wakefield Common," was chosen to illustrate the

month of May in 1969. This was a thrill because it represented my first nationwide exposure. The honor came with an award and a fancy banquet at a top-notch restaurant. The director of American Mutual came over to me after dinner and said, "You look more like a state trooper than an artist." I have no idea what people expect an artist to look like, because to this day I still hear that I don't particularly look like one.

I may have presented a conservative appearance to the world, but I was anything but that on the inside. I wanted to attain some renown in the art world, but it looked like time was passing me by. My emotions were boiling and I was often moody as I approached forty. I had heard somewhere that if you hadn't attained some success in life by age forty, then you never would. I was trying to accept the fact that my artistic aspirations were blowing away into the realm of "never would." Emerson said, "The mass of men lead lives of quiet desperation." I didn't want to join their ranks. The dream that had fueled my painting for so long—the desire for success and recognition—was drifting away, pushed aside by the reality of supporting a seven-person household. Whatever turmoil I felt creatively was always mediated by my love for my family. They would always come first.

Despite the lack of success on a grand scale, my paintings were selling at a good clip, averaging a few hundred dollars each, even without a formal relationship with a gallery. In fact, it seemed impossible to find anybody to represent my work for longer than a few months. I had approached a number of galleries in person and by mail, and had faced repeated rejection. The sales I did make came from art association exhibitions, or American Mutual and Jordan Marsh exhibitions.

After moving to Lynnfield we approached the town about opening a gallery in our home, but this request wasn't approved by the zoning board, despite our living one house away from the commercial district known as The Center. A compromise was agreed upon whereby we could have a small sign posted beside the driveway that read ROBERT O. CAULFIELD, ARTIST. To the left of the front door we erected a glass-fronted display case, and I would change the paintings in the case every month or so.

On the job one day my crew was heading through a woman's kitchen on the way to her basement when I spotted an American Mutual calendar on the wall, opened to the month that featured my painting. I pointed at it with the wrench I was carrying and told the woman that it was my work. She gave me a funny look for a moment but then was very excited to meet the artist in such an unlikely way.

The phone rang with bad news once again about a year after Grampa Caulfield's death. Gramma Caulfield had taken a turn for the worse. Her senile dementia had progressed to the point where she was getting violent, making it virtually impossible for Aunt Dot to take care of her at home. She had been taken to the Danvers State Mental Institution. It was not uncommon in those days for Alzheimer's patients to be sent to such a facility.

I wasn't going to risk not seeing Gramma Caulfield after what had happened to Grampa, so I drove to Danvers that night in a heavy rain while lightning slashed the sky. The institution was housed in a series of nineteenth-century Gothic buildings atop one of Danvers's highest hills, not far from the spot where many of the victims of the Salem Witch Trials had been hanged. The chill, the wind, the gloom of a late winter's night—it was like driving into a bleak and spooky nightmare.

The rain drenched me as I rushed toward the hospital entrance. There, an expressionless nurse with cold eyes greeted me. She escorted me to one of the wards as flashes of lightning outside the windows scattered dancing shadows down the corridor. An ear-splitting clap of thunder rocked the building. Horrible human squeals and shrieks echoed down the hallways. Stray light bulbs would illuminate the electric glare of insane, wild eyes peering at us from out of the darkness.

The nurse led me into a ward lined with large cribs in which lay not children but old women. The women reached out and tried to grab me, their gnarled fingers desperate to secure some human interaction. Others were asleep with dolls cradled in their arms. Some kept calling out for their mothers, while others just babbled. The nurse left me at Gramma's crib. I looked down at that familiar wrinkled face and glanced into her eyes. She wasn't there. I reached into the crib and smoothed her hair, telling her that I loved her. I thanked her for everything she had done for me. This was my true mother, the first person who had ever showed me love or treated me with decency.

Gramma and Grampa Caulfield were old-school. They weren't physically demonstrative and never hugged us or told us they loved us, but the force of their love was overpowering. You knew without explanation that they loved you deeply. Gramma Caulfield had saved my life, and now when she was at the end of hers, I was helpless to do anything to save her. I took hold of her hand and stood there for quite a while. I think on some level, deep in her soul, she knew I was with her.

I called Aunt Dot when I got home and told her we had to get Gramma Caulfield out of there; it was no kind of place for her to spend her last

days. Our family hadn't been made aware of the dated and near-inhumane conditions at Danvers before my visit.

Gramma Caulfield was removed and taken to a nursing home. She died there not long after, on April 25, 1969, at the age of eighty-nine. I miss her still.

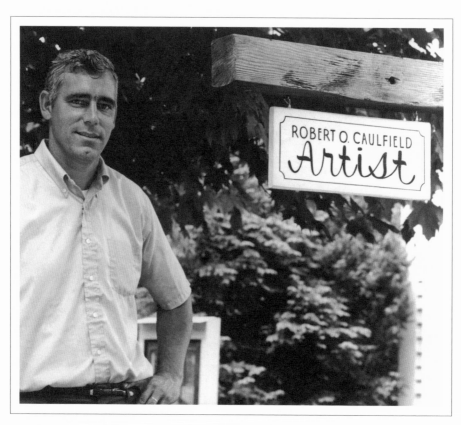

Lynnfield.
1969.

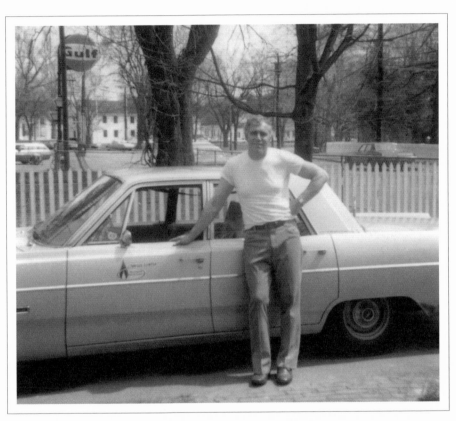

Me and my company car.
Early 1970s.

Dreams Die Hard

As a working foreman at the Gas Company, I was a member of both the management team and the working crew. While my allegiance was split between the two sides, I felt a stronger bond with the crew because I'd been a working man for over ten years and I was still a member of the union. As is often the case in employee-management relations, talks regarding a new contract between the union and management reached an impasse, and word went out that there was going to be a strike. This was in 1969. The strike came as a big surprise to me; I'd been working for the Gas Company for over fifteen years and there had never once been a work stoppage. A few months after Marilyn and I were married, I had walked a picket line for General Electric for a week. That had been my only experience with strikes.

Members of the union were assigned shifts to walk the Gas Company picket line. My shift was usually from midnight to 7:00 A.M. Walking that line got awfully cold as the night wore on, and the men would keep empty fifty-gallon oil drums full of burning wood. The flaming wood inside the drums would pop and snap and send showers of glowing sparks swirling into the air. I watched the sparks fly away into the black night and it made me think of the time when I was a kid, and saw the burning cats in the barrels. There was lots of coffee and all the men would grumble about how they were going to keep afloat financially if the strike lasted more than a week or two.

Marilyn and I didn't have any substantial financial reserves at this time in our lives. There was a definite fear among all the workers at the Gas Company that the strike might go on for many weeks, if not for months. If the force of everybody's worries could have taken form, it would have become a tornado. Marilyn still had her part-time job selling lamps at Jordan Marsh, but that didn't bring in anywhere near the kind of money we would need to make ends meet. Bobby and Cindy both had part-time jobs after school and offered to help us out if it came to that.

I went to the unemployment office to file for benefits. A bored bureaucrat told me that there was a two-week waiting period from the advent of unemployment until I could file a claim. What stung the most was that since day one of my employment with the Gas Company, I had had charitable deductions taken out voluntarily for the United Way; now my family needed help, and I couldn't get a dime. The strike wore on for three and a half weeks.

Toward the strike's end, two of the more elder foremen drove out to Lynnfield to tell me they thought it was way past time for me to become a full member of the management team. Not long after the strike was over, I was promoted to foreman.

The strike pulled me out of the emotional turmoil I'd experienced from not making a bigger mark in the art world. During the seventeen years I'd worked at the Gas Company, I had always believed artistic recognition was simply a matter of time—that my successful career as an artist was just over the horizon. Even though I liked the men I worked with and had some great times on the job, in many ways the job itself had become a sort of prison. I couldn't see a way out, especially after the strike. This made me realize how important it was to provide for my family. This was my reality check. It seemed that my success as an artist was a dream destined to exist only in my imagination.

When the strike ended and work resumed, I approached my new job as foreman with a renewed sense of purpose. A company car came with the job promotion—a nice perk—and there was also a raise in salary.

Our house in Lynnfield, though structurally sound, needed quite a bit of cosmetic work. I did a lot of it myself, and with the help of friends and relatives. Plastering, installing woodwork, and hanging wallpaper became second nature to me. With Bobby's help I completely renovated the kitchen during the winter of 1970. The tedium of all that carpentry work was relieved as we watched the Boston Bruins win the Stanley Cup for the first time in years, on a portable TV.

Marilyn and I went to visit an old high school friend of mine one night in the winter of 1971. He and his wife had recently returned from a vacation in the Hawaiian Islands. They brought out their snapshots and couldn't say enough about the beauty of Hawaii and how friendly the people were.

In February, Marilyn surprised me with a two-week vacation package for two to Hawaii. We would leave in March. To this day I still don't know how she pulled it off when our finances were so tight. Bobby was only seventeen, and we didn't think he was up to the responsibility of watching

his brothers and sisters for a week and a half, so Marilyn's younger sister Rene and her husband George agreed to come to Lynnfield and watch the kids for the ten days we'd be gone.

Marilyn had never flown before, and I hadn't been on a plane since my days in the marines. Our first stop was Las Vegas, where we stayed at the Sands Hotel. In 1971 elegance was still the rule in Vegas, and the casinos were filled with men in sharp suits and women dressed to the nines in evening gowns, jewels, and furs.

Next we stopped in San Francisco for a night before heading on to Honolulu. Stepping off the plane in Hawaii was like stepping into a warm, sunny summer dream full of flower-fragrant breezes. Except for a few three-day trips to the mountains in New Hampshire or the cursed trip to Quebec City, Marilyn and I hadn't been totally alone with each other for almost seventeen years.

At thirty-six, after having six children, Marilyn truly was more beautiful than ever. With her trim figure, killer tan, and blue, blue eyes, she still turned heads. We spent a few days on Kauai and the Big Island, where we walked over steaming lava from a recent eruption. This vacation experience was one of the best times of my life; an idyllic, romantic getaway with the woman I loved in one of the most beautiful spots on earth.

Ten days was a long time to be away from the kids, and we both looked forward to our return as the trip came to an end. Air travel in 1971 was far more luxurious than it is today. Genteel and unrushed, everything revolved around service.

When we stepped off the exit ramp at Logan Airport, all the kids were waiting for us. It was a terrific reunion. The kids had all behaved themselves while we were away, and all had gone smoothly—except for one incident when some of Bobby's friends came over and drank a few beers. Bobby hadn't even been home at the time. The basement was accessible through an unlocked trapdoor on the back porch, and the boys had gone down there to wait for Bobby, without asking anybody for permission. As they pulled out of the driveway, they banged into Rene and George's car and left a significant dent. It wasn't a big deal, but we were thankful that Rene and George had been there for us.

My new position as foreman came with a much larger burden of responsibility. As a member of management I'd go out on sites with a crew, but to my frustration, management was forbidden from doing any physical work.

I'd never been one to roll with the flow and was a typical "Type A" personality. I sweated everything. The stomach pains that had been bothering

me for years progressed to the point where they bordered on agonizing, so I went into the hospital for a number of tests. The results revealed that I had a duodenal ulcer. A strict bland diet was prescribed, and I followed that for the next few years. The diet lessened the pain quite a bit, but at times my ulcer would flare up and cause me a lot of grief.

My old friend George Carrette drove up to visit for a week that summer. He brought along his wife Skippy, his mother-in-law, and his five children. George's kids were full of high spirits, and for that week his kids and mine pretty much ran wild and just had a ball.

I had set up a studio in the basement beside a giant old furnace when we moved to 574 Main Street. I'd swing open the trapdoor on the back porch and head downstairs to paint a couple of times a week. It felt like stepping into a dungeon because I always had to close the door behind me so that none of the kids, or our dog Scamp, would fall through.

As the rigors and responsibilities of my new job became more apparent, I took long breaks from painting, sometimes going for three or four months without putting any paint to canvas. My desire to succeed hadn't lessened, nor had my desire to paint. It was more along the lines of trying to accept the fact that supporting my family as an artist was probably something that would never happen for me. Maybe all my dreams and aspirations were going to culminate in my becoming just another Sunday painter. I made that prospect more bearable by convincing myself that I'd always paint, but would do so without any expectations for success or recognition. The unrelenting creative drive that had fired my dreams was still burning within me, but it had been cordoned off by a wall of practicality.

Beginning when Bobby was around ten or twelve, I would take each of the children on a painting trip alone with me every year. It was usually a day trip to Gloucester or Rockport, but once in a while I'd drive up to Vermont for the weekend with one of the kids in tow. All of my children showed an aptitude for painting, some more than others, but they seemed to lack the overwhelming desire to draw and paint that had driven me since early childhood.

The American Mutual Insurance Company was very good to me. My paintings were eventually included in their national calendar five or six times. In 1971 they sponsored a one-man exhibition of my work in the lobby of their Wakefield office building, and I sold quite a few paintings. My Boston scenes were proving the most popular with buyers. Two Beacon Hill scenes were purchased by the Boston Gas Company for their headquarters at Number One Beacon Street for three hundred dollars

each. By this time in the early 1970s, I had sold well over one hundred of my paintings. Art sales are notably erratic, and while the extra money was nothing we could count on regularly, it always came in handy.

Bobby began his studies toward an engineering degree at Northeastern University in the fall of 1971. He transferred to Bridgeport University in Connecticut the following year to pursue a degree in business. Not wanting to burden him with student loans, Marilyn and I paid for most of his tuition and room and board. Bobby was an incredibly hard worker, and always had jobs during breaks and the summer months to help contribute toward the cost of his education. The summer before his senior year, I helped him get a job on one of the Gas Company work crews, and he enjoyed every minute of driving around the North Shore and digging ditches with the rest of the crew.

Cindy had gone out to visit relatives in Colorado and returned with a black-and-white mutt she'd named Shasta. Our cocker spaniel Freckles had been hit by a car and killed back when we lived on Falls Street. The grief the children suffered over his death made me swear we'd never get another pet, but I'd given in, and when we moved to Main Street, a collie mix the kids named Scamp joined our family. Scamp was also hit by a car. The children were so overcome with sorrow over his loss, I once again laid down the law. No more dogs. But Shasta's puppy ways and Cindy's persuasive skills broke me down yet again. Always independent, Cindy was out on her own and working in a bank shortly after graduating high school, leaving Shasta with us. Once grown, Shasta wasn't very good around kids. After she bit Wayne and then one of the kids' friends, we were forced to find another home for her.

Craig loved animals and had found a job taking care of a flock of chickens owned by a neighbor named Mr. Willard. Ninety years old and still very active, Mr. Willard lived in a rambling colonial house backed by acres of apple orchards, only a few houses up from us on Main Street. He kept thirty chickens in his barn and gave three to Craig to keep as pets, supplying us with fresh eggs for years.

I hadn't worked as a foreman more than a few years before I was offered a promotion to district supervisor. This position carried the responsibility of coordinating crews in a North Shore district that encompassed a number of towns: Swampscott, Marblehead, Lynn, Saugus, Lynnfield, and Nahant.

When I first received the job offer I was very happy, but when I took a look at the salary, I was less than impressed. New England Power—the corporate entity that owned Lynn Gas—was offering me barely a few hundred dollars more than what I had been making as a foreman. In the

end I couldn't turn down a chance to become part of upper management, especially since I didn't hold a college degree. I accepted the position. Within months, Lynn Gas was bought out by Boston Gas, the corporation that had recently purchased two of my paintings. The takeover brought a significant raise. Another financial benefit was the fact that even though I was on a management salary, I was paid overtime when I was called out on emergencies.

Beepers were cutting-edge technology at the time, and it seemed mine never stopped beeping. Awakened at any time of the night, I would have to drive to the location in my district where the problem had arisen. If Marilyn talked me into going out to dinner on a Saturday night when I was on call, Murphy's Law made it a pretty sure bet that the beeper would go off before the main course arrived. The worst eventuality in any potential gas line problem was that a house, or an entire neighborhood, could blow up. Preventing a catastrophic event like that was always in the back of my mind, and never did my ulcers any good.

In September of 1974 our youngest child, Wayne, began the third grade. Not needing to spend as much time at home now that the kids were getting older, Marilyn took a part-time job as a payroll clerk at the Lynnfield Town Hall. For the first time in our lives we were beginning to make some extra money, and decided to have a built-in swimming pool installed in the backyard. We also went on another vacation, this time with our neighbors and great friends, Christine and Richard Spillane, to Bermuda for a week.

Leon and Ivadelle had sold their farm in the mid-1960s and had moved to a smaller cape-style house a few miles down the road in Eliot, Maine. They kept the camp in Milton, New Hampshire, until the late 1970s, when they sold it to Marilyn's sister, Dotty. We would visit with Leon and Ivadelle at least once a month, and more often in the summer months up at camp. The rest of the year, either they would drive down to visit us, or we'd head up to Maine. Thanksgiving dinner was held at their house every year. We found space so that their three daughters, three sons-in-law, and twelve grandchildren could join them at the long table installed each year in the living room of their tiny home.

In December of 1974 I turned forty-four. All outward appearances indicated I was just another working man in the American mainstream. I could look back on my life and see that I had come a long way from my rough beginnings on the streets of Roxbury. The thought of ever experiencing poverty again was something I never let myself contemplate. I had a beautiful wife, five terrific children, a nice home, and most of the

comforts the middle-aged, middle class aspires to. I still believed that anybody who hadn't achieved success in the arts by age forty never would. There were exceptions, but they were rare. Though I hadn't achieved a smashing success, I still averaged a sale every couple of months or so, with my paintings averaging around three to five hundred dollars apiece. Dreams die hard.

Our Twenty-fifth Wedding Anniversary.
1977.

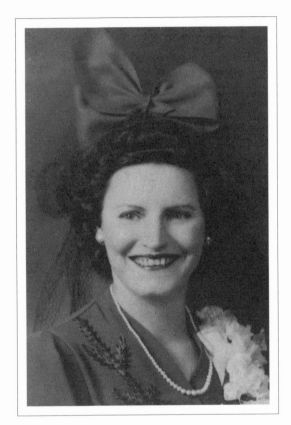

My mother.

Return to Ruggles Street

My childhood was something I never really talked about with Marilyn or the kids. They knew the basic facts surrounding my younger years, but Ruggles Street was nothing that I dwelled on. I had buried most of the events of my past, though in some way they must have played a role in forming my present. I tried to look at my beginnings in life as simply the card I had been dealt. Those long-ago events were all far beyond anything I could have ever controlled.

Some of my kids were more interested in my childhood than others, but all of them were fascinated with the mystery figure of my mother. By the mid-1970s it had been over thirty years since I had last seen my mother's face. I didn't have a single photograph of her. She had vanished from my life, and for all intents and purposes, from the earth as well. Nobody connected to my family had seen or heard of her since that day she had come to Gramma Caulfield's house, the last time I'd seen her. Where she had been so frail and sickly, I doubted that she was still alive. When the kids asked about her, I'd tell them about her blue eyes, dark hair, and flawless skin, as well as the fact she'd always been a snappy dresser. I left the fact she had been so cold and distant out of my recollections, but was very frank about her rejection of Joe and me.

One day I took Marilyn and the three younger kids for a ride into Roxbury to see the old neighborhood. It was a sunny day in the spring—one of those days when the last of the snow has melted, the trees are still winter-barren, and the promise of warm days to come freshens the air.

The mid-1970s were a time of violent social friction in Boston. In an effort to integrate the schools and provide better educational opportunities for all, inner-city students were being bused to other city and suburban schools, causing conflict. I hadn't been back to my old neighborhood since the 1940s when I'd gone to see Grandma Stoner and show her an art prize I'd won, only to find she had moved away. When I turned my station wagon onto Ruggles Street, a wave of memory crashed down and overwhelmed me.

221

The harsh sunlight exaggerated the decrepit state of the row house Joe and I had lived in with Grandma Stoner and her endless cats, conflicting with the dark and overcast memories in my head. We didn't get out of the car. I didn't think it would be a wise move for Joe Suburbia and his family to be strolling around those dangerous city streets.

As we drove slowly around the block, my eyes took in all the changes the years had wrought. The tiny lawns in front of each row house were now litter-clogged patches of dirt. The little picket fences were all gone and almost every windowpane was broken. The white paint that had once covered the walls of the row houses had flaked off, exposing gray clapboards. The entire block had the feel of a ghost town. The kids peppered me with questions: *Which house did you and Joe live in, Dad? Where did you see that man get beaten to death? Why aren't these houses painted? Did you have toilets back then?* I did my best to answer them even as I was trying to connect with that sad, wild boy I once was.

That night I tossed and turned and had trouble falling asleep. The return to Ruggles Street had stirred up a cauldron of terrible memories for me. I had forgotten just how awful my childhood had been. The effects of the demeaning poverty and the fear and uncertainty I had grown up with still lived on in me. It was a shock to find I remembered every moment of my childhood, when I had thought that the heartbreak had all been buried and forgotten in the past. The comfortable suburban life I had worked so hard to attain for my wife and family in Lynnfield was so many worlds removed from the squalid despair of my formative years. It was impossible to rationalize how witnessing the degrading parade of broken lives, alcoholism, and murder at that age could ever be connected to who I was now. As the days passed, I pushed the haunted memories away and focused on the present. Ruggles Street was a place I never wanted to return to, in memory or in life.

Not long after the Roxbury visit, my Aunt Dot gave me a photograph of my mother that she had found while cleaning out a dresser drawer. My mother looked just like I'd remembered her: manicured, fashionable, and lost. It's the only photograph of her that I have.

In February of 1975 our daughter Cynthia married Bradford Eaton, the young man she had dated since high school. Tall and handsome, Brad was immensely well liked by everyone, the sort of husband that any parent would dream of for their daughter. He was a couple of years older than Cindy and had recently graduated from college. Marilyn and Cindy spent over a year planning her winter wedding and reception. Fulfilling the promise of her childhood beauty, Cindy had grown into an extraordinarily

lovely young woman, with a personality and a heart to match. True to form, she was the most beautiful bride I had ever seen.

I continued exhibiting with the Lynnfield Art Association whenever they'd have a show. From time to time I would exhibit my paintings for short periods in other galleries. I always had a few paintings hanging in the Lynnfield library. Sometimes I'd exhibit my work in local banks, and one time, even in the lobby of a movie theater. A few of my Beacon Hill scenes were on display in a Brookline gallery when they were spotted by Tom Heinson's wife. Tom Heinson played for the Boston Celtics and is a Hall of Fame member. Mrs. Heinson liked my work and she wrote a letter telling me so. She was on the board of the Copley Society on Newbury Street in Boston, and urged me to become a member. The Copley Society is the oldest nonprofit art association in America, and among the most prestigious. Membership in the Copley Society is through competitive review and juried exhibitions. I had sent slides of my work to the Copley a number of times in the past, and they had always been rejected.

One night the phone rang, and the man on the other end of the line introduced himself as the vice president of the Copley Society. I guess Mrs. Heinson must have pulled some strings because the VP offered me membership—certainly a switch for this struggling artist—and I accepted the offer. From then on, the slides I sent into the Copley were usually accepted for exhibition. After I became a member I sold a couple of paintings a year through their gallery, with prices averaging between five and seven hundred dollars. I didn't take advantage of many of the social events they sponsored, due to my shyness and the fact that my job at the Gas Company was so time-consuming. Avoiding cocktail parties may have impeded my progress in the Boston art scene, but I've never been the type to stand around making idle conversation about art.

After having grown accustomed to the fact that I might never move beyond being a part-time artist, joining the Copley Society stirred my dreams of success and recognition on a larger scale once again.

My Uncle Owen and my Uncle Francis could not have been more different in terms of personality. If they had one thing in common, it was that they both smoked cigarettes nonstop. Uncle Owen was a very serious and sensitive man, while Uncle Francis was more jocular and funny. Uncle Francis was the one who had taken Joe and me down into his basement to watch him chop the heads off chickens when we had first come to live in Lynn. He had served in the army after World War II, and when I had gotten out of the marines I used to spend time with him talking about getting readjusted to civilian life. Soon after I became a member

of the Copley Society, Uncle Francis died of an inoperable brain tumor within three months of being diagnosed with cancer.

One evening, after I'd just sat down at the kitchen table for dinner, there was a knock at the door. When I opened it, nobody was there. I looked down and saw a tiny black puppy sitting on the threshold. Craig had bought the pup without my permission, knowing full well I had forbidden any more pets. Even the chickens had to go after three or four years because their coop, our yard, and our garage had become infested with rats. The new puppy was the runt of the litter, so tiny I could hold him in the palm of my hand. His big brown eyes melted their way into my heart within minutes. We named him Walter, and I swear that dog had a sense of humor. He soon grew into a real character. He was a Labrador mix, and the best dog we ever had. Walter was wonderful with children and his antics kept us entertained for the next eight years.

In June of 1976 Bobby graduated from Bridgeport University with a degree in business. The pride I felt the day he was handed his diploma was tremendous. Academically, my firstborn son had achieved what I had not, and by doing so, would have a far greater career path ahead of him. Bobby met his future wife at Bridgeport. An art major from Delmar, New York, Patricia O'Toole was effervescent and beautiful. She and Bobby married in 1977 and began their life together in Augusta, Maine, where Bobby had taken a managerial position with Digital Equipment Corp.

Once in a while I'd get some local press. Boston Gas published a company magazine called *Contact,* which featured articles about my artwork every so often. *The Lynn Daily Evening Item* ran an article about me in the May 15, 1976, issue which quotes me as saying, "This schedule of mine, doing my job with Boston Gas and painting when I so wish, has worked out very well and I have never regretted the decisions I have made in this respect. This arrangement has worked out well for me and I intend to continue painting while holding my job at the Gas Company." The article also gives some other insights into my life at the time, such as this quote: "My wife scrutinizes my work carefully and is my severest critic." Marilyn's role hasn't changed much over the years. She has a terrific eye for composition and I seek her advice to this day on every one of my paintings. The article continues with: "You know, I really can't describe exactly what it is. I love to paint, hoping for my own gallery one day, but my job with Boston Gas is great and I'm in no hurry to part with it." The journalist who wrote the article concluded with: "It appears that his mind is made up and it has been now for several years. Bob will remain a district supervisor with the gas company and

still there in his heart will be his love for painting, something that he doesn't intend to give up either."

The truth is, I would have quit my job in a second if I could have been guaranteed I would be able to support my family by selling my paintings. Assurances like that don't exist in the art world, however.

Marilyn and I began taking a yearly trip together for a week or so each winter. During this period we traveled to Puerto Rico, Aruba, Barbados, and Florida. In Barbados we stayed at a bungalow right on the beach. There was a private patio under the palm trees where we had breakfast every morning. The first morning, and every morning after that during our stay, a tiny red bird would come by and I'd feed him bits of toast. On our last day there, the bird flew onto my shoulder and dropped a flower into my pocket in what must have been some sort of thank-you gesture, and then flew away. I still have that flower pressed in a book. Beginning around 1977, we began taking the kids on an annual trip to Pompano Beach in Florida during February vacation.

Over the years, I sent slides of my work to several magazines— *Reader's Digest, Down East, Boston Magazine, The New Yorker,* and *Yankee,* among them. A few months after submitting my work, I'd always receive a polite rejection letter in the mail. Rejection was nothing new to me. I'd let a few months go by and then submit my latest work again.

In August of 1977, Marilyn and I celebrated our twenty-fifth wedding anniversary. Our family and friends surprised us with a big party, and it was a magical evening, spent with the people closest to us. In the first years of our marriage, money had been so tight that we celebrated our anniversaries at home. It wasn't until our seventh anniversary that we could afford to go out to a fancy restaurant. When Marilyn and I had run off together on that hot August night in 1952, we never truly gave any thought to the long-term repercussions of what we were doing. Our love was so strong that we couldn't see any other way of going through life unless it was together. Looking back, it didn't seem possible that twenty-five years could have passed. In 1952, quite a few people had been blatantly concerned that our marriage was doomed because of our differing religions. A number of those naysayers had ended up divorced themselves. Marilyn and I put our love for one another before all else, and that love only grew stronger as the years passed. It's different for everybody, but that's how it is with us.

The first few flakes of what was to become the Great Blizzard of 1978 began falling as I was on my way to work the morning of Monday, February 5. The snow didn't stop until late the next night. After a state

of emergency was declared, closing all the roads to automobiles, I was forced to stay at the Gas Company for the next three days. The storm dumped over four feet of snow on the metropolitan Boston area. Fierce winds kicked up drifts that measured fifteen feet in height. Over thirty-five hundred cars were stranded on Route 128. The ban on driving continued for almost a week after the storm, so I walked the seven miles home from Lynn to see Marilyn and the kids.

Craig graduated high school in 1978 and went off to New York City to study. I took a trip to New York to visit him and did a number of sketches all around the city. I hadn't been to New York since 1967, when Bobby and I had come to watch the Red Sox play the Yankees. As it had done when I'd first visited in the late 1940s, the city dazzled me with its energy and dynamic grandeur. My first painting with New York as the subject was a view of The Plaza on Central Park South. We visited the Metropolitan Museum and other tourist attractions like the Empire State Building and the Statue of Liberty. I loved Battery Park on Manhattan's southern tip, and painted a few watercolor scenes from sketches and photos I had taken when I returned to Lynnfield.

After three years of marriage, Cindy and Brad separated and filed for divorce. The news was difficult for me, but it devastated Marilyn. Cindy and Brad had appeared to be a golden couple living a very successful and happy life together. They had even recently bought their first house. The frictions that led to divorce had been building for some time, but neither Marilyn nor I had picked up on it. When I was a boy I had thought that everybody lived like me, and in some ways, I think I believed that Cindy and Brad's marriage was just like mine and Marilyn's.

With only our two youngest children left at home, Marilyn began looking for a smaller house. In late 1978 she found a three-bedroom colonial on New Meadow Road in Lynnfield, and we bought it. The best feature of the house for me was that half of the basement was finished as a den with wall-to-wall carpeting and wood paneling. The moment I saw that room, I could envision it as a studio. No more making my way through the trapdoor to spend time painting in the damp basement at 574 Main Street.

Bobby and Pat were still living in Augusta, Maine, and we drove up there on the day their daughter Kelly was born in April of 1981. As I held my first grandchild in my arms, my only thought was that like my own children, she would never have to suffer the horrors brought on by poverty. The next day we drove to New Hampshire to attend Cindy's second

wedding. The wedding was a quiet affair and that marriage eventually brought us two more grandchildren, Todd and Kimberly.

After sending in submissions of my work for years, in December of 1980 I received a letter from *Yankee* magazine, informing me that they would like a transparency (a four-by-five-inch slide) of one of my paintings, "to keep on file for possible use in *Yankee* . . . as a good possibility for a cover or center spread for one of our next year's fall issues." For once, it was better than an outright rejection. I had the transparency made, sent it in, and forgot about it.

In April of 1981, Marilyn and I made our first trip to Paris. Marilyn didn't want to stay in an American franchise hotel that might prevent us from seeing a more genuine side of the French capital. She booked us into the Hotel Burgundy, a small place near the Eiffel Tower. The hotel had a creaking, old, wrought-iron elevator, and the walls throughout the building were crammed with reproductions of works by the French Impressionists. Looking out of our window over the Parisian rooftops, I could hardly believe that my eyes were seeing the same city so many of the artists I admired had drawn inspiration from, and that many had lived in at one time or another.

I admired the city's acclaimed beauty, and filled a sketchbook with street scenes in no time at all. We climbed Montmartre, the hilly neighborhood that so many generations of struggling artists have called home. The magnificent white stone church at the summit is called Sacre Coeur. Marilyn's feet were so tired after the climb that she took her shoes off and soaked her feet in a fountain in front of the church. We strolled along the streets of Montmartre, which are lined with throngs of artists who set up easels to paint for the tourist trade.

The highlight of the trip was a visit to the Orangerie, a museum housing a number of Impressionist paintings. Many of Monet's water lily paintings were on display there before later being moved to the Musée d'Orsay. We visited the town of Vernon, located just outside Giverny where Claude Monet lived. Monet's house is now a museum. To stand in his yellow dining room and think of all the great artists who sat at his table, men like Renoir and Pissarro, was a wonderful experience. It was pure pleasure to walk through his garden and see the inspiration for some of his finest paintings.

Like most tourists, we visited Notre Dame, took a boat ride along the Seine, and stopped by the Saint-Lazare train station. I tried to take in every sensory experience I could, imagining how the Impressionists had observed

these very same scenes and drawn inspiration from them. Following our return from France, I plunged into one of the most productive periods of painting in my life.

The Boston Museum of Fine Arts held a comprehensive exhibition of the works of Camille Pissarro in 1981. I had felt an affinity for Pissarro's paintings of the French countryside and his cityscapes of Paris since discovering him in the 1950s. I bought a book in the museum bookstore that was to have a profound influence on my life. This book, *Camille Pissarro: Letters to His Son Lucien,* is an incredible journey inside the mind of a great artist; a man whose kindness and gentle qualities of leadership illuminated the Impressionist movement and inspired legions of other artists. Pissarro was a first-rate teacher, so much so that Mary Cassatt once said, "He was so much a teacher that he could have taught stones how to draw correctly." It was quite inspiring to discover that Pissarro had done his finest work in old age, work that shines with the vigor of youthful optimism.

I am often asked why I paint street scenes, and I always answer that it's simply what I'm drawn to emotionally. I hope that somebody looking at one of my paintings might see something through my eyes, or feel something that they may not have experienced, or that a painting might embellish their own experience. Many of my current street scenes contain horses and horse-drawn wagons, which were a common sight around Roxbury when I was growing up. There are numerous horse-drawn carriages adjacent to Central Park, and in the warmer months, they can be seen taking tourists around downtown Boston. Perhaps it's nostalgia on my part, but I often incorporate horse-drawn carriages into my work, rather than including automobiles. I try not to be overly philosophical about art, especially my own. I simply paint what appeals to me.

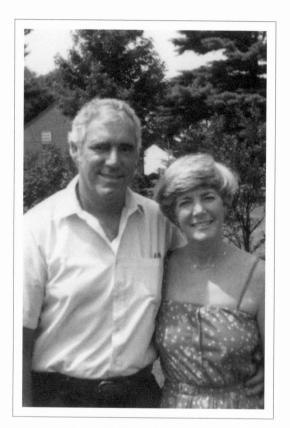

With Marilyn in the backyard
at 10 New Meadow Road.
Summer, 1982.

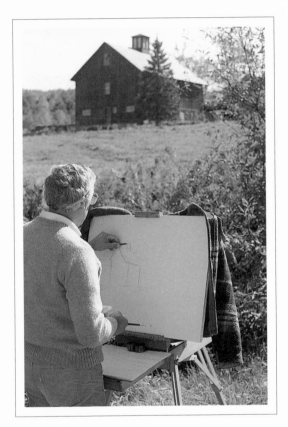

During the trip to Woodstock with Wayne.
October, 1983.

Woodstock, Vermont

Through the years, my work had been turned down by a number of New York art galleries. Banging on closed doors is part of any artist's life, so I'd revisit the galleries every other year with some examples of my latest paintings. New York is the center of the art world, and I was determined to exhibit my paintings there.

The Lynn Kotler Galleries were located at 3 East Sixty-fifth Street. Mrs. Kotler held exhibitions in which the featured artists paid a fee to have their paintings shown. Sales carried a twenty-percent commission instead of the standard fifty percent that most galleries deducted. I shipped ten paintings down to the gallery and drove to New York to attend the opening in January of 1982. Marilyn was unable to get time off from her job at the Town Hall, so Craig and Wayne went with me.

I had worked outside for over thirty years, but the frigid arctic air that whipped through the city on January 9 was the most severe cold weather I'd ever experienced. I worried about the temperatures affecting the turnout, but all in all, the reception for myself and a few other featured artists was well attended. I didn't sell any paintings, but at least my work was on display in New York for a few weeks.

In the summer of 1982 Bobby and Pat gave us our third grandchild, a daughter they named Krystle. One night in the fall of that same year, I came home from work and found Marilyn all dressed up for a night out. I'd expected a quiet night at home, but at her urging, I hopped into the shower and got dressed in a suit and tie. On the way to the restaurant she'd chosen for dinner, Marilyn asked me to pull over at a convenience store. She went inside and emerged a few minutes later with a beaming smile and an armful of magazines. She dropped ten copies of *Yankee* magazine on the seat beside me and said, "Congratulations, Bob. Your painting is the center spread." I opened one of the magazines and there it was, with the notation, *Stowe, Vermont, an oil painting by Robert O. Caulfield of Lynnfield, Massachusetts.* I couldn't believe my eyes. *Yankee* hadn't told me that one

of my paintings would be published, only that it was "a possibility." Marilyn kissed me. We were so thrilled to see my work in *Yankee*, we just sat there in the car for a few minutes, trying to absorb the fact that after thirty years of painting, my work had finally appeared in a national magazine.

Over dinner that night, Marilyn told me that Ivadelle had a subscription to *Yankee* and had received her issue in the mail a few days earlier. She'd called Marilyn right away to tell her the good news, and Marilyn decided to keep it a secret so that she could surprise me. We had a great evening. No matter how many times over the years I had tried to suppress my desire to become a professional full-time artist, the subject always made it back into my mind. We discussed the possibility of me leaving the Gas Company and finally pursuing art full-time.

Wayne, our youngest child, would be graduating high school the following spring. When he went away to college, we could quit our jobs and open a gallery somewhere. My work had been selling for years around New England. Why wouldn't we be able to replicate that success all around the country? No matter how much the dreamer in me wanted to chuck it all and run off to be an artist, the pragmatist in me didn't want to throw away the comfortable lifestyle I'd worked so hard for. My paintings had sold well, but sales were sporadic. At the time "Stowe, Vermont" appeared in *Yankee*, I hadn't sold a painting for almost a full year.

A few weeks later, I received word from the Copley Society that the very same painting that had appeared in *Yankee*'s center spread had been rejected for their latest exhibition. I didn't waste much time being angry about it. Politics again.

My son Wayne had a strong interest in photography, coupled with an excellent eye. By age seventeen he had already won some awards for his photographs. I asked him if he wanted to take his camera along on a painting trip with me to Western Massachusetts and Vermont. The weekend of October 8, 1983, I picked him up at his college in Westfield and we headed to Greenfield, where I wanted to paint the Patten area. I worked on a couple of landscapes while Wayne kept himself busy taking pictures of the colorful fall scenery.

Stephen Maniatty was a well-known landscape artist who made his home in Greenfield and maintained a gallery there. As a young man he had entered the Jordan Marsh Exhibition, and had won first prize. Wayne and I visited his gallery, and were amazed at the stacks of what seemed like hundreds of paintings there. We spent quite a lot of time talking with Maniatty about his career, and the art world in

general. Older now and a bit crotchety, the artist puffed on his pipe and sat at his easel, painting while we talked.

There was a scenic farm in Redding, Vermont, that I'd heard about, so we drove north to see it. The Jenne Farm offered a number of striking vistas. I was painting away at my easel in a rolling Vermont pasture when a bull charged out of nowhere, only to come to a snorting halt inches away from me, stopped in his tracks by a few strands of barbed wire. I took off, running so fast that I left a cloud of dust in my wake. Wayne laughed harder than I'd ever seen him laugh before; he had no idea I could still run that fast.

Wayne and I were heading home the next day along Route 4 in Vermont when we passed through the town of Woodstock. Traffic was heavy as it always is in Vermont at that time of year. Wayne yelled, "Dad, stop the car!" The endless line of cars in front of us had just begun to move a bit and I didn't want to stop. "Did you notice that house for sale?" he shouted. "That one there—the one beside the little park!"

I glanced back at the property in the rearview mirror but kept going. The excitement in Wayne's voice only grew stronger as he went on about what a great gallery the house would make. At his insistence, I pulled over about a half mile up the road, turned around, and headed back.

I parked in the driveway and we got out to take a look around. We were on Central Street, a main thoroughfare, and actually part of Route 4 as it passes through the downtown shopping district of Woodstock. The house for sale at 42 Central Street was adjacent to Tribou Park, a small, triangular expanse of lawn upon which rests a granite memorial dedicated to the men of Woodstock who fought in the Civil War. The park also features a Civil War–era cannon and a flagpole. The front portion of the house that had so appealed to Wayne was whitewashed brick, while the rear portion was a later wooden addition. Two seven-by-ten-foot windows fronted the street, but they were boarded up with plywood.

We looked through the side windows. What I could make out in the fading light didn't look very promising: buckled ceilings, peeling walls, old iron radiators lying around, and enough dust for a pharaoh's tomb. We went to the side porch and looked through another window. Wayne kept talking about how the large room on that side of the house would make a fine gallery once the plywood covering the windows came down and the parquet floor was refinished. The room also featured a fireplace as did the room across the hall, which also had a huge picture window. I got caught up in Wayne's excitement and my mind's eye could envision that room as a studio.

Wayne jotted down the realtor's phone number as we got back into the car for the return trip to Westfield to drop Wayne back off at school. We talked all the way home about what a wonderful gallery the house would make.

Marilyn wanted to see the house in Woodstock right away. She called the real estate agent and made an appointment to see the property that weekend. The moment I pointed out the house to her as we headed down Central Street, Marilyn loved it. After seeing the inside, however, our hopes crashed. The house had been vacant for two years. Almost every ceiling and floor would have to be redone. Many of the rooms in the one hundred-and-seventy-year-old house featured lime-green deep shag carpeting.

The realtor told us the owner was asking $165,000, explaining that the owner was also involved in a dispute with the town over the two picture windows, which had been installed without a building permit. The town had closed down the antiques shop he had been running because of the code violation. This was two years ago, and the town was still threatening to have the original windows reinstalled. The realtor told us there had been a number of businesses in the house in the past, and explained that although the house wasn't zoned for commercial use, the previous owners had run their businesses with home-occupation permits. Considering the sorry state of the house, Marilyn and I offered $125,000. We left it at that and drove home.

We figured there was no way the owner of the house would drop $40,000 off the asking price, and considered the chances of a sale slim to none. Marilyn had some serious second thoughts about a new life in Vermont after we made our offer. Trading our comfortable life in a metropolitan suburb of Boston for a new beginning in one of the most rural states in the nation was a bit daunting. So was the prospect of moving so far away from our family and friends.

While we were on another trip to France and Belgium, the Woodstock house crept into our conversations again and again The weeks passed after our return, and although we didn't hear anything about our offer on the house, the seed had been planted: We started to seriously consider early retirement and a move to Woodstock.

I would be turning fifty-three in December. If we took a chance like this, we would be giving up all the security we had worked for over three decades to build. I made some casual inquiries at work into early retirement and how that would affect my pension. I hadn't planned on retiring from the Gas Company until age sixty-five. Marilyn and I would

be giving up our combined salary of over $100,000 a year for the next ten years to take a chance on an extremely risky venture—opening an art gallery. Were we prepared for the possibility of failure? If our offer on the Woodstock house was accepted, could we afford to pay for both the house and all the repairs that would be needed? We discussed the pros and cons endlessly. Ultimately, Marilyn seemed to feel that it might be a good move. If worse came to worst, we could find jobs in Vermont.

One weekend we drove to Cape Cod to comparison shop and looked at galleries for sale down there. We did the same thing in Rockport, where I had dreamed of owning my own gallery since the 1950s. Nothing could compare to what the house in Woodstock offered. Confronted with the fact that my dream could possibly become a reality, I grew doubtful and was overwhelmed by second thoughts. Some of our friends and family thought we'd be crazy to take such a gamble and counseled against it, but our five kids never wavered in their support of the idea. They were one hundred percent behind our taking early retirement, seizing the opportunity, and opening the Robert O. Caulfield Art Gallery in Woodstock.

Bad news came our way in November, when we learned that my Uncle Owen had collapsed and been hospitalized. His body was ravaged by cancer, and he had to have a lung removed. Marilyn and I went to visit him after the operation, but he didn't know we were there. He lay unconscious in his hospital bed, wheezing and gasping for every single breath. It was a pitiful end for a man who had never been anything but kind to everyone. Uncle Owen never missed a single one of my ball games back when I was in high school. His daughter Barbara never recovered from losing her father. One winter night a few years later, she turned an exhaust-filled hose into her car window and asphyxiated herself out of the pain she just couldn't overcome.

The phone rang on a December night a few days before my birthday with news from Woodstock. Marilyn let out a whoop when she hung up the phone. The owner had decided to accept our offer of $125,000. On my birthday that weekend we drove up to Vermont to finalize the deal and look at our new house once again. At an age when many people are contemplating sailing off into the sunset, Marilyn and I were beginning a whole new adventure together—and I was fulfilling a dream I'd had since I was a boy.

We enjoyed a pleasant dinner at the Woodstock Inn, and then stepped outside to take a walk. Snowflakes fell softly on the foot of snow that had already accumulated as we walked toward the village center. When snow

falls that heavily, there is a muffled silence, and all I could hear was the sound of our feet crunching through the snow. We stopped near the quaint shops downtown, which were all twinkling with white Christmas lights.

Marilyn took my hand and said, "Bob, we are going to do this. I want to spend the rest of my life in this town." I held her in my arms and kissed her, and said that I wanted to spend the rest of my days there, too.

In order to afford the house in Woodstock, we had to put the Lynnfield house on the market. The house on New Meadow Road sold in two weeks. We signed a lease on a two-bedroom at the Royal Crest Apartments in North Andover a few towns away from Lynnfield, and most of our furniture went into storage. Our plan was to retire when I reached fifty-five. Until then, we would open the gallery during our weekend visits to Vermont for the next two years.

When we signed for the mortgage with a bank in Woodstock, the loan officer asked us when we were going to have the original windows reinstalled in the house. I gave Marilyn a funny look. Welcome to small-town America, where everybody knows everybody else's business.

Around this time, our son Bobby accepted an offer from his employer to go to Ayr, Scotland, on a two-year contract as a materials manager for a plant there. Marilyn was upset that Bob, Pat, and their two young daughters would be so far away for that long. I thought it was a fantastic opportunity for my son and his family, and placated Marilyn with the promise that we'd visit them a few times while they were over there.

In January of 1984 we drove up to Woodstock to appear before the planning board. While the house at 42 Central Street bordered the commercial district, it wasn't actually a part of it. A home-occupation permit would have to be approved before we could open the gallery. Home occupation is considered a sacred cow to people in Vermont. The many previous owners of the house had succeeded in getting approval, and it never crossed our minds that we wouldn't.

When we walked into the town meeting with our lawyer that night at 6:00, there wasn't a seat to be had in the large Town Hall auditorium. The time came to discuss our permit at about 7:15. One of our new neighbors stood up and said she definitely didn't want an art gallery in the house. She ran a pottery shop across the street and said, "I don't want to look out my window and see café curtains in those illegal picture windows." Whatever that meant.

A letter written by one of the town's most prominent residents, who lived nowhere near our property, was adamant in its opposition to a gallery

on the premises. More than a few of the townspeople stood up and said they wanted the house restored to its nineteenth-century character, and complained that they wanted it to be used for a home, not a business. One of the board members said he would table the permit for the moment and move on to other matters. They would approach the subject of the home-occupation permit again later that night.

For the next three hours and fifteen minutes I sat there beside Marilyn and our lawyer, listening to all the subjects brought up at the meeting and wondering just what the hell we'd gotten ourselves into. It was after 11:00 when the board finally returned to the subject of our permit. There was a lot of back-and-forth between our lawyer and the board members. At one point I stood up and spoke of our intentions for the house, trying to allay any fears. The verdict finally came in, in our favor, which was a tremendous relief. I had been sweating bullets during the meeting, picturing my dream slipping away. If we hadn't gotten the permit allowing us to open a business, we would have ended up the proud new owners of a dilapidated house two hours' drive north of Boston.

My job with the Gas Company was often pure stress. One night that winter, when the temperature outside was twenty degrees, one hundred and eighty houses lost their gas service. My crews scrambled to get the service repaired while my mind played over the number of potential lawsuits that might result from frozen pipes or lack of heat.

The crews did a fine job and got the service back up within six hours. When it was all over I drove home, thinking how little I'd miss the pressures of my job. Another source of stress was having to be on standby twice a month—on call twenty-four hours a day—meaning I had to stay close to home on those weekends. Unfortunately, this limited our weekend trips to Vermont.

We hired a contractor in Woodstock and the renovations on the house began in early 1984. It took the contractors almost eight months to make the house habitable. The gallery was the first room to be completed. When the contractors were done, the house had been transformed. Clean, white ceilings replaced buckling, water-stained plaster in every room. When the workers pulled up the wall-to-wall carpets, they found original pine and oak flooring under many coats of brown paint. Now, their lustrous finish restored, the floors shone. Marilyn chose the wallpaper for each room, and made the curtains for the gallery herself. The end result was in keeping with the tone of the old house. From the moment the first visitors stepped inside the gallery, they remarked on how charming the house was.

Despite all of these exciting developments, I still worried over every major and minor decision we had to make. My success so far in the art world had been minimal, and I had only applied myself to painting on a part-time basis. Could I actually support Marilyn and me with my artwork alone? The contractor's bills were going through the roof and would ultimately total more than eighty thousand dollars. It didn't seem possible that we could handle all of these bills. Marilyn somehow always kept our heads above water financially. I worried about painting every day. Would it turn something I considered a pleasure into a grind? How would business demands impact the way I felt about my art?

My ulcers were acting up again after being dormant for a few years. I went in to see a doctor and had a complete physical examination. I was given a clean bill of health except for the fact that my cholesterol was extremely high.

A local sign maker delivered a small wooden sign that was attached to a wooden lamppost out in front of the house. It read ROBERT O. CAULFIELD ART GALLERY. On Memorial Day weekend in 1984, all of the kids (except Bobby, who was still in the UK) came up to visit. The house was larger than it appeared from the outside, and there was plenty of room for everybody. A two-room efficiency apartment with kitchen and bath took up the first floor of the wooden portion of the house. There was a small garage, three other bedrooms upstairs, two more bathrooms, a master bedroom, plus the foyer, the gallery, and my studio. My studio—how fantastic to finally be up out of the basement. I set my easel up in front of the picture window to take advantage of all the natural light.

The Memorial Day parade passed right in front of the house. A chubby, middle-aged man wearing a stained sweatshirt walked by while we were standing out front; he stopped, crinkled his eyes, and looked at my sign. He said, "Robert O. Caulfield Art Gallery, huh? That's what's in there this week, I guess." Then he waddled away. Although it was only a dumb remark, it didn't do much for my confidence. Aside from the risks we were taking in opening a gallery in the first place, the house had seen more than twelve tenants or owners in the last ten years. It seemed that every business opening under its roof was doomed to fail.

That night, Wayne babysat some of the grandchildren and Marilyn and I took his brothers and sisters out to dinner. When we came home, Wayne was so excited he could barely speak. He had left the track lights on in the gallery, and a young couple walking by had seen the paintings hanging on the walls and had knocked on the door. They purchased a

nine-by-twelve-inch scene of two men warming their hands over a flaming barrel in a snowstorm. The painting sold for two hundred and fifty dollars, and we weren't even officially open yet. Marilyn and I took it as a good omen.

1970s – 1980s

·PLATE 27·

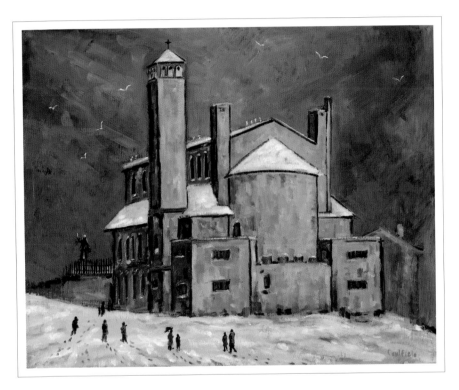

St. Anthony's, Revere
·1970s·

·PLATE 28·

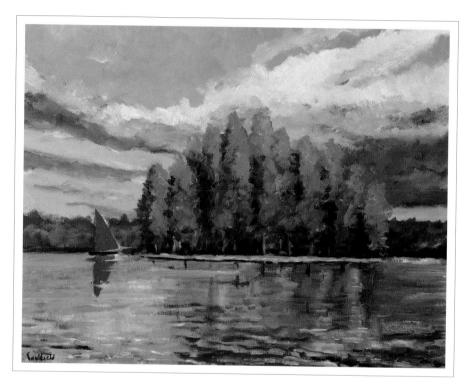

Three Ponds, Milton, New Hampshire
The view from Leon and Ivadelle's camp.
·1970s·

·PLATE 29·

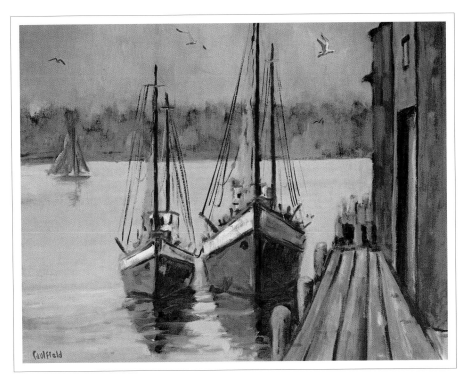

Gloucester Boats
Cover of American Mutual calendar.
·1971·

·PLATE 30·

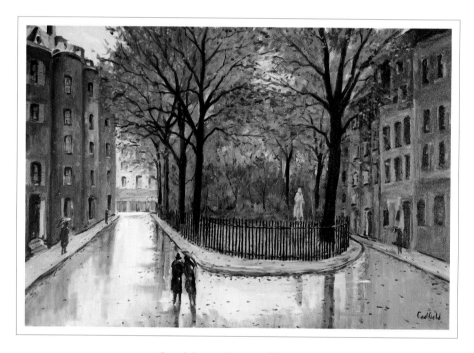

Louisburg Square, Boston
·1970s·

·PLATE 31·

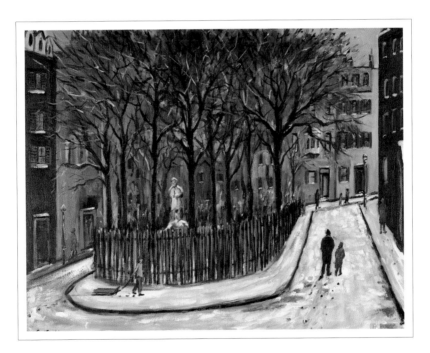

Louisburg Square, Winter
·1970s·

·PLATE 32·

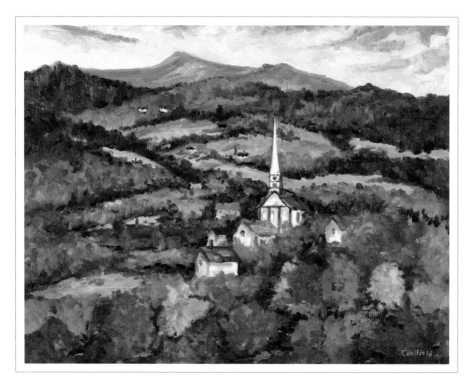

Stowe, Vermont
Center spread from Yankee *magazine.*
·1970s·

·PLATE 33·

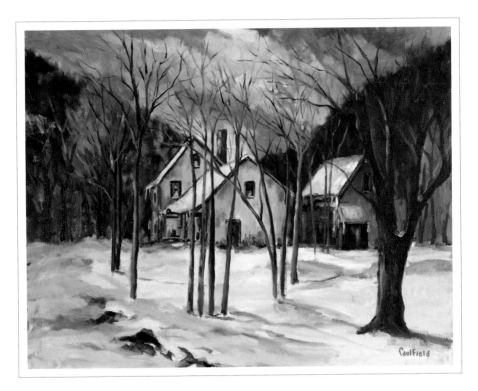

Moscow, Vermont
Marilyn's favorite painting.
·1970s·

·PLATE 34·

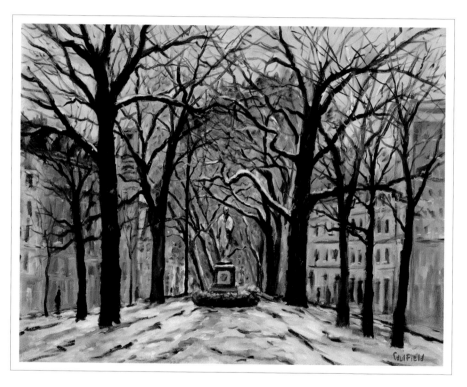

Commonwealth Avenue, Boston
·1970s·

·PLATE 35·

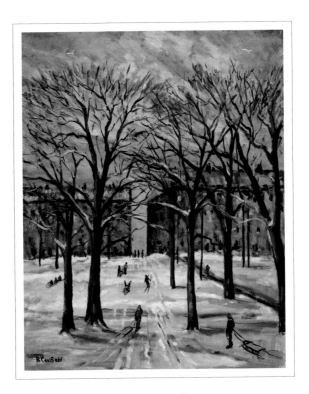

Sledding, Boston Common
·1970s·

·PLATE 36·

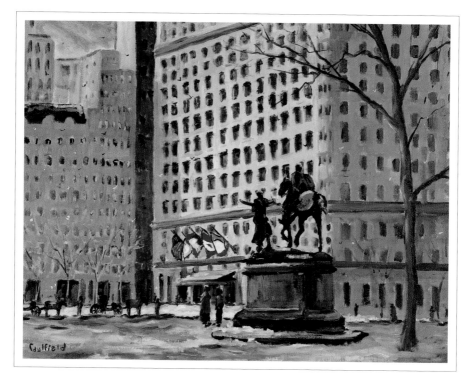

The Plaza, New York
My first rendering of what was to become a favorite subject.
·1978·

·PLATE 37·

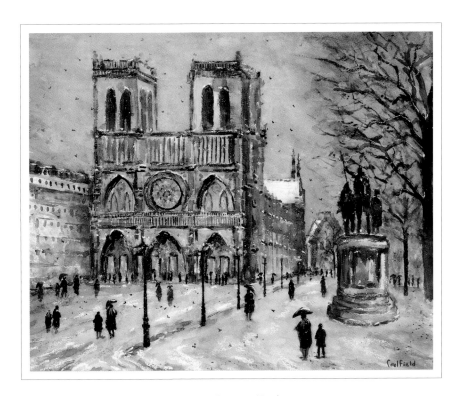

Notre Dame, Paris
·1980s·

·PLATE 38·

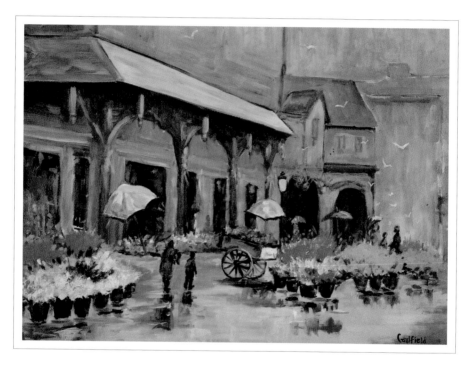

Flower Market
From a later American Mutual calendar.
·1980s·

·PLATE 39·

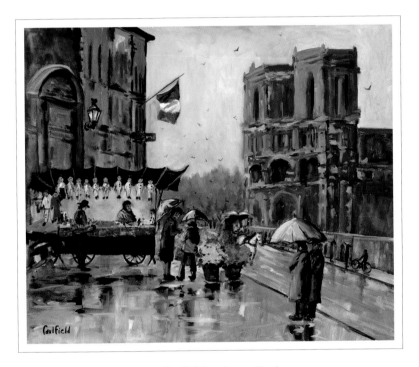

The Doll Merchant, Paris
·1980s·

·PLATE 40·

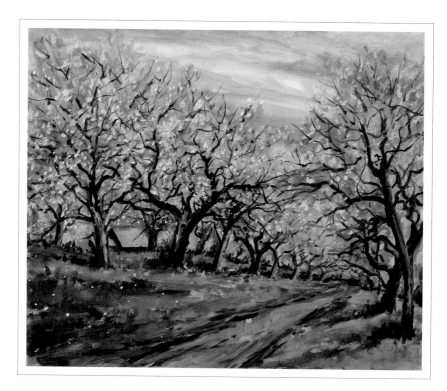

Vermont Apple Blossoms
·1980s·

·PLATE 41·

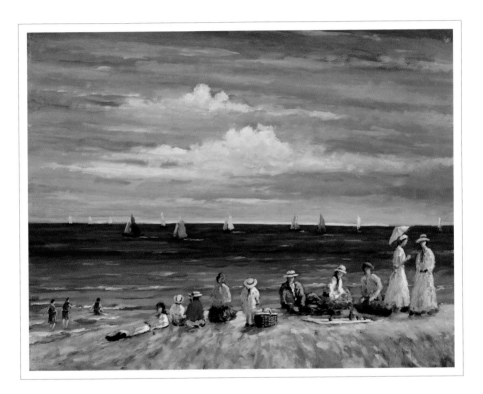

Sunday Regatta
One of my first beach scenes.
·1980s·

·PLATE 42·

Afternoon Light, Giverny
·1980s·

·PLATE 43·

Fall Shadows, Woodstock
·1980s·

·PLATE 44·

Light Snow, Fifth Avenue
·1980s·

Boston.
Early 1980s.

Lorelle's wedding in Woodstock, Vermont.
(Left to right) Wayne, me, Lorelle and her husband Paul, Craig, Bobby.
(Front, seated) Cindy and Marilyn.
June, 1988.

The Palette Lightens

Founded in 1761, the village of Woodstock lies on a Vermont valley floor, surrounded by the soft, rounded peaks of the Green Mountains. Mount Tom rises above the village center and the Ottauquechee River rambles through it. The noted American artist Ivan Albright made his home in Woodstock for many years. In the nineteenth century, a well-known sculptor named Hiram Powers was a resident. George Perkins Marsh, the father of the environmental movement, grew up at the base of Mount Tom. His book, *Man and Nature,* was published in 1864, and charted the destruction left in the wake of uncontrolled logging on Mount Tom.

Except for the automobiles and the parking meters, the streets of Woodstock look much the same as they did in the mid-1800s. The fine old homes surrounding the village green are scrupulously maintained to reflect the period in which they were built. Power and telephone lines are all underground, reinforcing the town's nineteenth-century character. Woodstock is often described in magazines, guidebooks, and newspapers as the most beautiful town in New England. I wouldn't disagree.

When we moved to Woodstock, there were only two other art galleries in town—Gallery II and the Fenton Gallery. After formally opening our gallery, we tried to drive to Vermont every weekend that I wasn't on call at the Gas Company. By the autumn of 1984 the gallery had become part of our routine. I took two weeks of vacation time that October, and painted every day. I'd be seated at my easel by around ten in the morning and would paint till lunchtime. After lunch I'd paint for a few hours more.

Foliage season brought an endless stream of visitors to the gallery, and we sold ten paintings in that two-week period. Despite my shyness, I forced myself to talk to people, though sometimes I think I rambled on too much.

Whatever doubts I had about painting full-time evaporated during those two weeks. It was fantastic to come downstairs and head for my studio to paint each day. I could focus all of my energy into painting and not have to worry about anything except what was on the canvas in front

of me. When the two weeks were up, the last thing in the world I wanted to do was go back to the Gas Company. There had been talk of another promotion coming my way, but Marilyn and I had already decided the course our lives would take, and nothing was going to sway us. I had one more year to go before giving notice that I'd be retiring early. Now that I was on the homestretch, I wondered how I'd summon the will to make it through another year.

My brother Joe had moved to Manchester, New Hampshire, with his family in the mid-1970s. He managed an insurance firm there that became hugely successful. Unfortunately, within a few years he suffered some severe health problems. These problems recurred around the fall of 1985. As he had done in the 1970s, Joe refused to see me when I asked about visiting him. I drove up to Manchester, and went into the hospital to see him anyway. When I stepped into his room, Joe yelled, "Get the hell out!" He said he didn't want me or anybody else coming to see him. Lying silent in his hospital bed, he stared off into space for forty-five minutes until I left.

A sense of anger overwhelmed me, and I kept questioning why I was making any effort at all to have a relationship with my brother when he obviously didn't want to have a thing to do with me. The force of his rejection stung as much in the 1980s as it had that day in the '40s, when we had been walking along the street in Lynn and he'd said he didn't want me around anymore—that he was embarrassed to be seen with his kid brother. For the first fifteen years of my life, Joe and I had been inseparable. We had survived a journey through the pits of hell together, but that bond didn't seem to matter to him. How could I understand the battles he was fighting in his body and his mind when he wouldn't even speak to me? In the end, my confusion in trying to rationalize his motives was overruled by my anger. I decided that from this point on, I wasn't going to go out of my way to see my brother.

Like many artists, I sometimes struggled with confidence in my work. Maniatty, the artist I'd met on the trip to western Massachusetts with Wayne, had told me that an artist "has to be an egotistical son of a bitch" to succeed. Rampant egotism wasn't exactly a hallmark of my nature; if anything, I still wrestled with self-doubt. I brought some of my paintings down to Massachusetts for Maniatty to take a look at. The few pleasant and constructive things he had to say about my work were sliced to shreds by his criticism. True to his crotchety form, he was pretty severe. It was a bit embarrassing because many people classified my work as American Impressionism, and the core of Impressionism is capturing light in one's work. He thought the paintings I showed him were "flat." Puffing on his

pipe, he waved his arm and shouted, "Paint the light, man!" Years later, I wished that Maniatty could have been there when a critic described my paintings as "dancing with light."

My Aunt Dot and Aunt Mary came up to visit us in Woodstock during the summer of 1985. They couldn't get over how beautiful the gallery was. Aunt Dot kept repeating, "Why didn't I notice your talent when you were a kid?" My obsession with drawing when I was younger was probably viewed as nothing but a hobby in most of my relatives' eyes.

Our kids were always coming up to see us. In the summer months we spent a lot of time together exploring the outlying countryside around Woodstock, hiking in the mountains, and swimming in the Ottauquechee River. In the winter there was skiing. The kids liked to go downhill, while Marilyn and I preferred cross-country.

There's an old saying that goes, "Vermont has four seasons, and three of them are winter." The cold weather is at its worst in January and February, when the temperature often plunges to twenty or thirty degrees below zero for days, and sometimes weeks, on end. I worried about the pipes freezing in the wooden portion of the house when we weren't around. A local landscaper kept the driveway plowed and the walkways cleared for us. When we'd drive up in the winter, we made our way to the door along paths cut through four or five feet of snow. Gigantic icicles would form over the picture windows in the front of the house, only to come crashing down during the spring thaw. The first time I heard that rumbling roar, I thought the roof had caved in.

My larger canvases were now priced at around one thousand dollars. The first time I sold one for that amount, I couldn't believe that I had made more money on one painting than I used to make in five months of working at the Gas Company back in the early 1950s.

April of 1986 was the date I had settled on for taking early retirement. I gave the Gas Company three months' notice. There were tempting offers from management to try to change my mind, such as the promotion that had been discussed, and a significant raise in my salary. Nothing they offered was enough to entice me; I had given thirty-five years of my life to the Gas Company, and it was time to move on.

On the one hand, it almost seemed miraculous that my artistic drive had survived all the years of backbreaking physical labor I had done, not to mention the years in management, and all the stresses involved in raising a family. Any doubts I had about supporting myself as an artist had gradually dissipated over the last two years. With the gallery open only part-time, we had sold over fifty paintings. These sales might seem

like they generated a lot of revenue, but the majority were smaller paintings that were priced in the five to seven hundred-dollar range. Almost every extra penny we earned went to taxes, or into the coffers of the contractor or the mortgage lender.

I would rather have left the Gas Company quietly, but my fellow workers insisted on throwing a retirement party for me. Over one hundred friends and family members came to see me off that night. We had a wonderful time. As the night wore on, I couldn't believe that I was on the threshold of living the life I'd dreamed of since I was a young boy: I was going to be a full-time artist. A few days later, Marilyn and I packed up the furniture in the temporary apartment in North Andover, and that was it. The new life in Vermont we'd spent years planning had suddenly become our reality.

Our nearest friend was now at least a two-hour drive away. I had experienced a lot more upheaval in my life than Marilyn had. Adjusting to small-town, rural life took her somewhat longer than it did me. We'd been coming to Vermont for over thirty years on painting trips and short vacations, not thinking for a moment that we'd ever end up living there. From day one I was deliriously happy with our new life in Woodstock. Marilyn missed home quite a bit at first, but the warmth and genuine friendliness of the locals, coupled with the pleasant, unhurried lifestyle Vermont offers, soon won her over. Many of the social problems common in more populated areas were nonexistent in Woodstock. It was, and still is, a bucolic village right out of a Currier & Ives print. Any time we got homesick, Lynnfield was only two hours away.

A couple of times a week somebody would come through the gallery and ask, "Where was the concert?" I told them then, as I still do today, that the famous Woodstock concert took place on Max Yasgur's farm near Woodstock, New York, a couple hundred miles to the west.

Another question I was often asked when we first opened was if I had any prints of my work. After doing some research, Marilyn and I felt that a lithograph would be more in keeping with the fine art we offered in the gallery. Prints can be run off in the many thousands, if not millions. For the most part they are worth only the paper they are printed on. A lithograph is a limited-edition print produced on high-quality paper, signed and numbered by the artist. The lithography process involves transferring a painting's image onto sheets made from zinc or aluminum. After a set number of lithographs are produced (in our case, five hundred), the printing plates are destroyed. Each lithograph might reflect minute changes in the printing process. This, along with the limited production

and the artist's signature, makes a lithograph a unique work of art.

There are thousands of fine printers who create lithographs. We settled on Mercantile Printing, the oldest printing company in Boston. They have produced lithographs for Andrew Wyeth, among numerous other artists. We made many trips down to Boston to check on the color, and finally it was finished. Our first lithograph was a reproduction of a watercolor I had done titled "Light Snow on Fifth Avenue." With everybody's focus on the quality of the image, no one discovered until it was too late that the title printed along the border of all five hundred copies read, "Light *Show* on Fifth Avenue." In the end we decided to let it go and keep the lithographs with the typo rather than destroy the entire run and create another, not wanting to repeat the many attendant trips to Boston the latter decision would have required.

An artist can always count on criticism and rejection as two constants in their profession. I was sitting at my easel painting one summer day when a woman walked into the gallery and struck up a conversation. It turned out that she was an artist and was currently exhibiting her work at the Grand Central Galleries in New York. She took her time examining my work, and then told me that my paintings "lacked punch." If that's so, I thought, then why are my paintings selling so well?

I settled into a work routine of painting every day, and soon I could see that my paintings were getting better. Though I didn't notice the colors in my palette growing lighter, other people did. For years I had been painting dark and stormy skies in my landscapes; now, there were more sunny skies appearing on my canvases. The changes in my work must have been attributable to the changes in my life. I no longer had to deal with the constant stresses of my job and the responsibilities involved in raising five kids. My heart no longer skipped a beat every time the phone rang like when I'd been on call at the Gas Company. My ulcers and stomach problems began to clear up as well.

Marilyn received a small pension from her previous job at the Lynnfield Town Hall, and although substantially reduced by taking early retirement, I received one from Boston Gas. Luckily, Boston Gas also provided excellent medical coverage for us both, so we didn't have to be concerned about insurance as we grew older. Between the pension checks and the uneven art sales, we were barely making enough to get by.

Marilyn took out a second mortgage on the house for ten thousand dollars to help make ends meet. After the foliage season in 1986, she decided to take a part-time job, so that we could count on that paycheck for a little extra security. I might sell two or three paintings in one day,

followed by weeks or months with no sales at all.

The only certain sales period we could count on seemed to be the foliage season. Whereas an average number of gallery visitors on any given day throughout the year could number from as low as one or two people to as many as twenty, during the two weeks in October when hundreds of thousands of tourists visited the state, the number of visitors to my gallery could number in the hundreds on a daily basis.

After first trying to find work in the treasurer's office in the Town Hall, Marilyn took a part-time position as a desk clerk at the Quechee Inn at Marshland Farms. The town of Quechee borders Woodstock, and was only a fifteen-minute drive from home. The extra money Marilyn's job brought in gave us a little more stability during fallow sales periods in the gallery. Marilyn's charm and warm manner were missed by me and the gallery visitors, but she excelled at her new job at the Inn. Within months she was promoted to front desk manager.

In November of 1986 a handsome couple in their sixties walked through the gallery door, said hello, and introduced themselves as Les and Ceil Fein. I was working at my easel and said hello as they made their way into the gallery. A Barbra Streisand song was playing on the radio. Ten minutes later, Les and Ceil stepped into my studio and said, "All these beautiful paintings and Barbra Streisand too?" We talked for quite a while, and they told me a bit about their lives. Ceil was warm and funny, while Les was more subtle and carried himself with a quiet dignity. Les explained that he was an art collector and wanted to buy two of my paintings, including one of my finest Beacon Hill scenes. It was the beginning of a friendship between collector and artist that has lasted almost twenty years.

Sales like these weren't doing much to alleviate our financial situation. In early 1987 Marilyn took out another ten thousand-dollar mortgage on the house. I remember reading somewhere that modern life can be distilled down to the monthly presentation of the bills—cynical, yes, but when you're struggling financially, all too true. There were times I wondered if we had done the right thing. Maybe some of our friends had been right. We had gone from making over a hundred grand a year to barely being able to pay the phone bill every month. Whenever regretful doubts would creep into my conversation, Marilyn wouldn't hear a word of it. She believed in me, and believed that working together, we would succeed.

On top of the other financial worries that were troubling me, Marilyn and Lorelle had been planning Lorelle's upcoming wedding for almost a year. It was going to be a first-class affair, with the reception taking place at the Woodstock Inn.

When we first told Ivadelle about our plans to move to Vermont, she wasn't so sure that this kind of risk was a good idea. Ivadelle explained that her opinion was based solely on her own experience. Like so many who had lived through the Great Depression, in the back of her mind Ivadelle always feared losing financial security and plunging back into the dire economic straits she and Leon had struggled through during the first ten years of their marriage. She also didn't like the fact that Marilyn would now be living almost three hours away from her. The first time that Ivadelle and Leon drove up to see the gallery, all of Ivadelle's doubts disappeared. Her face lit up and she exclaimed, "You did it, Bob, you did it!"

Barely able to balance a checkbook, I'm still somewhat perplexed by the economics of the art world. Like any other business, supply and demand are factors in determining the price of a painting. As an artist becomes better known and established, his paintings will command higher amounts. A few months after Marilyn had taken out the third mortgage on the house in the winter of 1987, a man came in and bought a painting for two thousand dollars—and he paid in cash. I closed the gallery a half hour early that night and drove over to Quechee to pick up Marilyn at the Inn. I carefully placed the hundred-dollar bills the man had given me all over the interior of the car. When Marilyn looked inside and saw all the money, she squealed with delight.

Our first full year in Woodstock had been more of a struggle than either of us had anticipated, but we had made it through. A few more big sales followed. For the first time I began to believe that we had made the right decision instead of just hoping that we had.

After graduating Westfield State College in May of 1987, Wayne decided to spend the following winter in San Diego with his girlfriend, Ann McGowan. He took a bunch of photographs of my work along with him. On a visit to Los Angeles, Wayne and Ann stopped into the Heritage Gallery on Rodeo Drive in Beverly Hills. The gallery owner was busy, but after a quick look at the photographs he asked Wayne and Ann to come back later. When they returned and met with the owner again, he told them he was very impressed with my work and wanted to see more of it. A month later I signed a contract with the gallery. Wayne and Ann also visited the Eagle Gallery in La Jolla, and my paintings were placed there, as well.

Les and Ceil Fein paid another visit during the foliage season in 1987, and bought more of my work. We asked them out to dinner and during the meal, Les asked why I didn't do any paintings of New York City. I told him I had painted a few scenes here and there over the last ten years, but had never spent all that much time in New York. Les gave me

some tips on potential New York subjects. He also said that he would visit some galleries in Manhattan and see if they might be interested in representing me. He and Ceil spent the winter months at their home in Florida. Les told me about a gallery owner that he knew in Palm Beach. He asked for some photographs of my work and said he would see what he could do.

A few months later I received a letter from Les in which he told me he wasn't having much luck with the Manhattan galleries. Then the phone rang one night and the man on the other end introduced himself as John R. Amann Jr., the owner of the gallery on Worth Avenue in Palm Beach. He told me he liked my work and wanted to see some more photographs. Before I knew it, my paintings were hanging on the walls of his gallery.

Things began happening so fast that it was difficult to keep pace. In the fifteen-month period between May of 1986, when we had moved to Woodstock full-time, and November of 1987, I had sold seventy-nine paintings. That number of sales was through my gallery alone. An additional thirty-seven had been sold in California. After knocking on gallery doors for years trying to get my paintings shown, it now seemed that gallery owners were coming out of the woodwork with offers to represent me.

I no longer had to price my own paintings. The gallery owners priced them for market demand, and as a result, the prices kept going up. By the spring of 1988, Marilyn and I were not only breaking even, but beginning to make a profit. Along with our burgeoning success came the familiar sting of rejection. When I submitted photographs of my work to the Ava Gallery in Hanover, New Hampshire, the home of Dartmouth University, they turned me down. Still, with more and more galleries representing me, I didn't have time to dwell on the occasional disappointment.

In June of 1988, our second daughter walked down the aisle. I never thought I'd see another bride as beautiful as my daughter Cindy, but Lorelle proved me wrong. She was stunning. It was an absolutely glorious day.

I was looking at some photos of that wedding recently and noticed that my father had attended. Since the Sunday visits to Gramma and Grampa's house had stopped following Gramma's death, the only time I saw my father was at weddings and funerals. We were always cordial to each other, but our conversations never went beyond the superficial. One time when we were standing in the gallery looking at my latest work, Lorelle wondered if my mother was still alive, and if so, could she have mysteriously visited the gallery. I had to smile to myself, because Lorelle didn't quite understand just how cold and uncaring a woman my mother

had been. Whatever had become of her, I knew she wasn't watching us from afar.

When Marilyn and I returned from a trip to Portugal and the South of France, John Amann called again. He asked me to paint three or four European beach scenes, but instead of portraying the people on the beach in a contemporary way, he wanted women in Victorian dress. I went through a number of sketches I'd done, as well as some photographs of the Riviera and the Algarve region of Southern Portugal, and painted a beach scene on a twenty-four-by-thirty-six-inch canvas. I shipped it down to Palm Beach and John sold it very quickly.

One of the main reasons we had gone on a trip to Portugal was to see the land Gramma Caulfield's ancestors came from, according to my family. It wasn't until many years later that I discovered Gramma's parents were of Portuguese descent, but had immigrated to America from the Azores, a chain of volcanic islands hundreds of miles off Portugal's coast in the Atlantic. Keeping an accurate history was never a strong suit with my family.

Wayne and Ann returned from California after six months. They married in Springfield, Massachusetts, where Ann was from, in October of 1988. That union gave us our fifth grandchild, a daughter they named Kaitlin. Not long after that, Bobby and Pat had a son they named Brian.

It became a rite of passage for all of my grandchildren to sit at my easel and give painting a go. Of my own children, Craig had shown the most aptitude for painting and was quite accomplished, but his creative passion lay elsewehere. There are a few of my grandchildren who seem gifted artistically. I still hope that one of the younger ones will pick up the artistic torch, but as of yet, none seem to have the drive needed to succeed as a painter.

At times I struggled at the easel myself. Some days it was almost as if I couldn't bring myself to stop painting. At other times, every single brushstroke was a true effort.

After quickly selling the beach scene I had sent him, John Amann asked me to do a series of them for his gallery. I didn't look forward to the task in the least. I considered it a chore, because except for the occasional commission, I had never before had to paint anything except what I had specifically chosen to paint—subjects that truly spoke to me. I have always undertaken my artwork with an intuitive approach. I understood what an important venue Worth Avenue in Palm Beach was, so I worked hard to make each of the beach scenes unique, even though the basic components were similar.

On occasion I would draw a scene in pastels. I also used to work in watercolors at regular intervals throughout the year, though lately I find myself working almost exclusively in oils. This was true of the beach scenes I completed for John Amann at this time. I finished the series of oil paintings for him, and waited to hear which ones he would choose for his opening.

In our gallery in Woodstock, sales continued to come in a tremendous rush, only to be followed by slower periods, sometimes stretching to two or three months, when not a single painting would sell. I discovered that relationships with galleries could be equally unstable. In February of 1989, the Eagle Gallery in La Jolla shipped all the paintings they had been exhibiting back to Woodstock. I had just shipped them two additional paintings at their request not a month before, because my paintings had been selling so well there. There was no letter, no phone call, no reason why. When I called the Eagle Gallery to see what had happened, all I got was a runaround. The often indifferent realities of the art business can be tough to accept; and like many artists, I have virtually no business sense. Except for some bruised feelings, I let it go.

In March of 1989, John Amann held the big opening night for his latest show, but my paintings weren't included. The fact that John hadn't included any of the series of beach scenes I had done at his request was a disappointment, somewhat mediated by the fact that I sold all five of these paintings in a matter of weeks from my own gallery.

Marilyn and I flew to Florida in May to meet with John and discuss his future representation of my work. I have an emotional investment in my paintings, so it's often difficult for me to remain unmoved by business decisions that affect them. John promised there would be bigger things for me on the horizon.

During that same trip, Marilyn and I decided to buy a condo in Boca Raton. Florida was only three hours from Boston by air. We had vacationed in Florida so often for the last few years that buying a condo made economic sense. We gave all five kids keys to the condo and encouraged them to visit whenever they wished.

Later that summer on a visit to Rockport, Massachusetts, I met Paul Strisik, a landscape artist I had admired for many years. He was a kind and gracious man. When I asked where he got the striking frames on his paintings, he told me where they were from. Through the years, I've asked hundreds of artists where they've gotten their frames; Paul Strisik was the only one who ever told me.

I sent a number of slides of my most recent paintings to John Amann in September. My paintings had been selling well in his gallery through the summer months, so I wasn't all that surprised when John called to tell me he wanted me to send him ten more. John was planning a big opening in November and would display my work along with that of the famous singer, Tony Bennett.

It seemed that our struggle to establish the gallery and my work had succeeded. In five years we had gone from making an excellent living in Lynnfield to virtually reliving the hard financial times of the early years of our marriage, to financial success again. When I had first moved to Woodstock I told Wayne that I'd be happy if we only sold one or two paintings a year. Now, five years into our adventure, we had sold over two hundred. Marilyn assured me that the future would only get brighter, but in the back of my mind, the fear that it could all disappear tomorrow still lingered.

With my grandchildren.
(Left to right) Krystle, seated; Kelly, pulling tie;
Todd, standing; Kimberly, seated.
1984.

With Marilyn.
Mid-1980s.

Change of Season

The foliage season in 1989 was an especially busy time for us. When the blazing red, orange, and yellow autumn leaves fell from the maple trees, and the endless hordes of tourists the locals call "leaf-peepers" finally dwindled, the season was over as quickly as it had begun. Marilyn and I were eager to head to Florida and relax for a few weeks in our new condo in Boca Raton. Our son Wayne offered to drive us into Boston. We would be vacationing for almost a month and planned on leaving our car at his house in Lynnfield.

Route 1 is an old four-lane highway packed with stores and businesses that meanders its way through a number of North Shore communities en route to Boston. We were driving along, in moderately heavy traffic, nearing the city of Revere, when a small pickup truck ahead of us swerved to avoid hitting something on the road. When the pickup swerved back to right itself, a huge two hundred and fifty-gallon oil drum in the flatbed bounced out onto the highway. A cement truck directly in front of us skidded sideways to avoid hitting the drum and tipped over, screeching along in a shower of sparks and ear-splitting noise. The truck came to a stop on its side, completely blocking traffic and spewing diesel fuel everywhere.

Wayne jammed on the brakes to avoid hitting the cement truck. My heart was in my throat as we skidded along the fuel-slicked highway, finally stopping about four feet from the overturned truck. I screamed at Wayne to back up and get free from the spreading diesel fuel; we were completely surrounded by it, and I was afraid it might catch fire and burn us alive.

There was no traffic coming up behind us yet, so we backed up and drove down an adjacent off-ramp to get out of harm's way. Wayne pulled over to the side, and we both hopped out of the car and ran over to the cement truck to make sure the driver was all right. When we got to the ·truck, he had already climbed out. Every inch of the driver's body was

trembling; he was absolutely snow-white as we led him to a guardrail and helped him sit down. Luckily, aside from being shaken up, he was physically okay.

Suddenly I realized that severe pains were coursing through my chest. I headed back to Wayne's car and told Marilyn that I could barely breathe. She said it must have been all the excitement we had just gone through. I nodded, and told Wayne we'd better get going or else we were going to miss our plane to Florida.

While waiting to board our flight at Logan Airport, I had a shot of whiskey, which helped to alleviate the incredible tension in my chest. When we arrived in Florida I still didn't feel right, but didn't say anything to Marilyn. I wanted her to enjoy our vacation and hoped that a good night's sleep would make me feel better.

The next morning, Marilyn and I drove to the beach. I took a short swim in the warm, blue waters, then headed up the shoreline for a walk. The sun's rays felt hot and cold at the same time. When I was swimming, my chest ached so badly that I had to return to where Marilyn was lying on the sand. I tried to describe the strange pain I was feeling, which was unlike anything I'd ever experienced before. Marilyn urged me to sit down and rest.

After we returned to the condo, Marilyn asked me if I'd pull up an old wall-to-wall carpet in the bathroom because some workmen were coming to install a new tile floor the next day. The air conditioner was on, and pulling up the carpet wouldn't normally have been very taxing, but as I worked I started sweating as if I were marching through the Sahara in July.

We went out to dinner that night. All through the meal an incredible tension and burning pressure throbbed in my chest. Marilyn grew quite worried and said that we should go to the hospital and get things checked out. I didn't want to go through all of that trouble. During the foliage season, Marilyn worked as many as twelve hours a day at my side in the gallery. In addition, she still worked a couple nights a week managing the front desk at the Quechee Inn. She deserved a long and relaxing rest. I convinced myself I was suffering from a severe case of heartburn and went to bed.

Sleep was impossible that night. I tossed and turned and barely got an hour's rest. The next day marked the opening of my big exhibition on Worth Avenue, and I was concerned about looking and feeling exhausted. Awaking from my restless night at about six the next morning, I knew

something was seriously wrong. The pain in my chest was excruciating. When I tried to rub my chest, I had trouble moving my arms. I tapped Marilyn in the bed beside me and told her we should get to the hospital right away. She went into the bathroom and began putting on makeup. The pain and pressure in my chest grew so intense that I yelled, "Mal, we have to go right now!"

Boca Raton Community Hospital was only a ten-minute drive from our condo. When we arrived at the emergency entrance, I could barely walk through the door and had to take baby steps into the lobby. The pain throbbing through my chest was unbearable. A nurse took me into a room and gave me a pill. An administrative type made the mistake of coming into my room and asking Marilyn for medical insurance information. Marilyn is never one to make a public outburst, but she raised her voice and said, "I can do that later. I may never see my husband again!" Emotions and tensions were churning at a full boil.

I knew something was dreadfully wrong, but I refused to believe I could be having a heart attack at the age of fifty-eight. No one in my family had ever had heart problems at my age. Unless they smoked cigarettes, Caulfields lived well into their nineties. My father had been fifty or more pounds overweight for years and was still going strong into his eighties.

I was given some more pills and something green to drink. To my immense relief, the pain began to subside. Later I was hooked up for an electrocardiogram. The doctors and nurses were all perplexed while awaiting the results. The consensus was that the cause of my pain was either an ulcer or a heart attack, with most leaning toward the possibility it was an ulcer that may have burst through my stomach lining. The nurses thought I looked too healthy to have any heart problems.

I had kept myself in good shape over the years. I walked at least a mile or two every day, and in the warmer months would ride my bike along the mountain roads outside Woodstock. I watched my diet, especially after the time in the early 1980s when one of my relatives pointed out that I was getting a double chin, "and beginning to look like my father." I only weighed about twenty-five pounds more than I had in high school.

A few hours passed. The young doctor who had been supervising my care was tempted to let me go home, although the fact that I was sweating and my arms had gone numb worried him. He said, "Mr. Caulfield, one of the best heart specialists in Florida just came into the emergency room, and I'd like him to take a look at you." The young doctor had already explained my symptoms to the specialist, whose name was Dr. Rosenthal.

Dr. Rosenthal walked into my room and took a look at the results of my EKG. He asked me if the pain and pressure I'd been experiencing felt like I had an elephant standing on my chest. I told him I'd never had an elephant stand on my chest, and he laughed. His manner grew serious when he told me he wanted to keep me in the hospital overnight, then give me some more tests in the morning. Marilyn called John Amann and told him we wouldn't be able to make the gallery opening in Palm Beach that night.

I underwent a thallium stress test the next morning. An hour later, a nurse stepped into my hospital room and asked me if I had a heart doctor in Boston. I had no idea why she was asking that, because a meeting had been scheduled with Dr. Rosenthal for ten that morning to discuss the results of my stress test.

Shortly after the nurse left my room, a priest stepped in and began giving me the last rites of the Catholic Church for the second time in my life. Marilyn squeezed my hand and did her best to hold back her tears. I told her that I loved her more than anything on earth. She said she loved me too. When Dr. Rosenthal showed up at my door within minutes of the priest's departure, the look on his face told me that things weren't looking good. Marilyn was as shocked as I was when the doctor told us that I had suffered a major heart attack a few days before. Not only that, he also said that three of the main arteries leading to my heart were plugged with cholesterol. One of my arteries was ninety-five percent closed, and the others were in the forty-five to fifty-percent range. He was surprised I had survived.

I was going to be rushed to a hospital in Miami right away to undergo what was then a new procedure, called angioplasty. Marilyn started crying and asked if we could go home so that I could have the procedure done in Boston. Dr. Rosenthal looked her right in the eye and said, "Your husband would never survive the trip to Boston."

Dr. Rosenthal told us that many people who suffer heart attacks go through exactly what I had: complete disbelief at the onset of the symptoms, which may lead to suffering pain for a number of days before help is sought—if they're lucky enough to survive in the first place.

I'd been an athlete, and had exercised my entire adult life. All I could think about as the ambulance shot south down Interstate 95 at eighty miles per hour with the siren wailing was, "How the hell could this have happened to me?" Marilyn was sitting up front beside the driver. A paramedic rode with me in the back. I thought about my mother for the first time in years.

She had always suffered from poor health. Perhaps I had inherited some sort of genetic infirmity from her. It had been almost fifty years since I had last seen or heard from her. I had no idea whether she was living or dead, and if she was dead, if it had been something like this that had killed her.

Even at high speed, the ambulance ride dragged on for almost an hour. I kept dozing off. The paramedics would wake me because they were afraid that if I fell asleep, I wouldn't wake up again. At South Miami Hospital I was rushed directly to the operating room. Three heart doctors were standing by in case the angioplasty ruptured an artery wall and I needed open heart surgery.

The angioplasty procedure consisted of threading a catheter into an artery in my thigh, up into my heart. At that point a balloon would be inflated to open up a passage through the cholesterol blockage. I was sedated with a drug that relaxed me but didn't put me under. The procedure seemed to take an eternity and in fact, did take several hours. When the doctor announced that the artery with ninety-five percent blockage was now open, everybody in the operating room applauded. The doctor leaned over toward me and said, "You poor bastard, we've been inside your heart all day."

When I was wheeled into the intensive care unit, Marilyn was waiting there with my daughters, Cindy and Lorelle. Bobby arrived later. My brush with death was frightening, but I realized that in the end, you have no choice except to be fatalistic about such things. Nobody is ever really ready to face death—especially when it comes out of nowhere.

Wayne and Craig flew in the next day. I couldn't believe all my children had come to see me. On one level, it drove home the fact that I'd had a very close brush with death, and showed me once again how strong our family ties remained. On another level, I felt bad that I had interrupted their busy lives. Marilyn came into my room, rubbed my head, and said, "At the exhibition on Worth Avenue last night they sold one of your larger paintings for ten thousand dollars." I smiled and said, "Mal, I really don't care. Am I going to live?"

I spent three days in intensive care, and a total of seven days in the hospital. Wayne later told me that when he walked into my room and saw me lying there, all hooked up to tubes and postoperative machines, it was the first time in his life he had ever seen me look old. He said, "You looked like a little old man lying there." I had certainly felt that way. Marilyn and I flew home two weeks later.

I had left Woodstock three weeks before as a healthy, vigorous man, and returned to Vermont an invalid. In the following weeks we met with more specialists in Boston, as well as a nutritionist. A friend of mine had suffered a heart attack more than ten years before I'd had mine. I had watched him grudgingly follow a regimen of strict dietary rules and endless medications, always hoping something like that would never happen to me. Now here I was with ten prescriptions I had to take every day and limitations on many of the foods I had enjoyed, like red meat and dairy. Ice cream had been my favorite dessert for decades, and I had eaten at least a half gallon a week for many years. Giving that up, along with many other favorite foods, wasn't easy—but when it's life or death, there's really nothing else you can do but make significant changes in your life. I made the changes.

I still suffered sharp pains in my chest over the next few weeks, but was assured this was a normal part of the healing process. In Florida, the doctors informed me there had been no damage to the heart muscle itself—even after walking around for a few days during the heart attack episode, with my heart starved for blood. The doctors in Boston had a completely different diagnosis. They surprised me with the news that my heart *had* undergone quite a bit of damage. Almost one-third of the heart muscle was not working properly. The doctors explained that with the passage of time, this damaged portion of the heart would recover.

A week after I returned to Woodstock, I sat at the easel in my studio and began working on a painting. I appreciated the holidays more than ever that year. Marilyn and I took another trip to Florida in late January and had the sort of wonderfully relaxing vacation we had anticipated in the fall.

John Amann had sold a few more of my paintings, so it was a surprise when we went out to dinner with him one night and he told us he was closing his gallery. This is not an uncommon event in the art world. Fluctuations in the economy, what's hot and what's not, fickle buyers, and a host of other factors make owning and running an art gallery an uncertain proposition in the best of times. After the stock market crash of 1987, many art galleries found that their days were numbered. Most of the galleries on Rodeo Drive in Beverly Hills went under in the next few years, including the Heritage Gallery, where my work had been on exhibition. When they returned my paintings, two of them were missing expensive frames worth a total of almost five hundred dollars.

By 1991, my paintings had been selling for a few years in the Gateway Gallery in Carmel, California, but we received a letter telling

us that gallery was closing too. The letter also included a list of all the paintings they would be returning. Marilyn checked the list against the inventory we had sent them; three paintings were not included on the Gateway's list. I called the gallery and told them about the discrepancy. A salesperson told me that the paintings in question had been sold and she didn't understand why they weren't on the list. It turns out the owner had left town in a hurry and moved to Bend, Oregon. The money we lost was a wakeup call that would change the way we dealt with other galleries in the future. From then on, Marilyn and I would be far more cautious when considering other venues for exhibiting my work.

Monet's lily pond. Giverny, France.
August, 1991.

Sketching in Central Park.
Early 1990s.

That's the Gallery Biz

In February of 1990 I had a stress test in Lynn and the results were excellent. When we drove down Boston Street toward the hospital, we noticed that the three-family house we'd lived in during the first years of our marriage had been torn down.

A brush with death has a lasting impact on your daily life. Once you have survived a heart attack, even the slightest pain in your chest can send you into a tailspin of worry that you might be in for another one. This fear isn't that far off the mark, because fifty percent of people who have a heart attack will suffer another one at some point.

My heart attack also had lasting effects on Marilyn. She feared she might wake up some morning and find me lying dead beside her. I, too, began wondering if I might die in my sleep. We discussed our fears with my doctors, and they alleviated our worries. We were extremely fortunate in that I had a first-rate medical insurance plan included with my pension from Boston Gas. That was a good thing, because medical bills for the heart attack ultimately totaled over thirty thousand dollars. We discussed the idea of closing the gallery and retiring to Florida, but those thoughts didn't last for more than a few vague conversations. I still burned with creative energy and had so many more paintings I wanted to do. Very few artists ever retire, anyway—most paint right up until the day they die.

I tried very hard to make changes in my life. The modifications in my diet were a given, but more challenging for me was trying to change the way I reacted to everyday stresses and strains. Always somewhat high-strung, I made a real effort to be calmer in my approach to everyday life, and to not let my emotions reach the point where my heart would race or my temper would rise.

After my stress test was over, Marilyn and I met Leon and Ivadelle for lunch. Leon had some very bad news: He had been diagnosed with lung cancer. Not only that, but the cancer had spread to one of his kidneys

and it would have to be removed. Leon was one of the strongest, healthiest men I'd ever known. He had literally never been sick a day in his life. His physical strength was astonishing. Well into his sixties, he had been able to beat almost all comers at arm wrestling. When he was diagnosed, Leon was almost seventy-seven years old, but to look at him even in the harshest sunlight, you would swear he was fifteen years younger. Marilyn put up a brave front for her father during lunch that day, though the news devastated her. She cried for days.

Marilyn accompanied her father later that week when he met with his doctors in Portsmouth, New Hampshire. The news for Leon only got worse. In addition to the cancer in one of his lungs and one of his kidneys, he also had cancer in his throat; he was essentially riddled with the disease. Leon had started smoking cigarettes when he was ten years old, but had switched to a pipe and cigars in his sixties. Ivadelle had smoked cigarettes for fifty years but had given them up at age sixty-five when she developed emphysema. Marilyn told me that when the doctor said they would not be operating on Leon's kidney because it would potentially prove more dangerous than leaving it in, it felt like the sky had fallen on her head. No one in our family had ever really considered the possibility of a world without Leon in it.

We offered to fly Leon and Ivadelle to Florida to spend some time with us in April. Ivadelle had flown once or twice in her life, but Leon was steadfast in his belief that if he ever got on a plane it would crash in a ball of flame, so he never flew. He was old-school, and that was that.

When Marilyn and I arrived in Florida that April, we found that John Amann already had plans to open a new gallery on Worth Avenue. He approached me with the idea of doing a number of paintings for the Upper Pinellas Association for Retarded Citizens (UPARC) charity exhibit in Clearwater, Florida, the following year.

The early 1990s were a difficult time for the American economy. Once again, we began riding the wave of feast or famine in terms of sales in our own gallery. The month of May brought some very welcome news with the birth of Wayne and Ann's second child, a son they named Brendan.

I switched doctors and began seeing Dr. Andrew Torkelson at Dartmouth-Hitchcock Hospital in Hanover, New Hampshire. John Sloan, an artist I greatly admired, had died in that very same hospital forty years before. When I told Marilyn about John Sloan's exit, she said, "Now that's a pleasant connection." Dr. Torkelson suggested I might learn how to better deal with stress at a so-called "stress school," so I signed up. Those classes didn't do much for me, probably because I thought

the whole concept was ridiculous. I can honestly credit Dr. Torkelson's caring and informed guidance with keeping me around in the years since my heart attack.

Just when the lack of sales in the gallery reached the point where I thought I'd never sell another painting, things would break. A prominent lawyer from Boston named Camille Sauroff had been collecting my work for years, and he came to Woodstock in late May of 1990 to purchase his ninth painting. As he and his wife Joyce were preparing to leave, he put his arm around my shoulder and said, "Okay, Robert, now go out and get famous."

In the seven years that had passed since we opened the gallery, I was becoming more and more well known in art circles around the nation. When we had first opened our doors, I had concerns over being thought of as a regional artist, but those doubts had eroded as my work began to spread. Soon, my paintings were hanging in homes all over America, and in Europe and Asia as well. I was very pleased with the slow and steady progress my work was making in the art world.

Despite my growing success, I often found my mind wandering back to the 1950s and 1960s. It wasn't nostalgia pulling at me; it was more a haunting question of *What if?* What if I had gone to a first-rate art school? What if Marilyn and I had moved to New York back when we were newlyweds? What if we had gambled on opening the gallery in 1958 or 1966, instead of waiting until 1983? Questions like these only led to frustration; they are as discouraging as asking why my parents couldn't have loved each other. You can't change the past—you can only learn from it.

Marilyn wasn't a big believer in advertising, but I was. We began running a monthly ad featuring one of my paintings in *American Art Review,* and gallery visitors would often say they had seen my work in that magazine. There were a number of local newspapers and magazines that ran articles about me, and that was gratifying.

July of 1990 found Marilyn and me visiting California. We saw all the sights in Los Angeles from Hollywood to Malibu and then headed up the coast to San Francisco and Carmel. Hollywood looked nothing like it had when I visited with my marine buddies on weekend leave back in the 1950s. What had once been the exciting center of movies, TV, and radio was now seedy and run-down. In those long-ago days I had been crushed by Marilyn breaking off our relationship. I wondered what my youthful self would have thought if I could have looked into the future and seen us walking hand in hand through the grounds of the Getty

Museum in Malibu, almost forty years later. As we stood before the magnificent van Gogh painting of irises that hangs in the Getty, all I could do was smile.

The city of Carmel far exceeded my expectations. This spectacularly scenic and beautiful Northern California coastal community has almost seventy art galleries in the downtown district. The rocky coastline is majestic, and the city is charming in the extreme. It was one of the most beautiful places I had ever seen.

Sales were very slow in the gallery that summer, but things began to pick up in September. In fact, we had the best foliage season ever. Our sales in that period totaled more than we had made in the first three years the gallery was open.

Back in the late 1970s, Ivadelle had found that preparing a Thanksgiving dinner for her ever-growing family was getting to be too much, so each of Marilyn's sisters began having their own Thanksgiving celebration. Leon and Ivadelle would take turns each year, rotating between the homes of their three daughters. Since moving to Woodstock, we had set up a long table for our family in the gallery and would celebrate there among all the artwork each November.

Marilyn surprised me with a trip to New York City for my sixtieth birthday that December. We had gone to the airport to pick up one of the kids, who had been vacationing at the condo in Florida. I'd thought it strange to drive all the way from Woodstock, when Wayne lived ten miles north of Boston, but Marilyn said she missed him and our daughter in-law. After their plane arrived and I thought we were getting ready to leave, Marilyn said, "We're not going home," and handed me airplane tickets for a flight to New York.

We flew into Kennedy Airport, where a limousine was waiting to take us to the Plaza. We spent the weekend there in a room overlooking the park, hitting the Russian Tea Room, the 21 Club, and a couple of Broadway shows. Because my birthday is only eleven days before Christmas, I've received combination gifts for these two events all my life. That weekend with Marilyn was a great time, and the best birthday present I've ever received. I brought along my sketchbook and camera and walked the streets of Manhattan, finding inspiration for new paintings on every other block.

John Amann included six of my paintings in the UPARC exhibit in the winter of 1991. They were featured along with the work of Peter Max. John called me when the event was over to tell me that my work had been the hit of the show. Five of the six paintings I had sent to UPARC

had sold. John was very excited and said that the following year, he was considering an exclusive exhibition of my work at the event, which would mean having to produce thirty or forty paintings. I was thrilled, if not a little intimidated at the prospect of all that painting.

I was equally thrilled when a prestigious gallery in Philadelphia sent me a letter in June of 1991, informing me they had accepted my work, and that it would go on display in their gallery later in the year. Three weeks after that, I received a rejection in the mail from the same gallery. The letter said they'd had second thoughts, and stated that my work "wouldn't go well in their gallery." Oh well, that's the gallery biz. There was another trip to France and a return to Monet's lily pond in Giverny.

The recession plaguing the economy continued, though once again, we had a fantastic number of sales in the fall. I still received occasional offers from galleries wishing to represent my work, such as the Master's Gallery in Carmel, but both Marilyn and I had grown quite leery after so many bad experiences.

True to his word, John Amann was devoting the following year's UPARC charity exhibit entirely to my work. He wanted forty paintings, including a number of beach scenes. It was an incredible amount of work for me, but seeing how well we'd done earlier in the year at the same exhibit, I began work on a number of canvases. I pored over my sketchbooks for material, drawing on the beaches and sunsets I'd sketched and photographed in Florida, but also going through old sketches and photos and referenced scenes of France, specifically the beaches at Etretat and Deauville.

John flew up to Vermont to help me make the selections for the UPARC exhibition, drawing from over thirty potential paintings I had completed in the past year. I was creatively exhausted when I finished, and even the thought of going near a canvas was something I didn't want to contemplate for a while. John was very happy with the work I had done. Shortly after he returned to Florida, I began packing up the paintings for shipping.

UPARC Charity Exhibition, Clearwater, Florida.
1992.

Our Fortieth Wedding Anniversary.
1992.

The Circle of Life

The UPARC exhibition in 1992 was the biggest event so far in my career as an artist. Sponsored by the Dupont family, it ran for four days from April first through the fourth, taking place in a mansion in Clearwater, Florida. The mansion was owned by a charitable couple who collected the work of George Inness, the nineteenth-century Hudson River School landscape painter.

Marilyn and I arrived the day before things were going to get under way and were put up in a nice hotel. John Amann and his wife met us early on the day the exhibition was to open, and together, we drove to the mansion. Opulent gardens surrounded the sumptuous home, which was every bit their equal in impressive grandeur. It was all a long way from Ruggles Street.

We met the owner, and then the four of us began removing the Inness paintings from the walls of the home and hanging mine in their place. After the paintings were hung, we strolled around the house to make sure each one was properly lit and looked good in its location. There were paintings placed in every room—on walls, over the fireplaces, and in some rooms, simply displayed on easels. Both Marilyn and I were equal parts delighted and anxious. John Amann assured us we would do well, and would sell quite a few paintings, if not all of them. The event was to be a black-tie affair attended by many of the wealthiest people in Florida.

Marilyn and I went back to our hotel room and tried to relax, but relaxation was impossible because we were both so excited. Thoughts of failure plagued me. Were we taking a risk in exhibiting my work alone without any other artists? The paintings had been priced in the two to ten thousand-dollar range—had they been overpriced? Marilyn did her best to calm my nerves as we dressed for the opening-night party.

When we arrived at the mansion that night, we were greeted warmly by the event's host, who led us to a quiet corner of the garden where a harpist was playing. Shortly after that, we were brought out into one of the main rooms to take part in a receiving line. That kind of thing is hard for me, but everybody coming along the line was so gracious and pleasant, it made it much easier for me to make an effort at small talk.

The night was a blur of faces and conversations, laughter and merriment. Hundreds of people attended, the men all dressed in their tuxedos, the women in jewels and ball gowns. At the end of the first night, John came up to me, absolutely beaming. We had sold nineteen paintings and the event still had three more days to go.

We flew home after the opening-night festivities. In the end we sold almost every single painting I had sent to Florida, over thirty in all. This was a tremendous boost to my confidence. My career really took off after this UPARC event. John immediately started making plans for a similar exhibition the following year.

People who had attended the show told their friends about my work, and for years afterward these people would eventually make their way to my gallery in Vermont. One day a woman from Massachusetts arrived in Woodstock by limousine and left the gallery with three paintings riding along with her in the backseat. A few weeks later, an elderly couple came into the gallery and purchased three large paintings. They paid by check, informing me that somebody would be coming from Boston to pick them up. Around lunchtime the next day, a man dressed as a butler stepped into my studio and told me he was there to pick up the paintings. I helped him carry them outside, where a long, black stretch limousine was parked in our driveway. It seemed like coming to pick up a few Caulfields in a limo was suddenly the in thing to do. It made me think of an old saying: Art always goes where the money is. Even so, Marilyn and I believe quite strongly that art shouldn't only be for the elite—that art is for everybody. As the prices of my paintings have risen through the years, Marilyn has made sure that the smaller canvases are priced so that anybody could afford one.

The exhilaration I'd felt after returning from my big success in Florida was soon tempered by the realities of running my own gallery. Since opening our doors in 1983, I've met an incredible number of wonderful people. I've also met my share of the not-so-wonderful. I remember that summer, a couple from Toronto came into the gallery and went absolutely wild over my work. They spent over three hours in the gallery and had me put "Hold" signs on six or seven paintings, saying they'd come back the next morning to make their final decision. They

never came back. That sort of thing happens occasionally in the gallery business, and you have to learn to let it all roll off your back.

In late July, our children surprised us a week before our fortieth anniversary with a huge party. That was a terrific night for Marilyn and me. A compilation of our old home movies had been put on videotape, and this was played for everybody. The kids had even invited Father Johnson, the priest who had performed our Catholic marriage ceremony forty years before. With Father Johnson presiding, we renewed our vows before all of our friends and family.

On August 1, our actual fortieth anniversary, we were in Paris once again. As the sun set that evening, we rode the elevator to the top of the Eiffel Tower. Later on, at midnight, we took a boat ride up the Seine. Marilyn had stood by my side now for four decades. That cute little blue-eyed brunette who caught my eye on Fisherman's Beach all those years ago has been a fantastic wife to me and a great mother to our children. She believed in me when nobody else did, enough to risk all the comforts of suburbia to gamble on opening our gallery. Sometimes I look back to when we were first married and think that we were just a couple of kids, having kids. Our love for each other is unconditional, and has been a constant source of strength and happiness for us. We have never wavered in our support of each other, or in our devotion to each other and to our marriage. I simply love Marilyn, heart and soul.

Foliage season that year was busier than ever for us. Marilyn was making the drive to Eliot, Maine, to see Leon and Ivadelle at least once a week. By the end of October, Leon was confined to a hospital bed that had been set up in his living room. Leon's doctors assured us he would probably live until Christmas, so Marilyn and I took a one-week trip to Venice, Italy. I had read about the wonders of Venice since my teenage years. We had cocktails at Harry's Bar, visited the famous Piazza San Marco, and enjoyed a gondola ride through the canals. I did a number of sketches and couldn't wait to get home and begin painting again.

Leon was terribly ill when we returned to America. When I saw him, I almost couldn't believe that he was still holding on. Throughout his life, Leon had taken pride in his appearance; he had never carried an extra ounce of fat on his muscular frame. It was awful to see that strong and powerful man wasting away before our eyes.

Marilyn and her sisters went to stay with their parents. Wanting me to rest, Marilyn sent me off to the condo in Boca. The morning after I arrived, the phone rang. It was Marilyn with the news we had all been dreading. Leon died at home on November 5, 1992.

On a chilly November day, Leon was laid to rest in a family plot in Lynnfield. As we all said our good-byes, a man wearing a kilt played the bagpipes Leon had loved since his boyhood days in Canada.

Leon Le Blanc was a man of simple tastes and needs. He had immigrated to Lynn from Nova Scotia when he was twelve years old and spoke only French. Leon used to joke that the only French he could remember after fifty years in the United States was *"Sacre bleu!"* He became Americanized, but never developed the American mania for money and material possessions. Family always came first and foremost in Leon's life. This kind and generous man had become the patriarch of a family numbering almost thirty members at the time of his death. Loved immensely by his daughters, his sons-in-law (whom he always called his sons), and his grandchildren and great-grandchildren, his loss was a terrible blow to us all.

Leon had been a second father to me. Thanks to him I had had my first art exhibition. He was a character, and a terrific human being who had enjoyed every moment of his life. It was wonderful to have known such a fine spirit. I can still picture him tossing horseshoes up at camp, and the look of jubilation that would come over his face when a horseshoe would clink the metal stake he'd aimed at, and he'd call out, "It's a ringer!"

I struggled with working on scenes of Venice through the winter months. Sometimes no matter how much I'm inspired, painting is a real effort, and I just have to push myself through it. At other times, I feel I could keep going for days on end. While my artwork is traditional for the most part, I never stop trying to improve, and to that end I continue studying art books and trying new techniques in my paintings.

In June of 1993 I signed a contract with the Wentworth Galleries. They would carry my work in their chain of thirty-five locations around the country. More success brings more pressure, but that was fine with me. It was nice to hear people come into the gallery and say they had seen paintings of mine before in Beverly Hills or Palm Beach or Carmel. Somebody visiting the gallery asked for my autograph for the first time, and I was sort of shocked that anybody would want it.

October brought us another grandchild when Ann and Wayne had a son they named Travis. Life was good, and as the '90s progressed, it got even better. My work was now selling well all over the country. There was another successful UPARC exhibition in the spring of 1994. In June of that year, Marilyn and I sold the Boca condo and bought one on the ocean in Highland Beach, Florida. I had dreamed of living by the water as long as I could remember.

John arranged a big exhibition in Luxembourg, to take place that fall. It turned out to be a disaster. Thirty paintings were shipped to that tiny country, and just weeks later, we received a letter from the gallery owners telling us they were going out of business. Both John and I tried to contact these people to find out when they would be shipping the paintings back, but we never heard a word from them.

Our worst fears were realized as the months passed, and we began to believe that the gallery owners had disappeared along with all of that work. Marilyn called the office of the American ambassador to Luxembourg, but we didn't receive any help from them whatsoever. The whole fiasco was a huge disappointment. Aside from the problems of dealing with an international situation, we were looking at expensive legal fees if we sued the gallery owners—that is, if we could have found them. In April we were told that the paintings were on their way home; then, two months later we were told that they were in London. The whole thing was a shady mess. Nine months after the paintings had been shipped to Europe, we received a letter from a clerk at the Luxembourg airport. The paintings had been sitting in storage at their British Airways warehouse for months.

When we drove to Boston to reclaim the paintings at Logan Airport, a customs agent there told me he was an artist and hoped to open his own gallery in Arizona when he retired. I gave him a few tips and wished him well. All thirty paintings were sold from my gallery within a couple of months. I sent the airport clerk in Luxembourg a check for two hundred dollars, as a thank you, but he sent it back along with an explanation that he had only been doing his job.

My work continued to sell quite well, and we typically sold around a hundred paintings a year from our little gallery on Central Street. With business so steady, Marilyn decided to quit her part-time job at the Quechee Inn so she could take on the full-time management of the gallery.

When Marilyn and I had moved to Woodstock, neither one of us had ever imagined achieving this level of success. As I'd learned, however, the life of an artist means that no matter how successful you may become, you can never take it for granted. During the winter of 1994, the Southern Vermont Art Association sponsored an exhibition of twenty of my paintings—not a single one sold. By contrast, at that year's UPARC exhibition in Florida, two of my paintings sold the night before the event even opened.

Ivadelle called Marilyn a few days before Christmas. "I just wrapped some presents," she said, "and now I'm not sure what to do next. I can't

remember." Within the week there was awful news. Ivadelle had been diagnosed with inoperable brain cancer. Ivadelle moved in with Marilyn's sister Dotty in Lynnfield, to spend the last months of her life among the family who loved her so much. Friends came from as far away as California and Florida to say one last good-bye. All of Ivadelle's grandchildren came to see her. One sad note was that Lorelle was pregnant with her first child, and Ivadelle wouldn't live to see her latest great-grandchild. A woman of profound faith, Ivadelle didn't fear death. She said she would, "just go to sleep and never wake up." She also looked forward to being with Leon again. She had moments of extremely clear thought that were followed by periods of confusion as the disease progressed.

Marilyn drove to Massachusetts to see her mother a couple of times a week. In February, Ivadelle took a turn for the worse. Marilyn moved down to Lynnfield to await the inevitable. In the last week of her life, Ivadelle refused to see any visitors other than her daughters. Marilyn, Dotty, and Rene were at her side day and night.

In a way, Ivadelle was lucky her cancer had progressed so quickly, as opposed to the horrible, drawn-out death that Leon had suffered through. Surrounded by family members as she rested in a canopy bed in Dotty's home, Ivadelle breathed her last on February 17, 1995. If she had lived another two weeks, she would have been eighty-two.

Ivadelle's death struck me a lot harder than I thought it would. I painted a couple of still lifes of flowers, using for a vase a Victorian water pitcher that had been hers. I had gone to visit her a number of times during her last months. We had talked about her life and her family, of whom she was quite proud; by her example, she had taught us all the true meaning of family. For me personally, she was a friend, a mother, and the absolute definition of grace, class, and kindness.

As Ivadelle herself would have been the first to admit, death was part of the circle of life—the way things must be, even when we wish otherwise with all our hearts. That circle was completed, in a way, when my daughter Lorelle gave birth to her first daughter two months later. She and her husband named our ninth grandchild Camille.

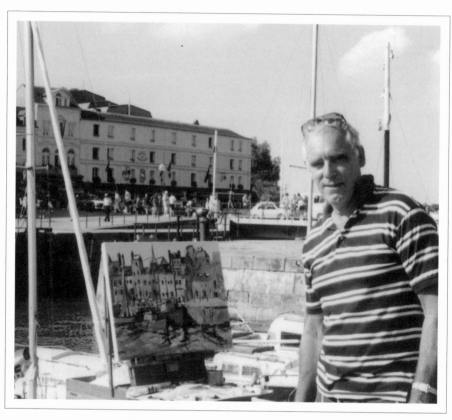

Painting *en plein air* in Honfleur, France.
Early 1990s.

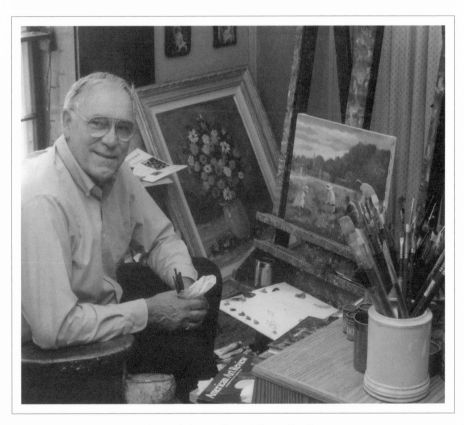

At work in my Central Street Studio.
Late 1990s.

Travels

June of 1996 found Marilyn and me in France once again, this time on a visit to Provence, Nice, and Cannes. After a three-day stay at Eze, a little town outside Monaco, we took a three-day drive through the Alps. It was the best scenic trip we'd ever taken, and I returned home bursting with ideas for new paintings. I spent the summer months working on seven or eight paintings at once.

The Wentworth Galleries called me again. There had been a few conversations with them over the last year because my work had sold so well in their chain of mall-based art galleries. The thirty-odd paintings they bought had sold out in six months, and they wanted to order another thirty or forty. After giving the request much thought, Marilyn and I decided to turn them down. I couldn't just crank out that number of paintings, and the prospect of keeping the Wentworth chain stocked—along with my own gallery, and all the other galleries around the country that represented me—was far too daunting. I would have loved to stay with them, but it wasn't feasible.

I'm often asked where I find inspiration for the subjects I paint. I'm not quite sure myself. There are paintings I have done that have kicked around in my imagination for years. Some are direct results of a trip, while others come out of the blue.

Our friends, Mimi and Marshall Heuser, invited us to their home in Louisville to attend the Kentucky Derby in 1996. The pomp surrounding the Derby, and the event itself, were incredibly beautiful and exciting. Churchill Downs is a setting that would move many a landscape artist. The horses, the white steepled roofs of the grandstands, all the dazzling neon colors on the horses—I admired it all, but didn't feel any urge to paint it. I think it comes down to mood. If a scene strikes me emotionally, then I'll paint it.

People can often be very literal when asking about the location in a landscape painting. When I'm working on a landscape, I might paint the

compositional elements exactly as they appear in life—such as in a New York City or a Boston scene—or I might change this or that to make the overall composition stronger. Then there are times when I mix a lot of different elements together. For instance, in one of my beach scenes I may use a sky from Florida with a beach from France, and mix in figures wearing Victorian or Edwardian costumes. Some of my flower scenes are drawn completely from my imagination. The end result is what I'm interested in; the effect or feeling I'm trying to capture in a scene is what's important. Art is all about communicating emotion.

I'm not sure if the idea was planted in my head while watching *Doctor Zhivago* in the 1960s or not, but visiting Russia had long been a dream of mine, so we decided to plan a trip to Moscow. Marilyn and I usually like to do our own thing when we travel, and have always avoided packaged tours. However, Russian society was still in flux after the Soviet era, and the travel agents we spoke to stressed that it would be far more prudent to travel with a tour group. Our plane arrived four hours late because of a mix-up at the connecting airport in Europe, so it was very dark when we landed in Moscow in December of 1996.

Moscow is a gray and monotonous city in winter, and I was surprised to see there wasn't any snow on the ground yet. People told us that it was the first time in centuries there had been no snow before December 15. Our luck changed the following day when the snow began falling by the foot. The snowfall transformed the dark city into a fantastic white metropolis. Our tour guide was an ex-corporal in the Soviet army who spoke fluent English. For the next week we visited museums, schools, and my favorite, Red Square, where St. Basil's church is located. I shot endless rolls of film and made almost as many sketches.

We enjoyed seeing Moscow, but nothing prepared us for the next week when we took the midnight train to St. Petersburg. At 2:00 A.M. Marilyn and I couldn't sleep, so we went to the dining car for a snack, and watched Russian soldiers flirting with the pretty girls on board. Some of the soldiers hauled out a balalaika and a small accordion and soon they were all dancing in the aisles.

Two feet of snow had just fallen on St. Petersburg, and everywhere I looked, I saw old women shoveling snow, and not a single man. I mentioned to Marilyn we should try that arrangement in Woodstock. She said if I'd let her gain seventy pounds and wear a babushka, we'd have a deal.

St. Petersburg is one of the most beautiful cities I have ever seen. We spent an entire day in the Hermitage, the Tsar's former Winter Palace and

now a museum. There was a striking exhibition of Impressionist paintings that had been plundered during World War II and hadn't been on public display since. It was a strange sensation to stand in the same room the Russian Imperial family had been ushered into before they were taken prisoner at the onset of the Russian Revolution. Without a doubt, Russia is one of the most exciting countries we have ever visited. The people were friendly and wonderful. The only downside was seeing some horrific poverty. It made me shudder because I knew that these people had no immediate way out of their circumstances—just as I hadn't when I was a child.

Almost since the day we opened the gallery in Woodstock, people had been asking me why I wasn't exhibiting in New York. There were a lot of reasons. New York is a very tough nut to crack, as I'd found out twenty years before when I had been an unknown trying to find a Manhattan gallery to represent me. Then there were the problems we had experienced with so many other galleries where we had arranged to sell my work. Even a man as prominent and well connected as Les Fein had experienced nothing but difficulty when he tried to get New York galleries to accept my work. So New York had dropped lower on my priority list, until Marilyn began looking into Art Expo. An artist friend had suggested it might be a good venue for us, as well as a way to meet people in the art world.

We made arrangements to rent a booth at the February 1997 Art Expo show. Hundreds of artists, galleries, publishers, and others connected to the art world would be displaying their wares at the Jacob Javits Convention Center in New York over a six-day period. After renting a van, I packed it with thirty-four paintings and a bunch of promotional brochures. The first three days of the exposition were restricted to professionals in the art world, and then the show was opened to the public.

A well-dressed gentleman stopped at our booth on the first day of the show. He asked if the artist was going to make an appearance, and I said, "I'm the artist." While shaking my hand he said, "I think you're one of the best artists in the nation." He introduced himself as Patrick Sarver, the editor of *Art Trends* magazine. So began a friendship that was to last for years. *Art Trends* was very good to me, and the magazine ran a number of articles on me and my work.

Marilyn and I were both quite pleased with the results we had at Art Expo. We sold eight paintings and met a number of people in the art business. Three of the paintings were sold to a gallery on Lexington Avenue called Gallery 71. We went back to New York three weeks later

and took a cab ride past the gallery. It was truly gratifying to see a twenty-two-by-thirty-inch painting of mine in their front window. My work was finally on exhibition in Manhattan.

Another exciting development at Art Expo was meeting a decorator for the Plaza Hotel. She was interested in making reproductions of my New York scenes to hang in the Plaza's suites. In another strange art-world twist, we didn't sell a single painting at the UPARC exhibition in Florida that year. There were quite a few residual sales from Art Expo, and we decided to reserve a booth for the following year.

We took a trip to Europe on the *Queen Elizabeth II* that summer to celebrate our success. After a visit to London, we headed back to France, rented a car, and drove to Rennes and then on to Cancale, where we stayed at a beautiful chateau that had once been commandeered by the Nazis. We returned again to Etretat, a seaside village that never ceases to inspire me. We flew home on the Concorde—something Marilyn had long dreamed of.

When we moved to Woodstock in 1983, there were two other art galleries in town. One had since gone out of business, but by October of 1997, there were eight other galleries in town. Still, our sales kept growing. I always got a kick out of it when somebody would come into the gallery with a tape measure and start taking the dimensions of the paintings, because that was a concrete sign that the person wouldn't be buying. For some reason that foliage season, we had more buyers than ever before, and also more measuring tape–wielding non-buyers than I'd ever come across.

That fall, Lorelle gave birth to our tenth grandchild, a daughter she named Julia. December brought a chimney fire. There was an awful roar as fist-sized chunks of burning embers fell down out of the chimney into the fireplace. After the fire department put it out, there wasn't any lasting damage—just an awful lot of soot covering all of the paintings in my studio. A tight-lipped adjustor came by, and the pittance the insurance company eventually paid out covered the cost of cleaning about half the paintings.

Winter brought the annual two- or three-week period where temperatures plunged to twenty below. Every so often there would be a frozen pipe or some other damage caused by the frigid temperatures and all the accompanying ice and snow, but for the most part our little house weathered winters well, as it had done for almost two hundred years.

Life progressed along the routine Marilyn and I had adopted. There were periods of painting, followed by trips to our condo in Florida throughout the winter. When I go to Florida, I'll do an occasional sketch

and take photographs for later use in my beach scenes. When I return to Woodstock after three or four weeks of not painting, there is always a period when I have to battle to get back into the creative groove of things.

It seemed rarely a month passed without a gallery somewhere in America contacting us and inquiring about exhibiting my work. There were times I'd look at Marilyn and just shake my head in amazement. After the struggles in the early part of our marriage, and then settling into life in Lynnfield, we had risked it all to open the gallery. It had all paid off.

In August I received a phone call from my brother, Joe. I was surprised to hear from him, since the only times I had seen him over the last ten years was at weddings or funerals. He asked if he could drop by for a weekend visit, and I told him we'd love to have him come and stay with us, and to see the gallery.

The negotiations with the Plaza Hotel stretched on into the fall. After all the back and forth, they had pretty much settled on placing three reproductions of my work in a number of their suites. Still, there was no finalization of the deal.

Joe visited in September of 1998. For the first time in recent memory, Joe seemed like his old self. There had been some very hard times for him through the years. His marriage hadn't survived his bouts with illness in the 1970s and '80s. I was happy to find when he arrived in Woodstock that he was brimming with personality and good humor. We spent hours reminiscing about our childhood together on the streets of Roxbury, and comparing notes on our families. Joe has three fine sons of whom he is quite proud, and a number of grandchildren. It was good to reconnect with my brother after so many years of distance, and to feel that the breach between us had started to heal.

That fall, I shipped a five-by-six-foot painting I had been commissioned to do to a company in New Jersey. Because the painting was so large, I couldn't send it by Federal Express or UPS, and had to use a special shipper. I couldn't believe it when I received a phone call telling me that the painting had arrived at its destination with a couple of holes in it. Marilyn and I rented a van and drove down there to pick it up. The damage was minor—the holes were actually tears about one inch by two inches—so I patched them and delivered the repaired painting myself to prevent the possibility of any further damage.

We participated in Art Expo for the next two years and did quite well. Eventually, the deal with the Plaza Hotel was finalized. Copies of three of my paintings were placed in over forty of their suites. Marilyn

and I have made a yearly trip to New York City around Christmas time for years; it was especially nice that year to check into a suite decorated with Caulfield prints.

My father died in May of 1999 at the age of ninety-two. He had spent the last ten years of his life in a nursing home. Though he suffered from diabetes, he never lost his sharp mind. I brought my grandson Brendan to meet him a few months before he died. Brendan called him "Great Grampa Joe." I couldn't believe the impressive funeral my father was given. It was quite a surprise to see such a large turnout of people saying their final good-byes to such a solitary man. Why this gregarious, pleasant man— well liked by everybody, hard-working, and with no vices, who remained close to his parents and siblings—abandoned his own children, is something I'll never understand.

We launched our gallery Web site that summer. Marilyn hired a firm to get it all up and running, and collaborated with them on the overall design. She became so fascinated by the process that she took private lessons in HTML and web design and began updating the paintings on-line herself.

The thought of publishing a book of my work had been kicking around in my mind for years. Marilyn and I were visiting a gallery owner who represented me on Las Olas Boulevard in Fort Lauderdale that November, when the subject of a book came up. Our discussion, and the art books I had seen at Art Expo, convinced me that it was time to do my own.

1990s – 2000s

·PLATE 45·

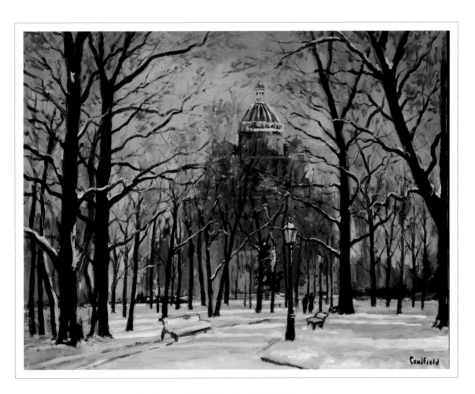

St. Isaac's Cathedral, St. Petersburg
·1990s·

·PLATE 46·

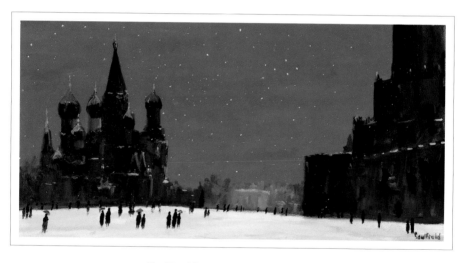

St. Basil's, Moscow, at Dusk
·1990s·

·PLATE 47·

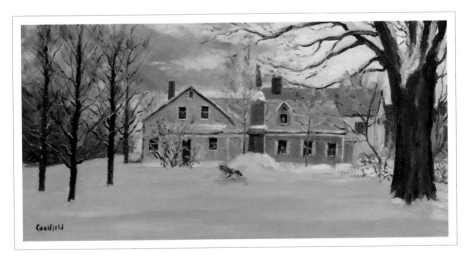

Our Gallery at 42 Central Street, Woodstock
·1990·

·PLATE 48·

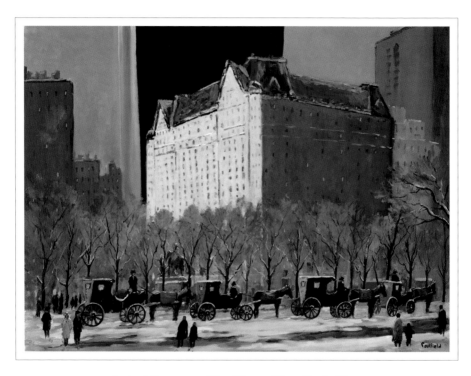

Late Afternoon, The Plaza, New York City
·1990s·

·PLATE 49·

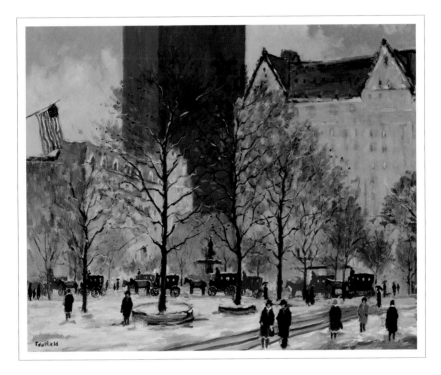

The Plaza, Evening
One of the paintings confiscated by the FBI.
·1990s·

·PLATE 50·

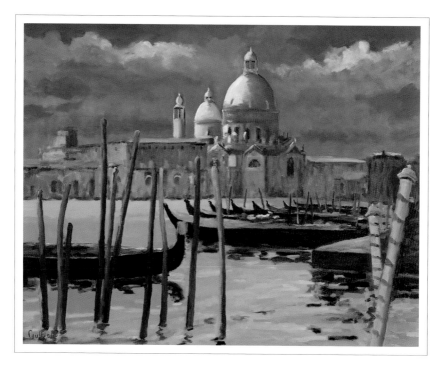

Santa Maria della Salute, Venice
·1990s·

·PLATE 51·

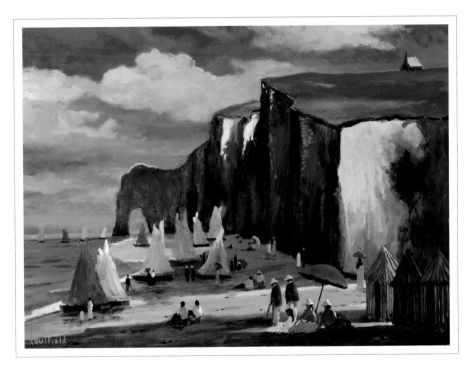

Etretat, France
·1990s·

·PLATE 52·

Mount Tom, Woodstock
·1990s·

·PLATE 53·

Vermont Village
·1990s·

·PLATE 54·

Boston Common
·2000·

·PLATE 55·

Arlington Street Church, Boston
·2000·

·PLATE 56·

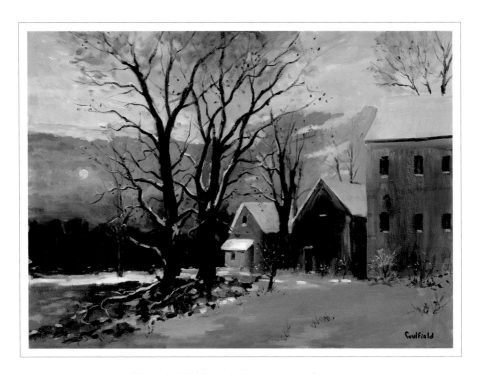

Church Hill Road, Vermont, at Sunset
·2000·

·PLATE 57·

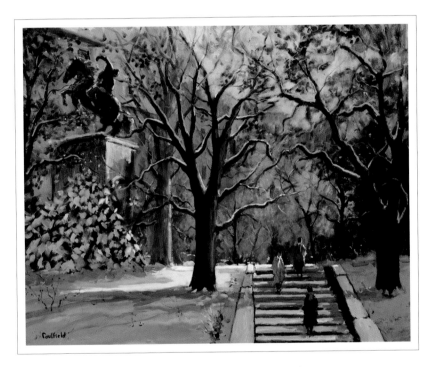

Central Park, New York, Dusk
·2000·

·PLATE 58·

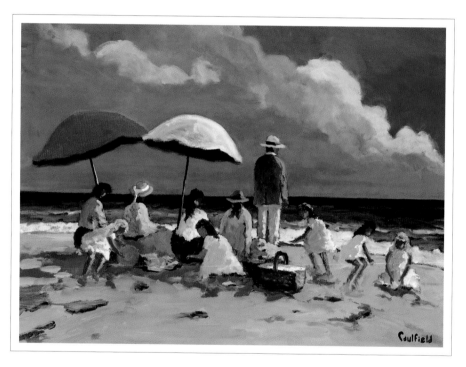

Summer Day at the Seashore
·2000·

·PLATE 59·

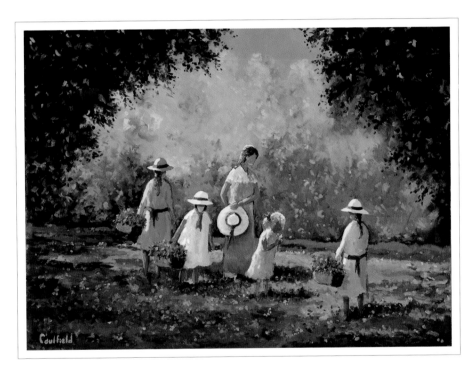

The Flower Garden
·2001·

·PLATE 60·

Springtime in the Garden
One of the first paintings completed after my stroke.
·2001·

·PLATE 61·

Boylston Street
·2002·

·PLATE 62·

Brooklyn Heights Promenade
·2003·

·PLATE 63·

The Iron Gate
·2003·

·PLATE 64·

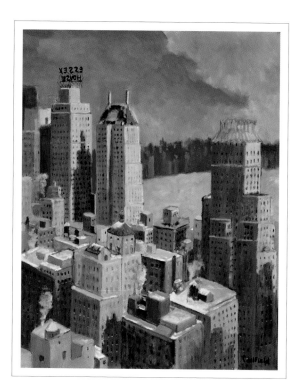

View from Avenue of the Americas
·2003·

·PLATE 65·

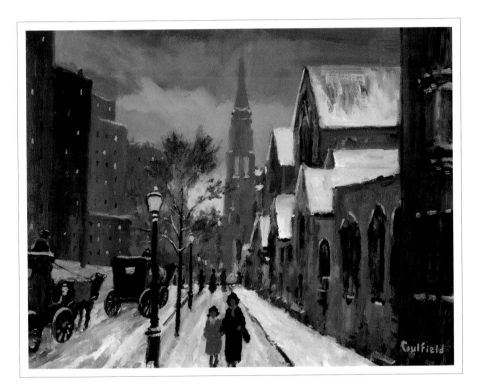

Newbury Street, Boston
·2003·

·PLATE 66·

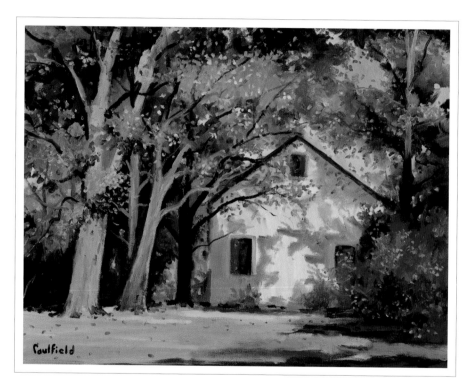

Autumn Leaves
·2004·

The Robert O. Caulfield Art Gallery.
Eleven The Green, Woodstock, Vermont.
Winter, 2003.

PHOTO BY DEBRA M. GAINES

Celebrating Marilyn's birthday on Martha's Vineyard.
(Back, left to right) Wayne, his wife Ann, Craig, me, Marilyn, Cindy, Bob's wife Pat, and Bob.
(Middle, left to right) Todd, Kim, Kaitlin, Lorelle's husband Paul, Krystle, Brian, and Kelly.
(Front, left to right) Travis, Julia, Lorelle holding Brooke on her lap, Camille, and Brendan.
Memorial Day, 2004.

One Hell of a Ride

My first book, *The Art of Robert O. Caulfield*, was published in October of 2000. My middle son Craig came to Woodstock to help me compile the book from a brief summary of my life I had written a few years before. I also wrote short paragraphs on what had motivated me to do many of the paintings that were included. We contacted a number of people who had bought my work in the past, retrieving paintings from their collections so that transparencies could be made for full-color reproductions within the book.

Within two months of the book's release, it had sold over 1,500 copies. I became quite experienced at giving short speeches at book signings. The first edition of 3,500 copies has sold out and a second edition is forthcoming. A man who came into the gallery recently bought a copy for his mother, telling me she had checked it out over twenty-two times at the local library. Things like that are always nice to hear.

While we were researching my early life for the art book's biographical introduction, a fluke led us to some public records which cleared up an almost sixty-year-old mystery. We discovered my mother's death certificate. She had married again (how many times, I don't know), and was buried in a section of Dorchester, Massachusetts, under a different last name than Freeman, her surname at the time of her disappearance. There was no question that the death certificate was hers; her birth date matched the one on her marriage license with my father, and the singular name of Nehemiah Hemeon appeared as her father on her birth certificate, the Freeman marriage license, and her death certificate.

The death certificate lists the cause of my mother's death as "myocardial infarction" (heart attack) and "arteriosclerotic heart disease." Under the heading of "Other Significant Conditions," schizophrenia was listed. My mother's actions when I was a boy began to make a certain kind of sense. People suffering from schizophrenia often hear voices in their heads, and have trouble connecting with others.

My mother died on February 19, 1982, at the age of seventy-two. It was a shock to learn that she had died in Roxbury, where she had been living on Walnut Avenue. Roxbury is roughly fifteen miles south of Lynn and Lynnfield. For the forty years she had lived on after her disappearance, my mother had been just a fifteen-minute car ride away. Grandma Stoner had also died in Roxbury in January of 1969 at the age of seventy-six.

Discovering my mother's whereabouts helped clear up some of the mystery for me. Learning that she had struggled with mental illness led me to read some literature on schizophrenia. No matter how much I tried to rationalize her actions now that I knew a possible reason behind them, I still couldn't forgive her for abandoning Joe and me.

While Craig was in Woodstock helping me put the art book together, he heard Marilyn talking to a client on the phone one day. Marilyn had called a man in Los Angeles who had purchased two of my paintings at Art Expo in New York back in 1997 for over fifteen thousand dollars. He had given Marilyn a deposit of ten percent, with the agreement that the remainder would be paid off in two or three installments. The first check he gave us bounced, as did the second one, which arrived by mail. Ever since, Marilyn would call him once a month, but he would always manage to sweet-talk her into buying more time to make things right. This was the first time Marilyn had ever experienced this sort of thing, and this man played on her goodwill. We rarely had problems with clients paying their bills, which is why she let this situation drag on for almost three years.

We contacted the local police to see what they could do to get the paintings returned. Luckily, Marilyn had kept copies of the original bounced checks—checks which had been drawn on a closed account, making the offense a felony. A few more checks that bounced had also been sent through the mail, which would add mail fraud to his list of charges. This was beyond the jurisdiction of the local police force, so the officer overseeing the case put us in touch with the FBI.

A young woman brandishing an FBI badge came to our gallery in the spring of 2001 and interviewed Marilyn and me. At the FBI's request, I sent photographs of the paintings in question to the Los Angeles branch of the agency. A week or two later, the FBI agent and her associates were hooking up recording equipment to the telephone in our kitchen. They needed Marilyn to call the man who had the paintings and get him to somehow implicate himself in their theft.

Marilyn was a bit nervous, but she dialed the Los Angeles number. The man answered the phone. He recognized Marilyn's voice, and

immediately said, "Good morning, Marilyn." As she had done many times in the past, Marilyn asked the man when he was going to make a payment on the paintings. He replied with his usual sleight of hand and song and dance. When the FBI agent shifted on her chair, Marilyn caught a glimpse of the handgun strapped in a holster under her jacket, which ratcheted up her nervousness even more.

The man in Los Angeles said he'd send a payment later in the week, just like he always did, then explained that he was going through difficult financial times. As the phone call continued, it seemed the man was perceptive enough to sense that something wasn't quite right, and he tried to cut the call short. Marilyn said good-bye, but because of how nervous she was, she misspoke and called the man William.

"No, Marilyn," he said, "my name's Warren, you know that." The FBI agent smiled when she heard this and gave Marilyn a thumbs-up as the call ended. Until the moment the man had corrected Marilyn, the FBI didn't have enough to implicate him. For some reason, Warren stating his own name gave them sufficient grounds to retrieve the paintings.

I can just imagine the look on that man's face a few weeks later when FBI agents stormed into his house on a sunny California morning and removed the paintings from his walls. Not long after that, the paintings were once again hanging in my gallery.

As you grow older, you have to accept the fact that death is going to take people from your life. I had lost friends, family, and co-workers, but you're never fully prepared for when someone in your family dies young. Marilyn's sister, Rene, died of ovarian cancer in April, 2000, at the age of fifty-six. That very same disease had taken Marilyn's beloved grandmother, Gladys, at exactly the same age when Marilyn was a girl of thirteen.

The New England television show *Chronicle* taped a segment on my life and career in June of 2001. It has since been rerun nationally on PBS. This was my first television exposure, and years later, people still come into the gallery telling me they've seen me on the program. Ron Gollobin, the journalist who produced the piece, did a wonderful job encapsulating my life and work. It was a genuine treat to participate in the project with him.

We went back and shot footage of myself on the streets of Roxbury, and in front of the Roxy Theatre, which at the time was a boarded-up shell and has since been torn down. Two of my sons came with me that day. As we walked down Warren Street in front of the Roxy, one of them asked me if anything looked anything like it had way back in the 1930s. Glittering fragments of broken glass and cast-off bottles of booze littered the gutter, just as they did when I was a kid. Homeless men congregated

in the doorway of that apartment beside the Roxy, those sad rooms where my mother had tried to pull the splintering fragments of her life into a family.

A few buildings looked similar enough to bring back some memories, but the passing decades had brought tremendous changes to the neighborhood. All of the row houses—including the one I'd lived in for the first ten years of my life—were gone, replaced with new housing in a wave of urban renewal. The one thing that hadn't changed on the sidewalks fronting the run-down bars on Warren Street was the smell. If despair and poverty and the dregs of cheap booze could leave a scent, this combination would pretty much capture the Roxbury of my childhood.

My son asked me if any memories I might have forgotten had come back, and I said no. I remembered the details of my childhood as if they had been engraved in my mind with a lightning bolt. Though with age I may have forgotten a detail here or there, those early years live on with a striking clarity for me.

That same spring of 2001, the Galerie d'Orsay on Newbury Street in Boston hosted a one-man exhibition of my work, and that opening-night party was one of the best nights of my life. My family and friends all attended, and the d'Orsay sold a number of paintings. To top it all off, Lorelle had given birth to her third daughter a few weeks earlier. Baby Brooke is our eleventh grandchild.

My life had been going so well for so long that I had almost become accustomed to not having the rug pulled out from under me. We had enjoyed our best year yet in terms of Woodstock gallery sales, and in the fall of 2001, Marilyn began looking into buying a property about a half mile down the street from where we lived.

The Ebenezer Fitch House has stood at 11 The Green since 1827. (A green is another name for a common.) I was completely happy in our house and gallery at 42 Central Street, but Marilyn was feeling crowded by the lack of room. Our success found many of the upstairs rooms packed with paintings and frames, as they now served more as storage areas than bedrooms.

The stately and spacious brick home on The Green overlooked Mount Tom, and the Ottauquechee River ran right under a cliff at the rear of the backyard. I went to see it with Marilyn and the realtor, and I was impressed—but the asking price was more than a million dollars. I wondered how we could ever afford it. Eleven the Green was one of the finest homes in Woodstock. The house had a grand front room that could

easily be converted into a gallery, while a sunny room in the rear of the house overlooks the river and Mount Tom, and would make a great studio. Marilyn put in a bid and we waited to hear if our offer was accepted.

On October 16, after a frantically busy day in the gallery, I was standing at the desk talking to Marilyn. We were both exhausted. Marilyn said, "Bob, it's five o'clock. Would you please take down the open sign so we can close?" I stepped toward the front door and a strange rippling sensation zipped through my cheek and stopped me in my tracks. Instantaneously, my left arm went dead. I yelled, "Mal, I think I'm having a stroke!" Marilyn rushed to my side.

The Ottauquechee Health Center was only a block from the house. We hurried over there and the second we walked through the door, Marilyn shouted, "My husband is having a stroke." A nurse took me into a room and gave me a pill and everything in my mind flashed back to my heart attack episode twelve years before—except this time, there was a comedy-of-errors twist to it all.

An ambulance arrived. Two female attendants wheeled me outside on a gurney. When they tried to lift the gurney into the back of the ambulance, they couldn't get the wheels to collapse. They tried again and again, with no success. Finally, I asked them to unstrap the restraints securing me so I that could climb into the ambulance myself. After I did so, the women passed the gurney back inside, I got on, and they strapped me back down for the ride to the hospital. Marilyn was furious; this little Three Stooges episode had wasted fifteen minutes or more of precious time. When the ambulance arrived at the hospital, my exit was somewhat less of a circus act than my entrance had been.

I had no sensation at all in my left arm, which dangled limply at my side. I was told I'd be staying overnight for observation and was given an MRI. The results showed that a small blood vessel had burst on the front right lobe of my brain. Marilyn wanted to stay the night with me, but the doctors convinced her I would be better off just resting, so she took a cab home. I kissed my wife goodnight and suddenly I was alone. The doctors explained to me that the next twenty-four hours were critical because I could have another stroke that might have far more serious and incapacitating results.

A nurse would wake me every hour to take blood pressure readings, making sure I hadn't suffered another stroke. As the night wore on, I couldn't sleep. I lay there trying to grapple with what might be my new reality. I have always been left-handed, and it was just my luck that the stroke had

affected my left arm—the thought that I might never paint again wasn't something I could comprehend. I pushed aside any feelings of self-pity as my thoughts drifted back over my life. It had really been one hell of a ride from Ruggles Street to Woodstock. If my career as an artist was over, then I'd still go on somehow.

I still had Marilyn, whose love and guidance had been a constant in my life for fifty years. I still had my children and grandchildren, not to mention many great friends. I had been dodging disaster all my life, but mixed in with that luck, or perhaps driving it, had been my strong work ethic. For years I had watched Grampa Caulfield leave the house every morning at ten to head to his job at Durgin-Park. He'd return home at eleven each night, a schedule he kept up well into his eighties. I myself had worked hard at the Gas Company for thirty-five years, and had funneled that same drive into my art career. I was determined to do whatever it might take to rehabilitate my left arm and begin painting again. Forcing myself to paint with my right hand was also an option I considered.

Apart from the damage to my left arm, everything else seemed unaffected. My speech and all of my other motor functions were fine. There was absolutely no pain; that's why they call strokes the silent killer. When asked if there had been any symptoms beforehand, I told the doctors that for the last two days I'd had the sensation of sweat trickling down my forehead. When I'd reach up to wipe it away, my forehead would be bone dry.

Just as it happened after my heart attack, a parade of friends and family members came through my hospital room. Once again, I felt profound embarrassment at interrupting everyone's lives. When I woke up on my third day in the hospital, I could move the fingers on my left hand. By the fifth day after the stroke, I was able to move my left arm a little. A week after the stroke, I went home to Woodstock.

Each passing day brought more mobility to my arm. I was given therapeutic exercises to perform, and these helped my recovery. Three weeks after my arm had lost all feeling, I was ready to sit at my easel and face the big question: Could I still physically paint? The fear that I would never be able to paint again had wracked my mind for weeks. By this point I had recovered the use of my arm fully eighty-five percent. I placed a twenty-two-by-thirty-inch canvas on my easel and began blocking in a garden scene full of flowers.

The relief I felt at being able to complete that painting was overwhelming. In the following months I regained ninety-five percent use of my left arm. Today I have no residual effects whatsoever and have recovered almost one hundred percent use.

Our bid was accepted, and we proceeded with buying the house on The Green, moving in during February of 2002. Like our house at 42 Central Street, this, too, was a private home, and a home-occupation permit was required before we could reopen the gallery in the new location. We applied for the permit and everything was going smoothly, until we received a letter from a neighbor's lawyer. The neighbors, whom we had never met, objected to having a commercial establishment next door to their home, and had filed an injunction against us getting a permit.

Houses in Woodstock often wait for a buyer for a year or more. Marilyn and I had been phenomenally lucky in selling 42 Central Street two weeks after putting it on the market. We would be generating no income for the period of time the lawyers were battling, a period that could potentially stretch up to six months or longer. This was stressful, considering what we had just paid for the new house.

Neither Marilyn nor I could understand our neighbor's motives. Eleven The Green stands dead center in the Village of Woodstock, across from the biggest commercial establishment in town, the Woodstock Inn. If one stands in front of our house and looks to the left, not one hundred yards away stand a bank, the library, the courthouse, two other art galleries, and the downtown commercial district. Concerns about increased foot traffic in the neighborhood didn't make sense, considering The Green is lined with parking meters and sees endless foot traffic all day long. Art galleries are extremely low-key business establishments in the first place.

Having been in business for almost twenty years by this point, Marilyn and I tried to make the best of a bad situation. Still, there were many sleepless nights. Every time either one of us ventured out the door into town, people would tell us how awful it was that we were being treated this way.

On a July morning we walked across The Green to the courthouse with our lawyer, friends, and family. The neighbors opposing the permit didn't even show up for the hearing. It was all over within minutes when the judge ruled in our favor. I marched directly across The Green and with the help of one of my sons, erected a blue-and-gold sign proclaiming 11 The Green, THE ROBERT O. CAULFIELD ART GALLERY.

The months of stress and anxiety leading up to the verdict were capped off by the best night of my life, and Marilyn's too. Our five children threw us a surprise fiftieth wedding anniversary party on August 1, 2002. We spent a perfect summer night in a beautiful restaurant on Suntaug Lake, once again surrounded by all the family and friends who had been with us for so many years.

Though love wasn't a close acquaintance when I was a child, I have been so very fortunate to have known it intimately throughout my adult life. I adore my children and am extremely proud of each and every one of them. My grandchildren are a constant joy. And then, as ever, there's Marilyn.

An old high school friend of mine dropped by the gallery recently and our conversation turned to my football days. What struck me was his belief that in my youth, I had been the most spectacular natural athlete he had ever seen. He remembered watching Coach Palumbo work with me one-on-one, forcing me to conform to the standards of how *he* thought a football should be kicked or passed, instead of encouraging me to freestyle. My friend felt that conforming to the coach's guidelines had impacted my performance, somehow diminishing my ability.

Maybe in a way it's best that my artistic education was somewhat meager. Although I took a few drawing classes over the years, I've never had a single painting lesson. Whatever internal force compels me to paint might have been constrained by an art-school version of Coach Palumbo if I had formally studied art under a mentor or in a university setting. I did the best I could in trying to express myself under the circumstances I had to contend with.

I have painted over two thousand canvases in my fifty-year career. I hope that after I'm gone, in decades to come, people might look upon my work and wonder about the man who created it. It's important to me that I'm leaving something behind to let people know that I was here. I'm not sure if any artist is ever truly satisfied with the work he has done. I hope that as long as I can paint, I will continue to grow as an artist.

That young boy who scribbled all over Roxbury in chalk; that young man who opened the Coronet Art Gallery with some friends in Lynn, and, dreaming of recognition, sold his paintings for thirty and forty dollars apiece, is today an old man; and even though some of my paintings now sell for over thirty thousand dollars each, I'm still the same person.

Considering the physical setbacks I've experienced in the last fifteen years, I'm not sure if I'll be blessed with another twenty years of life, reaching my nineties as so many in my family line have done. In my remaining time on this earth, I want to paint what inspires me, and enjoy the company of Marilyn, my children, and my grandchildren.

Oftentimes on summer afternoons, Marilyn and I will relax on our back patio after we close the gallery for the day. Two rare arctic elms throw shade over our flower garden. The lawn is a deep green at that time of year, rolling on toward the covered bridge that crosses the river

adjacent to our property. At five o'clock in the afternoon the sun shines high over Mount Tom, although at that time of day the light takes on a subdued, golden hue. It's so peaceful, and so very far from the crowded city streets where I began my life, that at times it feels as if there's a disconnect between what my life was, and what it is now—as if through Gramma and Grampa Caulfield's intervention, I somehow stepped into a life I wasn't destined to live.

Certain periods of my life, especially the early years, seemed like nothing but trouble on the way to eternity when I was going through them. Although, no matter what kind of turmoil I encountered, happiness somehow always came around again. The one direct and ceaseless link to me and that unloved and unwanted boy on the wild streets of Roxbury is my art.

All the ensuing years of hard work, all the struggles, all the heartbreak and the great times, have more than once found me out on that patio, looking out over the sublime view Marilyn and I are so blessed to enjoy, giving Marilyn a wink and saying, "Not bad for a couple of kids from Lynn who started off with nothing, huh?"

Sunset in Woodstock.
Summer, 2004.

Epilogue

My mother died in the third month of winter. This knowledge had lingered in the back of my mind since I had discovered it on her death certificate in March of 2000. A death in our family in December 2003 reminded me once again of the fragile grip we all have on life, and prodded my decision to visit my mother's resting place, almost sixty years after she disappeared.

Mattapan is a suburb of Boston, not far from Roxbury. My mother was buried there in Mount Hope Cemetery, little more than two miles south of Ruggles Street, in February of 1982. Brilliant sunshine and single-digit temperatures marked the day two of my sons and I visited the cemetery clerk's office with my mother's death certificate in hand, on a February morning in 2004. The clerk gave us directions to the grave, and then we drove to a treeless section of the cemetery.

The frigid winter air sent a chill through me as I studied the map I had been given. When we found the location where my mother's grave should have been, we thought there must have been a mistake—only a patch of faded winter lawn awaited us. No number, no marker—nothing. One of my sons jotted down the names of the two adjacent gravestones and we returned to the clerk's office. The clerk told us that the empty patch we had seen was indeed my mother's grave.

On the way back to that desolate spot, I looked out at distant, bare tree branches accentuating the blue sky in that monochromatic landscape of granite stones, all bearing the names of people someone must have loved once—names like Rosado, Hinton, and Wynn. Patches of snow lay here and there on the lifeless grass. For the first time in six decades, I knew where my mother was.

"Schizophrenia" is listed under "Other Significant Conditions" on my mother's death certificate. My reading on the subject of schizophrenia led me to consider for the first time that my mother may not have been responsible for the events of my childhood. Schizophrenia targets the relatively young, and almost always manifests itself before age forty.

A disease long cloaked in mystery, schizophrenia was first diagnosed by a German psychiatrist in the 1890s. Differentiating between thoughts, feelings, and actions becomes difficult for those suffering from this affliction. Hearing voices, seeing visions, and experiencing hallucinations are the primary symptoms. Schizophrenics often retreat from social life and withdraw into a frightening world where the inability to tell what is real from what is imaginary can often have devastating consequences. Schizophrenia has no cure, but modern medicine has a number of medications that can mediate the symptoms and quiet the voices and delusions, medications that were not available to my mother.

When I first discovered my mother's fate in the spring of 2000, I was revisited by emotions I thought had long ago disappeared: hatred, disappointment, the weight of childhood rejection, thwarted love—but most of all, confusion.

Could it be possible that my mother was already grappling with the symptoms of a debilitating mental illness by the time I was born? When her disease became more pronounced, losing her grip on reality must have been both terrifying and heartrending. During most of her lifetime, mental illness was misunderstood and demonized, treated with fear and a lack of understanding by society and the medical community.

If my conclusions are wrong—if my mother's rejection of her two sons was entirely selfish, mean-spirited, or intentional—it cannot change the past. Those reckless days spent trying to win my mother's affection in that cramped apartment next to the Roxy Theatre are all bound by disillusion; constrained by the memories of the young boy who tried to love her once, but who experienced only endless bewilderment at his mother's actions. After seven decades, my childhood memories of Ruggles Street often seem more recent than what happened the day before yesterday. They have a power and a clarity that never fades.

I lowered my head and said a prayer for the stranger who had been my mother. So sad that she never knew what became of her sons and their families. So strange that for the rest of her life she had lived only a short drive away from us all.

My mother never had a chance at a normal life, never mind happiness. If her search for happiness included finding a family, I doubt she ever succeeded. It's ironic that, in a way, my life has been about discovering the meaning of family, a lesson my mother was most likely never able to learn. I placed some red and white tulips on her bare grave and thought once again of the last time I'd seen her for that brief moment in Gramma Caulfield's kitchen, six decades before.

Curiosity had brought me from Vermont to Mount Hope Cemetery. But as I stood there on that clear morning, I realized that although the childhood memories of my mother would remain forever vivid, the anger that had always infused them had disappeared. I felt peaceful. At some point in the last few years, I had begun to forgive my mother for actions that may have been entirely beyond her control.

On our way out of the cemetery we once again stopped at the clerk's office to ask about buying a headstone for my mother. The clerk told us that she was actually buried on top of another person in a shared grave, and that we would have to contact the individual who had purchased the cemetery plot to do anything like that. He kindly searched some records in a vault and gave us a name and address from over twenty-five years ago. So far I have had no success in contacting the owner of the grave. Marie Hemeon Caulfield still lies nameless in that cold ground, as mysterious as ever.

My mother must have never made her way out of poverty. Perhaps in her final days, someone took pity upon her and paid for her funeral, but didn't care enough to spend money on a headstone. The harsh facts of her burial reflect the events of her life. However, the cemetery where my mother lies is in a wooded section of the city, full of parks and rolling hills. Even though her grave is modest, it is quiet, neat, and well-kept. She'd like that.

I was glad I had come to Mattapan. I knew there was no reason to come back again. As I walked back to the car one thought was insistent above all others: I hope that in my life, I have done the memory of my mother proud.

I intend to paint until the day I die. Camille Pissarro explained his thoughts about his work in a letter to his son, Lucien: "It is only in the long run that I aim to please . . . but the eye of the passerby is too hasty, and sees only the surface. Those in a hurry will not stop for me." I couldn't explain how I feel about my own work any better.

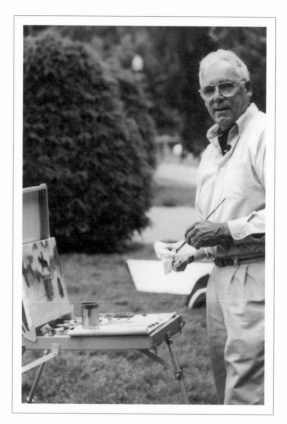

Painting in the Boston Public Gardens
for WCVB-TV's *Chronicle*.
May, 2000.

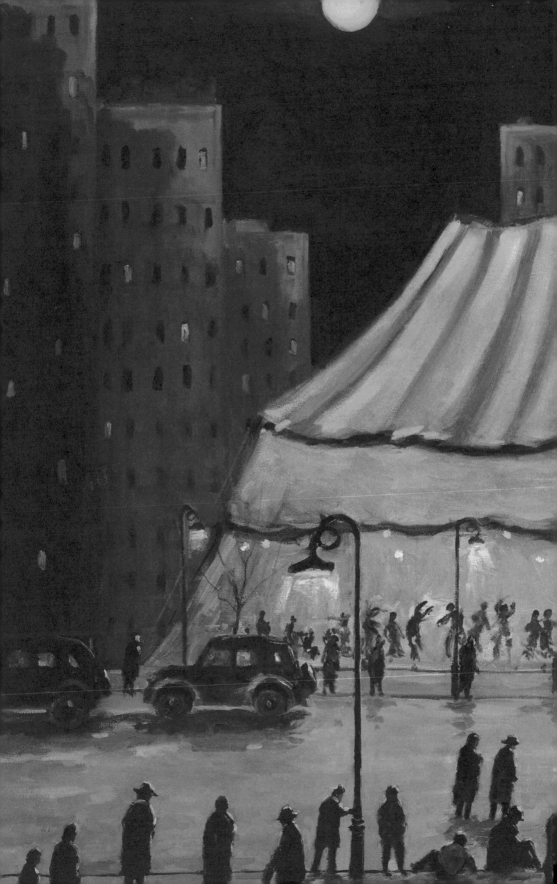